GW00771314

ASTRO NOISE

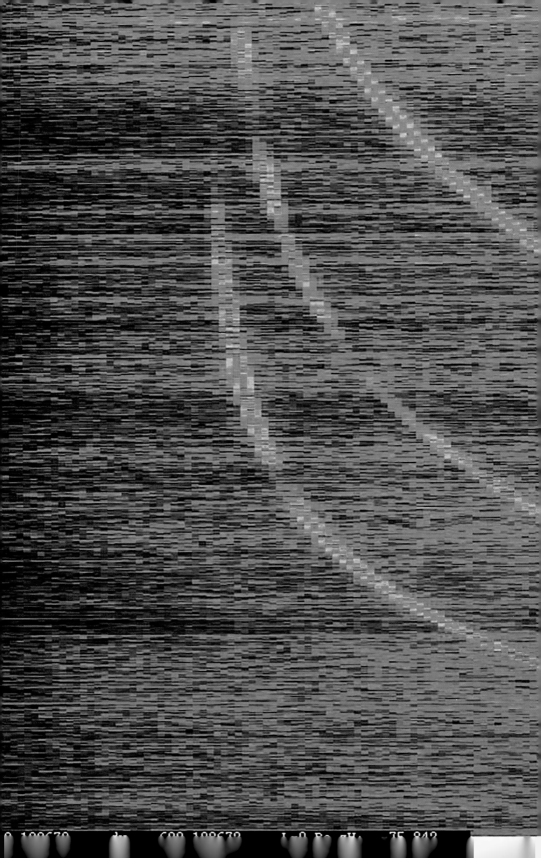

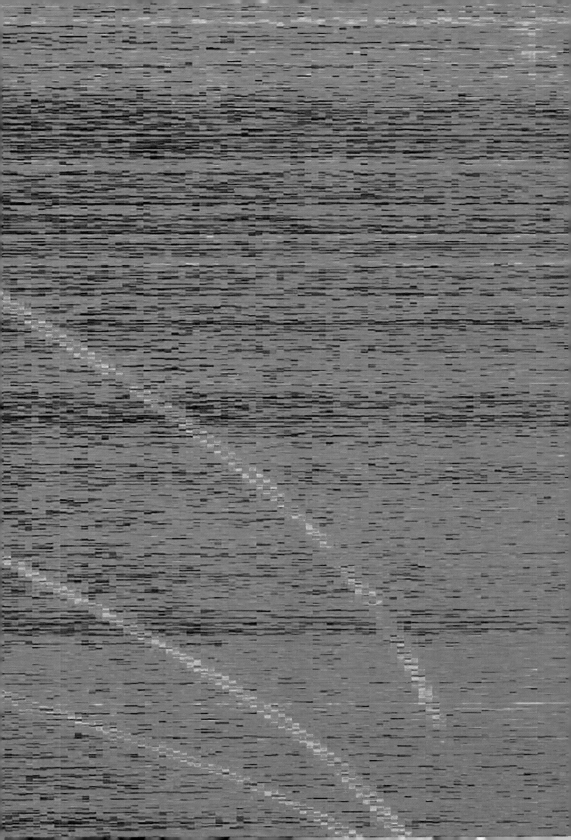

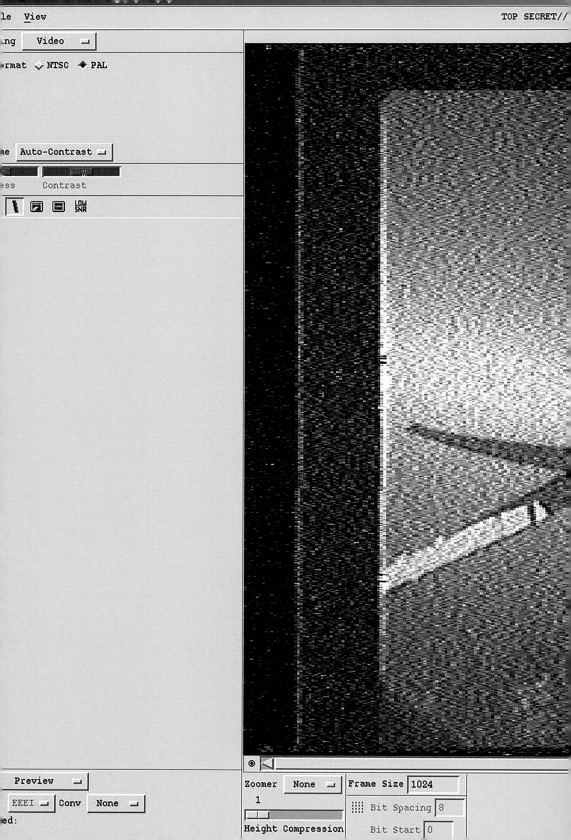

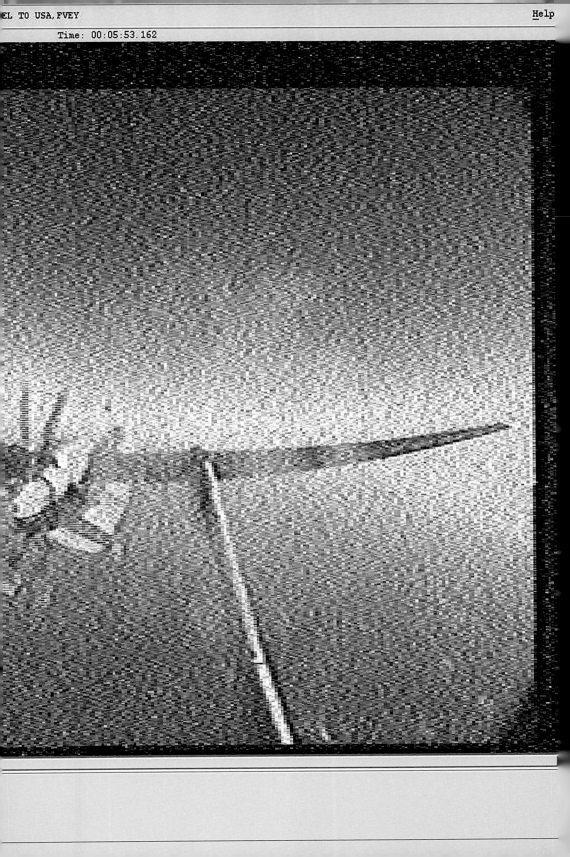

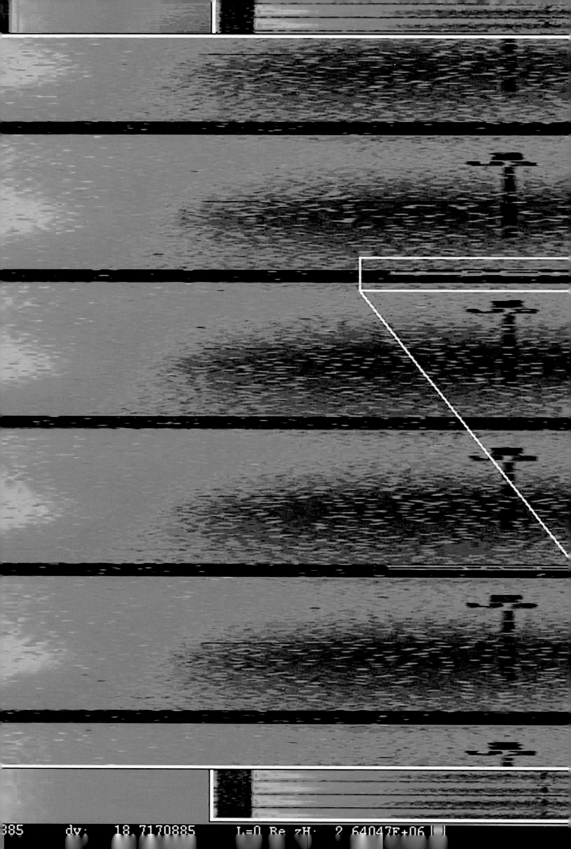

Total: 261281050
Width: 8232
Scale: 1

et Worksheet 1

ne: Apply Taps (Find LRS)

at 261281050

Pos 240967664

Row 29272

Col 560

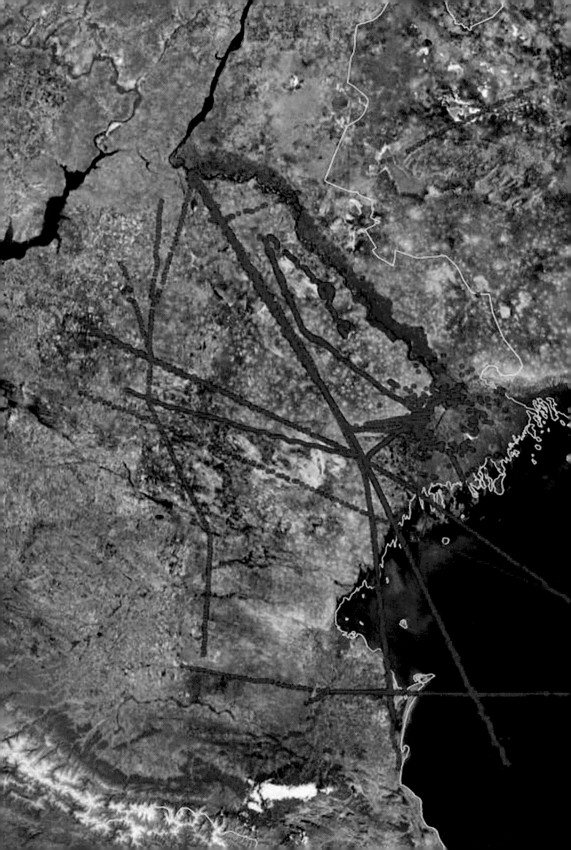

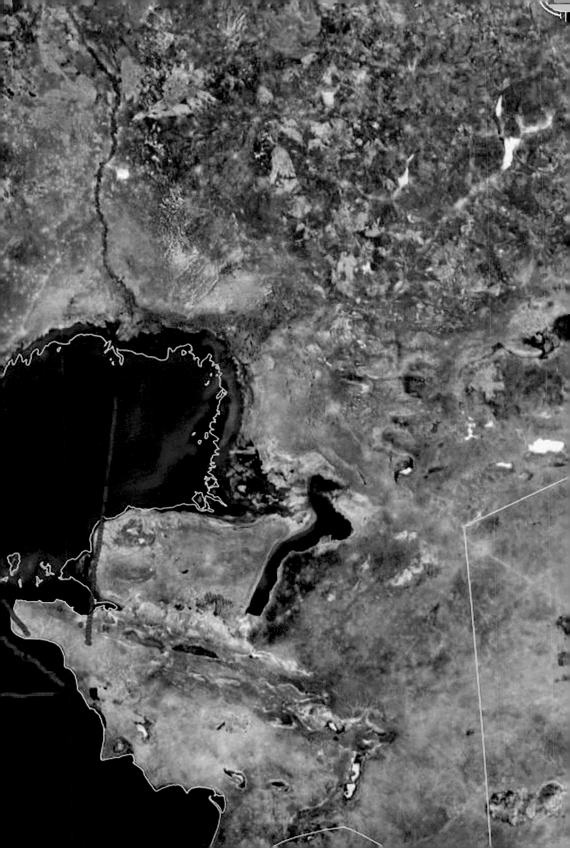

Whitney Museum of American Art, New York
Distributed by Yale University Press, New Haven and London

LAURA POITRAS

ASTRO NOISE

A SURVIVAL GUIDE FOR LIVING
UNDER TOTAL SURVEILLANCE

With an introduction by Jay Sanders and contributions by
Ai Weiwei, Jacob Appelbaum, Lakhdar Boumediene, Kate Crawford,
Alex Danchev, Cory Doctorow, Dave Eggers, Jill Magid,
Trevor Paglen, Edward Snowden, and Hito Steyerl

CONTENTS

FOREWORD

Adam D. Weinberg

IT SEEMS INCONGRUOUS THAT Gertrude Vanderbilt Whitney (1875–1942), one of the wealthiest Americans of her day, helped to support some of the most socially and politically engaged artists of her time. Through the establishment of the Whitney Studio Club and its successor, the Whitney Museum of American Art, Mrs. Whitney's early commitment to radical realist artists and her profound belief in the democracy of American art positioned her (and Juliana Force, the Museum's first director) as a champion of free expression and the Whitney as a site for potential controversy.

In 1908, in one of her first and most audacious acts, Mrs. Whitney purchased four of the seven paintings from the historic Macbeth Gallery exhibition of "The Eight," artists who challenged and ultimately broke the stranglehold of the conservative and exclusive National Academy. These works by Robert Henri, Ernest Lawson, George Luks, and Everett Shinn, today cornerstones of the Museum's collection, were largely disparaged for their distasteful subject matter: the gritty life of the urban lower classes. Given her own academic training as an artist and her penchant for realist work, it is not surprising that Mrs. Whitney favored figurative art; nevertheless, she decisively aligned herself with progressive artists committed to revealing an unflinching view of contemporary life. It is worth noting that a number of these Ashcan School artists, such as Henri and John Sloan, worked as newspaper illustrators, were contributors to the socialist magazine *The Masses*, and attended lectures by renowned anarchist Emma Goldman and other activities associated with leftist causes. As Avis Berman wrote in her biography of Mrs. Force, *Rebels on Eighth Street*, "Buying those canvases . . . was, consciously or unconsciously, a statement of class rebellion. Gertrude understood that these were the paintings of democrats, and collecting them was an act of engagement."

While Mrs. Whitney and Mrs. Force were hardly radicals, their

willingness to engage charged artistic and political issues, particularly from an interpretive *documentary* perspective, became a hallmark of their nearly four-decade partnership. This was manifested in the thematic exhibitions they organized such as *The Immigrant in America* (1915) and *America Genre: The Social Scene in Paintings and Prints (1800–1935)* (1935), with their selections of the social realists William Gropper, George Grosz, Robert Gwathmey, and Reginald Marsh for Annual and Biennial exhibitions, and in the numerous, provocative acquisitions they made.

For a time in the post-Whitney/Force era, the Museum's commitment to the reportorial tradition in art primarily took the form of exhibitions by artists it had shown in previous decades, including Jack Levine (1955), Philip Evergood (1960), Alice Neel (1974), and Jacob Lawrence (1974). In subsequent years, in tune with political developments of the time and in response to the investigation of the fundamental nature of representation itself, the Whitney's interest in social documentary work—broadly speaking—exploded. Profound and urgent philosophical questions about art-making were being interrogated: How do cultural biases shape the language of representation? Who has the right to speak for or about the individuals being represented? Is it appropriate to make art based on the victimization of others? How do commercial interests and the government determine or limit what we can create? Diverse and numerous exhibitions attacking these questions from multiple positions ranged from *The Prison Show: Realities and Representations* (1981) to *Black Male: Representations of Masculinity in Contemporary American Art* (1994–5), and asserted the critical need for socially engaged art while concurrently questioning its effectiveness. And in recent years, Whitney exhibitions related to questions of surveillance and systems of social control have come in the form of solo exhibitions by artists including Taryn Simon (2007), Jenny Holzer (2009), Omer Fast (2009–10), and Jill Magid (2010).

* * *

Laura Poitras is a documentary filmmaker best known for her works *My Country, My Country* (2006), *The Oath* (2010), and *CITIZENFOUR* (2014), a trilogy of reports on the "war on terror" and its consequences

for all people, everywhere. For some time, Poitras had wanted to depart from her filmic practice to create an installation that would possess both the urgency of fact and the visceral and emotional qualities of "real" space. In 2013, she wrote in her journal (an excerpt of which appears in this volume): "I should think about using NSA material in the exhibition. To draw people in and break news. To mirror the themes of the surveillance mechanism. Maybe an art exhibition could do that—both create an aesthetic experience and reveal information that evokes an emotional response." Her desire, I believe, is to deliver a wake-up call, making real the threats omnipresent in a surveillance society.

Poitras's approach in *Astro Noise* involves a sequence of installations utilizing projections, real-time video, the architecture of space, and meaningful artifacts; she uses the artwork as a vehicle to create an empathetic situation that provokes individual moral and ethical responses among viewers. The subject of each work, however, is not so much the other—the hooded prisoner held captive for unknown reasons; the potential targets of drone strikes lying unaware under the star-filled skies of the Middle East; the artist herself, who has been the target of numerous governmental investigations—but rather the public who pass through the installation; that is, *us*. Poitras has framed a series of sequential experiences that make us keenly and threateningly aware that we are the ones watching and being watched. As we travel through a narrative dreamscape composed entirely of fact, we are made cognizant of the many types of watching: looking, seeing, observing, contemplating, staring, studying, gazing, peering, spying.

In *Astro Noise*, the artist poses acute and devastating personal, political, aesthetic, and metaphysical questions: Does privacy exist in a world where the real story of your life is an aggregation of data points? Who has the right to this information and how it is used? Given the avalanche of data collected around the world and around the clock, how can we hope to understand the use of this information, no less manage, regulate, and legislate it? What are the existential repercussions of living in a world where it is impossible to be alone, ever? And then there are the enduring questions that face all artists who produce social critique: What does it mean to manipulate fact for the "greater good" of an art experience? How does the notion of beauty factor into the moral calculus regarding art of this sort?

Poitras is a risk taker, and I don't refer here solely to the personal, physical, and political risks she has taken working in a war zone or trading in national-security documents. In *Astro Noise*, she takes artistic risks, pushing beyond her familiar territory of narrative filmmaking and mining new and seemingly incongruous ground: the intersection of big data, surveillance, and art. Interestingly enough, when Edward Snowden chose to reveal his secrets to Poitras, he selected her because, as he is quoted herein, "The combination of her experience and her exacting focus on detail and process gave her a natural talent for security." These words, *exacting*, *detail*, and *process*, are critical to the vocabulary of all great art. But, more important, art is a possible response to total surveillance itself, and not merely by unmasking it; art's randomness, ambiguity, illogic, anarchy, unpredictability, and chance operations themselves challenge oppressive and insidious systems of structure and control. As catalogue contributor Jacob Appelbaum puts it, in a rousing exhortation, "Only in ephemerality are we free and only in that freedom we will be at liberty. Your task is to create that ephemerality for everyone, without exception, and to make that space as large as is possible. A world without gods or masters!"

* * *

I would like to thank Laura Poitras for her courage and for placing her trust in the Whitney to help realize her vision for *Astro Noise*. And, great kudos to Jay Sanders for having the foresight and perseverance to bring this demanding and complex project to fruition.

Ambitious projects are impossible to realize alone, and we are fortunate to have an exceptional group of supporters for this exhibition. We owe a tremendous debt of thanks to The Andy Warhol Foundation and its president, Joel Wachs, for their consistent commitment to artists who push the envelope and for their recognition of the importance of Laura Poitras's work at this moment. The Teiger Foundation has been a visionary supporter from the very beginning, offering an early leadership gift for exhibition research. The Keith Haring Foundation Exhibition Fund and The Reva and David Logan Foundation also made generous contributions to ensure that this work could be realized to its full potential and shared with a diverse audience at the Whitney.

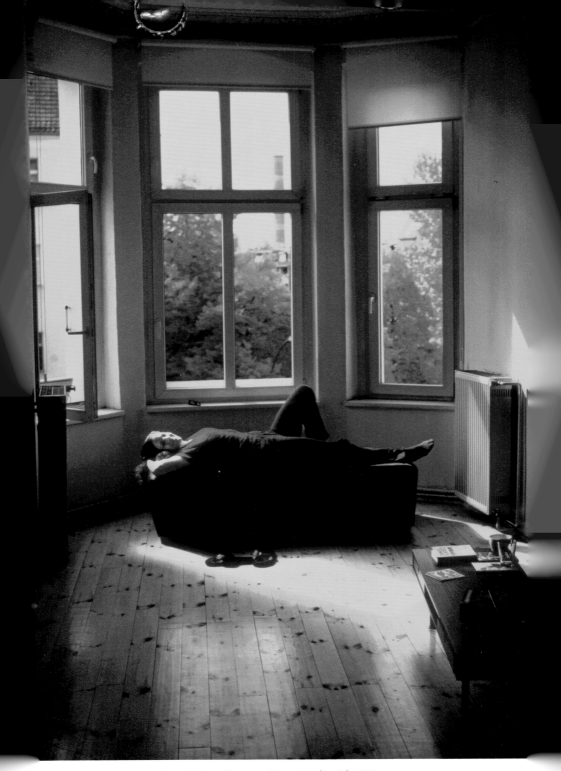

Jacob Appelbaum, *Laura Poitras, Summer of Snowden (Berlin)*, 2013

INTRODUCTION

Jay Sanders

ARTIST, FILMMAKER, AND JOURNALIST Laura Poitras compels us to rethink how an artist can explore and convey the nature of power, expand our understanding of the larger world, and shape our sense of responsibility. Despite her fundamental desire to sidestep personal visibility, and in the face of considerable adversity and personal risk amid dangerously unknown conditions, she has relied on the power of art and storytelling as a means of communicating the complexities of life today. It is no coincidence that Poitras calls her production company Praxis Films. Praxis is philosophical thought taking form as concrete action in the world. Political theorist Hannah Arendt, who viewed Western thought as too weighted toward the contemplative, argued that praxis in the form of everyday political action is the true realization of human freedom. Poitras shows us the lives of specific individuals confronting their historical circumstances and state power, just as she has confronted these circumstances herself.

Poitras entered the orbit of the Whitney Museum of American Art four years ago with her inclusion in the 2012 Whitney Biennial. The urgency of her work—its complex, intimate, and real-time depiction of the global effects of the post–September 11, 2001 world on individuals' lives—was vitally clear to all of us who organized that exhibition. In the Biennial, Poitras presented *The Oath* (2010), the second film in her then-in-process "9/11 Trilogy." In the Biennial's exhibition catalogue, participating artists were invited to represent themselves or their work in any way they chose. Poitras opted to publish four pages of Department of Homeland Security documents that she had obtained through a Freedom of Information Act request. They detailed her treatment at U.S. airports on returning from travels abroad—repeated detainment and questioning as well as searches of her camera equipment and personal belongings. The documents recount firsthand the extent to which the American government is able to search, seize, copy, and hold one's

property, including data, without a warrant or suspicion of a crime. At the time, Poitras was in the process of shooting footage and gathering materials for her third and final post-9/11 film, which would follow the "war on terror" back to the United States, in the form of massive, top-secret National Security Agency programs of global surveillance.

As part of the Biennial, Poitras organized a public event at the Whitney, the Surveillance Teach-In. Foretelling what we were soon to learn via the revelations of Edward Snowden and through Poitras's film *CITIZENFOUR* (2014), the Teach-In brought together William Binney, a former NSA technical director turned whistleblower, and Jacob Appelbaum, a computer-security expert, privacy advocate, journalist, and hacker, for the two to meet for the first time, onstage at the museum. Appelbaum questioned Binney about how technologies he had helped develop to enable the United States to spy on potential foreign enemies had, unbeknownst to him, been repurposed for domestic surveillance. Among the audience, these revelations created a palpable sense of a reality unmoored, an atmosphere of conspiracy

Jacob Appelbaum and William Binney (center left and right) speaking at the Surveillance Teach-In, organized by Laura Poitras for the 2012 Whitney Biennial, Whitney Museum of American Art, New York, April 20, 2012

theories, paranoia, and disbelief. The disorientation and duress were enhanced by another aspect of the evening, Poitras's collaboration with the performance group Stimulate, whereby a portion of the visitors to the Whitney were temporarily detained on arrival and taken to the museum's courtyard. They were released after several minutes, but they experienced, at least briefly, being snagged in an unexpected structure of control. By the end of the evening, inkjet-printed canvas photographs of WikiLeaks founder Julian Assange—another subject of Poitras's work—had found their way onto the walls of the museum's galleries upstairs, a renegade gesture that remains a mystery to this day.

Soon thereafter, fearing that, in the United States, she could not complete the film on which she was at work, Poitras relocated to Berlin. With the unexpected emergence of Snowden in her life in early 2013—via email contact from a mysterious "Citizen Four"—the focus of this third film in the "9/11 Trilogy" radically shifted as she became a protagonist in the narrative, documenting his story in real time and playing a key role in its unfolding on the world stage. The result, *CITIZENFOUR*, was an astonishing cinematic feat, one undertaken as Snowden's revelations and Poitras's reporting ricocheted around the globe and sparked a far-reaching debate on the ethics of an empire based on democratic principles monitoring entire populations in the name of protecting them.

During the period after Snowden had contacted her, Poitras began examining ideas for expanding her cinematic practice into installations and media environments, considering the moving image beyond long-form films, and looking toward other ways of addressing and engaging an audience. As *CITIZENFOUR* began to take shape, she realized that the nature of what she was attempting to convey—a vast, often-invisible infrastructure that affected every individual around the world—also lent itself to other kinds of artistic expression. Poitras contacted me, describing her ideas for presenting the culture and mechanisms of surveillance in a very different way, through structured visual experiences that might embody and express the course of American foreign policy and operations in the post-9/11 world. Such an approach would provide much more than journalistic information or a single cinematic narrative and would compel an audience to enter into a visceral, dialectical relationship with the way those around the world endure the effects of America's response to the attacks of September 2001.

Snowden's first revelations hit the news in June 2013. As the watershed reporting based on the Snowden archive fueled public debate internationally, we invited Laura Poitras to create an exhibition of work as one of the first shows at the new Whitney Museum. After nearly a year of avoiding travel to the United States, Poitras returned to New York in April 2014, in part to receive the prestigious George Polk Award for her national-security journalism, and began planning her first museum exhibition.

The resulting exhibition's title, *Astro Noise*, echoes with associations. Discovered accidentally by astronomers in 1964 and initially thought to be a technical error, *astro noise* refers to the faint background disturbance of thermal radiation left over after the big bang; it is most evident to earthbound observers in the form of microwaves that seem to pervade the universe, unaffiliated with any specific source. Measurements of the energy of these waves have been used to determine the age of the universe and are one of the firmest pieces of evidence for the big bang hypothesis. More pointedly, Astro Noise is the name Edward Snowden gave to an encrypted file containing evidence of NSA mass surveillance that he shared with Poitras in 2013.

In the exhibition *Astro Noise*, Poitras expands on her project to document post-9/11 America through a series of interrelated installations that incorporate documentary footage, primary documents, and narrative structure. The works builds on subjects she has examined in her films: mass surveillance, the war on terror, the U.S. drone program, Guantánamo Bay prison, military occupation, and torture. The opening work, a double-sided projection, situates visitors directly in the aftermath of the events of September 2001. On one side is projected Poitras's short film *O'Say Can You See* (2001/2011), the only previously realized component of the exhibition, which features slow-motion images of onlookers gazing at the remains of the World Trade Center. On the reverse appears formerly classified footage of the U.S. military's interrogation of prisoners captured in Afghanistan in November 2001 and later sent to Guantánamo Bay.

In the second gallery, the projection environment *Bed Down Location* fast-forwards fifteen years, siting the viewer within the present-day war on terror, under night skies where the United States carries out drone strikes and "targeted killing." With a name taken from the military term used to describe the sleeping coordinates of people targeted

for assassination by drones, the work consists of video of the night sky from countries such as Yemen, Pakistan, and Somalia projected onto the gallery ceiling. *Bed Down Location* leads to *Disposition Matrix*, a winding corridor perforated on either side with peephole slits cut into the walls. Beams of light emanating from the openings provide the sole source of illumination in the dark passageway. Each slit allows a view into the secret state—but only a partial, cutaway one—in the form of documents, videos, and still images. These and other works in *Astro Noise* plumb the realities of detainment and the visual manifestations of surveillance in provocative, confrontational ways.

In place of a traditional exhibition catalogue, *Astro Noise: A Survival Guide for Living Under Total Surveillance* presents a collection of texts at once subversive and matter-of-fact concerning life in a surveillance state. Poitras invited artists, novelists, technologists, a data journalist, and a former Guantánamo Bay prisoner to contribute in ways that, whether playful, ardent, or theoretical, extend beyond both journalism and art writing. The aim of the book is to create an imaginative yet useful field

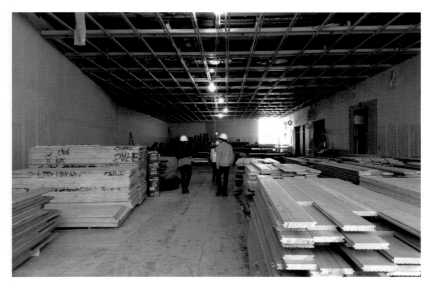

Laura Poitras and Jay Sanders touring the Whitney's new building during construction, New York, April 14, 2014

guide of critical perspectives and responses to contemporary political reality. Some writers worked directly with Poitras, drawing from the archive of documents leaked by Snowden: Kate Crawford relays the metaphorical potential for how the archive can speak, while Jill Magid was tasked with compiling a glossary of intelligence terminology. Others contributed fiction: Cory Doctorow pens a Sherlock Holmes story on mass surveillance, and Dave Eggers excerpts the screenplay for his novel *The Circle* (2013), imagining corporate social media obtruding on government functions. Collectively, the many authors' inventive contributions express much more than simply the facts at hand.

And the facts themselves can have a powerful aura of their own. Opening and closing the book are image spreads culled from the Snowden archive from a program called Anarchist, an operation run by the British intelligence service GCHQ in which intercepted signals from radar systems, satellites, and drones are processed and analyzed. Too, in the days before sending this book to print, Poitras received a number of redacted documents obtained through a Freedom of Information Act lawsuit she filed against the Department of Homeland Security, the Department of Justice, and the Office of the Director of National Intelligence. Presented in part here, these newly released documents reveal the alarming extent to which she has been under investigation for her work: she has not only been placed on a watch list but has also been the target of classified FBI and grand-jury investigations.

In mid-September 2015, as the book neared its final stages of production, Poitras and I sat down to speak about the impending exhibition.

JAY SANDERS: I know you're always reluctant to describe the work you make before it's completed. You also once told me that you don't like to repeatedly tell the same story because it hardens into a definitive account in your own mind—you lose the complicated sensorial aspects of an experience when it becomes an anecdote.

LAURA POITRAS: I'm not a fan of talking about my work, particularly about work in progress. The work is visual and not verbal for a reason.

JS: I have strong memories of first contacting you about doing this exhibition, at a time when you couldn't safely enter the U.S., and then later

when you finally came to see the Whitney's new building while it was still under construction. Over the last year, as the work for *Astro Noise* has been quietly taking form in your New York studio, have you found your artistic process different as it pertains to making installations and an exhibition as opposed to films?

LP: In many ways it's not different. I'm interested in installation work that has a narrative experience. To have a clear beginning, middle, and end, with reveals and twists: all those things happen in a plot, but they are mapped more abstractly when the museum viewer is the protagonist. I want to draw viewers into the narrative of the work so that they leave it in a different mind-set from when they entered. I'm also interested in having bodies in spaces and asking them to make choices, which is not something you get to do in a movie theater.

JS: I'm always interested in issues of audience, of who experiences art and to whom it's addressed. In contemporary visual art, it's an interesting question, because it's most often made for the network of artists, collectors, scholars, writers, and curators who make up the art world. Museums are the place where the broadest public is invited into that dialogue, where the access points are much wider. How do you think about the relationship between the museum context and the public, particularly concerning the political content of the work, and how is it different from that of a movie theater?

LP: There are two questions here—one about audience, the other about institutional context. In terms of audience, there is something really great about the populist medium of cinema. It's seductive; most people can engage with it. I want to bring that kind of narrative engagement into the installation work. How the context of the museum impacts the work is a separate question. I obviously don't want to sanitize the political content. But there is always a risk of having work co-opted by the institution—that's a risk every artist or filmmaker confronts when making decisions about publication or distribution. In the end I hope the work I'm doing, no matter the form it takes, expresses an emotional and political urgency that connects to audiences.

JS: Your work is exemplary, in the films of course but especially with this exhibition, in intensely considering the interaction of viewers as a fundamental component. The audience becomes a primary factor in how each work occurs.

LP: There's a detached quality I often see in museum and gallery spaces that I want to avoid. What I connect to in the work of an artist like Christian Boltanski is the journey it takes you on.

JS: The first work viewers will see is your film *O'Say Can You See*. It represents a turning point in your work as an artist, as it was the first film you made in response to the events of September 11, a central subject ever since. You shot it near the World Trade Center site just days later. I remember you curated a film program as part of the Rencontres Internationales du Documentaire de Montréal (RIDM) in 2012 that included Andy Warhol's infamous *Blow Job* (1964). You wrote a short text that characterized *Blow Job* as a very extended reaction shot and spoke too about the limits of representation, about revealing instead through reaction. It's striking that *O'Say Can You See* consists entirely of reaction shots, on a scale that's both intimate and massive. I rewatched it again today, and the film took me back to the much more raw feeling of that moment, a more open-ended state.

LP: I love cinematic language. There's probably nothing more exciting than the reaction shot because it is a moment of transference where viewers project what they think someone is thinking and feeling. Reaction shots also, as you say, reveal the limits of representation. I don't know if it's possible to represent the tragedy and destruction of what happened at Ground Zero. By staying with the reaction shot, I felt I could "see" things better than if I had pointed the camera at something no longer there. *O'Say Can You See* is a documentary even though it provides very little exposition. It's a primary document of people trying to make sense of the unimaginable. The film itself is also about the limits of seeing—both the desire to see and the limits of seeing.

JS: Right. And you now make it part of a new work by recontextualizing it in the form of a two-sided projection, sharing a screen with

interrogation videos from 2001. History's course has become clear. So when a viewer comes around the back of *O'Say*, it begins the dramatic reveal of the exhibition, as that two-sidedness signals the onset of the dialectical nature of each work. And this careful staging of moving images in situ prompts dramatic engagements that change one's relationship to an image. You start to open your eyes to things that as American citizens we might not otherwise see. The night sky in *Bed Down Location* is populated with unseen drones yet visually calls to mind a planetarium or James Turrell's skyspaces: the celestial reveal.

LP: The entire exhibition is about the post-9/11 era, but it is also very much about cinema itself, with the use of reaction shots, planetarium-style ceiling projections, peepholes, narrative loops, and reveals. Already in the time of the Lumières and Méliès, cinema contained the tension between documenting cold, hard reality (people leaving a factory, trains arriving) and creating magic and fantasies. By asking people to lie down in *Bed Down Location*, I want them to enter an empathetic space and imagine drone warfare—not simply to understand it from news articles but to ponder the sky and imagine that there is a machine flying above you that could end your life at any moment. What does that feel like? Many people in the world are living under skies where that is a reality. There's a lot of conceptual art that talks about violence or power in an intellectual way, but I want to expand people's understanding emotionally.

JS: The potency of the gesture lies in the particularities of how the gallery is arranged, so that viewing the sky occurs in a calm, contemplative space that creates a dissonance with its more ominous overtones. With the next piece, *Disposition Matrix*, there's a different kind of emotional resonance for viewers, one of being confronted with all these windows, or peepholes, onto secrets that appear not as a totality but in slivers— brief, partial views.

LP: In both of those spaces I'm interested not just in the experience of the viewer as protagonist moving through a narrative journey but in how other bodies create that narrative experience. And I very much like the idea of creating a space that challenges the viewer as to whether to

venture in or not. My documentaries are about these kinds of questions. We live life not knowing what will happen next. What do people do when they're confronted with choices and risks?

JS: These ideas set up challenges for the museum too. Art asks a lot of viewers, but within the museum context, there's often the sense that the explanations are at hand as well. Maybe one of the tensions *Astro Noise* will create will lie in taking away a little bit of that ease.

LP: It will be confrontational. There will be echoes of the Surveillance Teach-In, where we detained people at the museum and interrogated them before they could enter.

JS: You see in art the struggle of how to represent an incredibly complex situation and how to respond artistically or creatively to it. In your work you find ways to reveal the complexity of geopolitical affairs in how they affect individual lives. By tracing people's lives, larger, highly complicated machinations come into focus.

LP: It's not just that I'm tracing people's lives and relating their compelling narratives. They're real people who are navigating real risks. There's a very direct connection between the films and what people are actually experiencing. They're people who are putting their lives on the line for a set of beliefs.

JS: What then are some of the tactics that go into making your documentary work?

LP: My films rely on access, which is a kind of tactic. Those tactics are not always visible in the stories you see on screen. To get access to Guantánamo for *The Oath*, for example, I approached *This American Life*, explained I was making a documentary, and asked if I could produce something for them as well, so we could travel to Guantánamo under their umbrella. My editor Jonathan Oppenheim and cinematographer Kirsten Johnson went and filmed the first military tribunal at the prison. I was in Yemen filming. I didn't try to go to Guantánamo because I was on a watch list, and I assumed the request would be denied

if my name was on it. We didn't break any media rules, but I wasn't fully transparent with the military about the full scope of the project. At some point they became suspicious and said they looked like a documentary crew and tried to have them removed from the island, but the other media covering the trial protested. We made a tactical and ethical decision that the benefits of documenting a prison that exists outside the rule of law, where people are being imprisoned without charge, outweighed our obligation to be fully transparent.

JS: I was struck that you had a very immediate vision for this book, that it wouldn't be a monograph on your work or an attempt at approximating the exhibition. It was refreshing to link the exhibition and the publication intrinsically and create them together but to decide that in a certain way they were on separate missions. The book can be self-sufficient; it can live as an independent entity outside the show.

LP: The reification of the artist doesn't interest me. Instead, I wanted to do something about practice and political realities that I hope will work on its own terms and will also make a statement against art theory or theory for theory's sake. The idea of collaborating with artists and writers, and in some cases asking them to write about the Snowden archive, was very compelling.

I was also interested in juxtaposing fiction and nonfiction. There are so many stories from the war on terror that are unbelievable but true. For instance, there's the case of Khaled El-Masri, who was kidnapped by the CIA because they got his name wrong, sent to a black site in Afghanistan where he was tortured, and months later, when the CIA realized they had abducted the wrong person, they released him alone at night on an isolated road in Albania. When El-Masri tried to sue the CIA, the U.S. government denied him the right to do so on the grounds that a trial would reveal state secrets. I hope the *Survival Guide* provides a practical and metaphorical road map to understanding and navigating this kind of landscape, of total surveillance and the "war on terror."

A Survival Guide for Living Under Total Surveillance

THE ADVENTURE OF THE EXTRAORDINARY RENDITION

Cory Doctorow

Three examples of information cascades. From HIMR
Data Mining Research Problem Book, GCHQ, 2011

HOLMES BUZZED ME INTO his mansion flat above Baker Street station without a word, as was his custom, but the human subconscious is a curious instrument. It can detect minute signals so fine that the conscious mind would dismiss them as trivialities. My subconscious picked up on some cue—the presence of a full stop in his text, perhaps: "Watson, I must see you at once." Or perhaps he held down the door admission buzzer for an infinitesimence longer than was customary.

I endured unaccountable nerves on the ride up in the lift, whose smell reminded me as ever of Changi airport, hinting at both luxury and industry. Or perhaps I felt no nerves at all—I may be fooled by one of my memory's many expert lies, its seamless insertion of the present day's facts into my recollections of the past. That easy facility with untruth is the reason for empiricism. No one, not even the storied Sherlock Holmes himself, can claim to have perfect recollection. It's a matter of neuroanatomy. Why would your brain waste its precious, finite neurons on precise recall of the crunch of this morning's toast when there are matters of real import that it must also store and track?

I had barely touched the polished brass knocker on flat 221 when the handle turned and the door flew open. I caught a momentary glimpse of Holmes's aquiline features in the light from the hallway sconce before he turned on his heel and stalked back into the gloom of his vestibule, the tails of his mouse-colored dressing gown swirling behind him as he disappeared into his study. I followed him, resisting the temptation to switch on a light to guide me through the long, dark corridor.

The remains of a fire were in the grate, and its homey smell warred with the actinic stink of stale tobacco smoke and the gamy smell of Holmes himself, who was overdue for a shower. He was in a bad way.

"Watson, grateful as I am for your chronicles of my little 'adventures,' it is sometimes the case that I cannot recognize myself in their annals." He gestured around him and I saw, in the half-light, a number of the first editions I had gifted to him, fluttering with Post-it tabs stuck to their pages. "Moreover, some days I wish I could be that literary creation of yours, with all his glittering intellect and cool reason, rather than the imperfection you see before you."

It was not the first time I'd seen my friend in the midst of a visit by the black dog. Seeing that man—yes, that creature of glittering intellect and cool reason—so affected never failed to shake me. This was

certainly the most serious episode I'd witnessed—if, that is, my memory is not tricking me with its penchant for drama again. His hands, normally so steady and sure, shook visibly as he put match to pipe and exhaled a cloud of choking smoke to hover in the yellow fog staining the ceiling and the books in the highest cases.

"Holmes, whatever it is, you know I'll help in any way I can."

He glared fiercely, then looked away. "It's Mycroft," he said.

I knew better than to say anything, so I waited.

"It's not anything so crass as sibling rivalry. Mycroft is my superior in abductive reasoning and I admit it freely and without rancor. His prodigious gifts come at the expense of his physical abilities." I repressed a smile. The Holmes brothers were a binary set, with Holmes as the vertical, whip-thin ONE, and Mycroft as a perfectly round OH in all directions. Holmes, for all his cerebral nature, possessed an animal strength and was a fearsome boxer, all vibrating reflex and devastating "scientific" technique. Mycroft might have been one of the most important men in Whitehall, but he would have been hard pressed to fight off a stroppy schoolboy, let alone some of the villains Sherlock had laid out in the deadly back ways of London.

"If my brother and I have fallen out, it is over principle, not pettiness." He clenched his hands. "I am aware that insisting that one's grievance is not personal is often a sure indicator that it is *absolutely* personal, but I assure you that in my case, it is true."

"I don't doubt it, Holmes, but perhaps it would help if you filled me in on the nature of your dispute?"

Abruptly, he levered himself out of his chair and crossed to stand at the drawn curtains. He seemed to be listening for something, head cocked, eyes burning fiercely into the middle distance. Then, as if he'd heard it, he walked back to me and stood close enough that I could smell the stale sweat and tobacco again. His hand darted to my jacket pocket and came out holding my phone. He wedged it deliberately into the crack between the cushion and chair.

"Give me a moment to change into walking clothes, would you?" he said, his voice projecting just a little louder than was normal. He left the room then, and I tapped my coat pocket where my phone had been, bewildered at my friend's behavior, which was odd even by his extraordinary standards.

I contemplated digging into the cushions to retrieve my phone—my practice's partners were covering the emergency calls, but it wasn't unusual for me to get an urgent page all the same. Private practice meant that I was liberated from the tyranny of the NHS's endless "accountability" audits and fearsome paperwork, but I was delivered into the impatient attentions of the Harley Street clientele, who expected to be ministered to (and fawned over) as customers first and patients second.

My fingers were just on its corner when Holmes bounded in again, dressed in his usual grey man mufti: Primark loafers, nondescript charcoal slacks, canary shirt with a calculated wilt at the collar, blue tie with a sloppy knot. He covered it with a suit jacket that looked to all appearances like something bought three for eighty pounds at an end-of-season closeout at a discounter's. As I watched, he underwent his customary, remarkable transformation, his body language and habits of facial expression shifting in a thousand minute ways, somehow disguising his extraordinary height, his patrician features, his harrowing gaze. He was now so utterly forgettable—a sales clerk in a mobile-phone shop, a security guard on a construction site, even a charity mugger trying to get passersby to sign up for the RSPCA—that he could blend in anywhere in the UK. I'd seen him do the trick innumerable times, with and without props, but it never failed to thrill.

"Holmes—" I began, and he stopped me with a hand, and his burning stare emerged from his disguise. *Not now, Watson,* he said, without words. We took our leave from the Baker Street mansion flats, blending in with the crowds streaming out of the train station. He led me down the Marylebone Road and then into the backstreets where the perpetual King's Cross St. Pancras building sites were, ringed with faded wooden hoardings. The groaning of heavy machinery blended with the belching thunder of lorries' diesel engines and the tooting of black cabs fighting their way around the snarl.

Holmes fitted a Bluetooth earpiece and spoke into it. It took me a moment to realize he was speaking to me. "You understand why we're here?"

"I believe I do." I spoke at a normal tone, and kept my gaze ahead. The earpiece on the other side left Holmes's near ear unplugged. "You believe that we are under surveillance, and given the mention of

Mycroft, I presume you believe that this surveillance is being conducted by one of the security services."

He cocked his head in perfect pantomime of someone listening to an interlocutor in an earpiece, then said, "Precisely. Watson, you are an apt pupil. I have said on more than one occasion that Mycroft *is* the British government, the analyst without portfolio who knows the secrets from every branch, who serves to synthesize that raw intelligence into what the spying classes call 'actionable.'"

We turned the corner and dodged two builders in hi-viz, smoking and scowling at their phones. Holmes neither lowered his tone nor paused, as either of those things would have excited suspicion.

"Naturally, as those agencies have commanded more ministerial attention, more freedom of action, and more strings-free allocations with which to practice their dark arts, Mycroft's star has only risen. As keen a reasoner as my brother is, he is not impervious to certain common human failings, such as the fallacy that if one does good, then whatever one does in the service of that good cannot be bad."

I turned this over in my mind for a moment before getting its sense. "He's defending his turf."

"That is a very genteel way of putting it. A more accurate, if less charitable characterization would be that he's building a little empire through a tangle of favor trading, generous procurements, and, when all else fails, character assassination."

I thought of the elder Holmes, corpulent, with deep-sunk eyes and protruding brow. He could be stern and even impatient, but . . . "Holmes, I can't believe that your brother would—"

"Whether you believe it or not is irrelevant, James." He only called me by the old pet name of my departed Mary when he was really in knots. My breath quickened. "For it's true. Ah, here we are."

"Here" turned out to be a shuttered cabinetmaker's workshop, its old-fashioned, hand-painted sign faded to near illegibility. Holmes produced a key from a pocket and smoothly unlocked the heavy padlock and let us both in, fingers going quickly to a new-looking alarm panel to one side of the door and tapping in a code.

"Had an estate agent show me around last week," he said. "Snapped a quick photo of the key and made my own, and of course it was trivial to watch her fingers on the keypad. This place was in one family for

over a century, but their building was sold out from under them and now they've gone bust. The new freeholder is waiting for planning permission to build a high-rise and only considering the shortest of leases."

The lights came on, revealing a sad scene of an old family firm gone to ash in the property wars, worktables and tools worn by the passing of generations of skilled hands. Holmes perched on a workbench next to a cast-iron vise with a huge steel lever. He puffed his pipe alight and bade me sit in the only chair, a broken ladder-back thing with a tapestry cushion that emitted a puff of ancient dust when I settled.

"I was deep in my researches when the young man knocked. I may have been a little short with him, for he was apologetic as I led him into my study and sat him by the fire. I told him that no apologies were necessary. I have, after all, hung out my shingle—I've no business snapping at prospective clients who interrupt my day."

Holmes spoke in his normal tones, the raconteur's humblebrag, without any hint of the nervousness I'd detected in him from the moment I'd stepped through his door. We might have been in his study ourselves.

"I knew straightaway that he was a soldier, military intelligence, and recently suspended. I could see that he was a recently single man, strong willed and trying to give up cigarettes. I don't get many visitors from the signals-intelligence side of the world, and my heart quickened at the thought of a spot of real intrigue for a change."

Holmes folded his hands at his breast and I knew the tale was begun.

"I understand that you are a man who can keep his confidences, Mr. Holmes," my visitor said.

"I have held Strap 3 clearance on nine separate occasions, though at the moment I hold no clearances whatsoever. Nevertheless, you may be assured that Her Majesty's Government has given me its imprimatur as to my discretion."

He barked a humorless laugh then. "Here stands before you proof that HMG is no judge of character."

"I had assumed as much. You've brought me a document, I expect."

He looked abashed, then defiant. "Yes, indeed I have," and he drew this from out his pocket and thrust it upon me.

Holmes drew a neatly folded sheet of A4 from his inside pocket and passed it to me. I unfolded it and studied it.

"Apart from the UK TOP SECRET STRAP1 COMINT markings at the top, I can make neither head nor tail," I admitted.

"It's rather specialized," Holmes said. "But it might help if I told you that this document, headed 'HIMR Data Mining Research Problem Book,' relates to malware implantation by GCHQ."

"I know that malware is the latest in a series of names for computer viruses, and I suppose that 'malware implantation' is the practice of infecting your adversaries with malicious computer code."

"Quite so. You may have heard, furthermore, of Edgehill, the top secret Strap 1 program whose existence was revealed in one of the Snowden documents?"

"It rings a bell, but to be honest, I got a sort of fatigue from the Snowden news—it was all so technical, and so dismal."

"Tedium and dismalness are powerful weapons—far more powerful than secrecy in many cases. Any bit of business that can be made sufficiently tedious and overcomplexified naturally repels public attention and all but the most diligent of investigators. Think of the allegedly public hearings that demand their attendees sit through seven or eight hours of monotonic formalities before the main business is tabled—or of the lengthy, tedious documents our friends in Brussels and Westminster are so fond of. If you want to do something genuinely evil, it is best for you that it also be fantastically dull."

"Well, this document certainly qualifies." I passed it back.

"Only because you can't see through the lines. Edgehill—and its American cousin at the NSA, Bullrun—is, quite simply, a sabotage program. Its mission is to introduce or discover programmer errors in everyday software in computers, mobile devices, network switches, and firmware—the nebulous code that has crept into everything from insulin pumps to automobiles to thermostats—and weaponize them. All code will have errors for the same reason that all books, no matter how carefully edited, have typos, and those errors are discoverable by anyone who puts his mind to it. Even you, John."

"I sincerely doubt it."

"Nonsense. A nine-year-old girl discovered a critical flaw in the iPhone operating system not so many years ago. The systems have not grown

less complex and error prone since then—the only thing that's changed is the stakes, which keep getting higher. The latest towers erected by our offshore friends in the formerly unfashionable parts of London rely upon tuned seismic dampers whose firmware is no more or less robust than the iPhone I made you leave under a cushion in my flat. The human errors in our skyscrapers and pacemakers are festering because the jolly lads in signals intelligence want to be able to turn your phone into a roving wiretap."

"You make it sound terribly irresponsible."

"That's a rather mild way of putting it. But of course, we're discussing the *unintended* consequences of all this business, and my visitor had come about the *intended* consequences: malware implantation. Watson, allow me to draw your attention to the very bottom of the deceptively dull document in your hand."

I read: "Could anyone take action on it without our agreement; e.g., could we be enabling the U.S. to conduct a detention op which we would not consider permissable?" A cold grue ran down my spine.

Holmes nodded sharply and took the paper back from me. "I see from your color and demeanor that you've alighted upon the key phrase, 'detention op.' I apologize for the discomfort this thought brings to mind, but I assure you it is germane to our present predicament."

My hands were shaking. Feigning a chill, I stuck them under my armpits, wrapping myself in a hug. My service in Afghanistan had left many scars, and not all of them showed. But the deepest one, the one that sometimes had me sitting bolt upright in the dead of night, screaming whilst tears coursed down my cheeks, could be triggered by those two words: *detention op*. I did not sign up to be an Army doctor expecting a pleasant enlistment. What I saw in Kandahar, though, was beyond my worst imaginings.

"Take your time." There was a rare and gentle note in my companion's voice. It made me ashamed of my weakness.

I cleared my throat, clasped my hands in my lap. "I'm fine, Holmes. Do go on."

After a significant look that left me even more ashamed, he did. "'I presume that you are here to discuss something related to this very last point?' I asked him. For as you no doubt perceived, Watson, the page there is wrinkled and has been smoothed again, as though a thumb had been driven into it by someone holding it tightly there."

I nodded, not trusting my voice.

"I had done many of these insertions," the man said, looking away from my eyes. "And the checklist had been something of a joke. Of course we knew that we could break something critical and tip off an alert systems administrator. Likewise, it was obvious that exposure would cause diplomatic embarrassment and could compromise our relationships with the tech companies who turned a blind eye to what we were doing. As to this last one, the business about detention ops, well, we always joked that the NSA was inside our decision loop, which is how the fourth-gen warfare types talk about leaks. Christ knows we spent enough time trying to get inside *their* decision loop. The special relationship is all well and good, but at the end of the day, they're them and we're us and there's plenty of room in that hyphen between Anglo and American.

"But the truth was that there was always the chance that the Americans would act on our intel in a way that would make us all want to hide our faces. Don't get me wrong, Mr. Holmes, we're no paragons of virtue. I've read the files on Sami al-Saadi and his wife, I know that we were in on that, supervising Gaddafi's torturers. I don't like that. But since the Troubles ended, we've done our evil retail, and the Americans deal wholesale. Whole air fleets devoted to ferrying people to torture camps that're more like torture cities.

"Have you ever read an intercept from a jihadi chatroom, Mr. Holmes?"

"Not recently." He gave me a look to check if I was joking. I let him know I wasn't.

"The kids don't have much by way of operational security. Loads of 'em use the same chat software they use with their mates, all in the clear, all ingested and indexed on XKeyscore. Reading the intercepts is like being forced to listen to teenagers gossiping on a crowded bus: dirty jokes about mullahs whose dicks are so short they break their nose when they walk into a wall with a stiffie, trash talk about who's a real hard jihadi and who's a jihobbyist, complaints about their parents and lovesick

notes about their girlfriends and boyfriends, and loads of flirting. It's no different to what we talked about when I was a boy, all bravado and rubbish."

"When you were a boy, you presumably didn't talk about the necessity of wiping out all the kaffirs and establishing a caliphate, though."

"Fair point. Plenty of times, though, we fantasized about blowing up the old comprehensive, especially come exams, and some of my mates would honestly have left a pipe bomb under the stands when their teams were playing their archrivals, if they thought they'd have got away with it. Reading those transcripts, all I can think is, 'There but for the grace of God . . .'

"But they're them and I'm me, and maybe one of 'em will get some truly bad ideas in his foolish head, and if I can catch him before then—" My visitor broke off then, staring at the fire. He opened and shut his mouth several times, clearly unable to find the words.

I gave him a moment and then prompted, "But you found something?"

He returned from whatever distant mental plain he'd been slogging over. "They wanted a big corpus to do information-cascade analysis on. Part of a research project with one of the big unis, I won't say which, but you can guess, I'm sure. They'd done a new rev on the stream analysis, they were able to detect a single user across multiple streams and signals from the upstream intercepts—I mean to say, they could tell which clicks and messages on the fiber-taps came from a given user, even if he was switching computers or IP addresses—they had a new tool for linking mobile data streams to intercepts from laptops, which gives us location. They were marking it for long-term retention, indefinite retention, really.

"I—"

Here the fellow had to stop and look away again, and it was plain that he was reliving some difficult issue that he'd wrestled with his conscience over. "I was in charge of reviewing the truthed social graphs, sanity checking the way that the algorithm believed their chain of command went against what

I could see in the intercepts. But the reality is that those intercepts came from teenagers in a chatroom. They didn't have a chain of command—what the algorithm fingered as a command structure was really just the fact that some of them were better at arguing than others. One supposed lieutenant in the bunch was really the best comedian, the one who told the jokes they all repeated. To the algorithm, though, it looked like a command structure: subject emits a comm, timing shows that the comm cascades through an inner circle—his mates—to a wider circle. To a half-smart computer, this teenager in Leeds looked like Osama Jr.

"I told them, of course. These were children with some bad ideas and too much braggadocio. Wannabes. If they were guilty of something, it was of being idiots. But for the researchers, this was even more exciting. The fact that their algorithm had detected an information cascade where there was no actual command structure meant that it had found a *latent* structure. It was like they set out knowing what they were going to find, and then whatever they found, they twisted until it fit their expectations.

"Once we have the command structures all mapped out, everything becomes maths. You have a chart, neat circles and arrows pointing at each other, showing the information cascade. Who can argue with maths? Numbers don't lie. Having figured out their command structures from their chatrooms, we were able to map them over to their mobile communications, using the session identifiers the algorithm worked out.

"These twerps were half smart, just enough to be properly stupid. They'd bought burner phones from newsagents with prepaid SIMs and they only used them to call each other. People who try that sort of thing, they just don't understand how data mining works. When I've got a visualization of all the calls in a country, they're mostly clustered in the middle, all tangled up with one another. You might call your mum and your girlfriend regular, might call a taxi company or the office a few times a week, make the odd call to a takeaway. Just looking at the vis, it's really obvious what sort of number any number is: there's the 'pizza nodes,' connected to hundreds of

other nodes, obviously takeaways or minicabs. There's TKs, telephone kiosks, which is what we call payphones, they've got their own signature pattern—lots of overseas calls, calls to hotels, maybe a women's shelter or A&E, the kinds of calls you make when you don't have a mobile phone of your own.

"It makes detecting anomalies dead easy. If a group of people converge on a site, turn off their phones, wait an hour and then turn 'em on again, well, that shows up. You don't have to even be looking for that pattern. Just graph call activity, that sort of thing just leaps straight out at you. Might as well go to your secret meeting with a brass band and a banner marked UP TO NO GOOD.

"So think of the network graph now, all these nodes, most with a few lines going in and out, some pizza nodes with millions coming in and none going out, some TKs with loads going out and none coming in. And over here, off to the edge, where you couldn't possibly miss it, all on its own, a fairy ring of six nodes, connected to each other and no one else. Practically a bullseye.

"You don't *need* to be looking for that pattern to spot it, but the lads from the uni and their GCHQ minders, they knew all about that pattern. Soon as they saw one that the persistence algorithm mapped onto the same accounts we'd seen in the chatrooms, they started to look at its information cascades. Those mapped right onto the cascade analysis from the chat intercepts, same flows, perfect. 'Course they did—because the kid who told the best jokes was the most sociable of the lot, he was the one called the others when they weren't in the chat, desperate for a natter."

I stopped him. "Thinking of your example of a group of phones that converge on a single location and all switch off together," I said, "what about a group of friends who have a pact to turn off their phones whilst at dinner, to avoid distraction and interruption?"

He nodded. "Happens. It's rare, but 'course not as rare as your actual terrorists. Our policy is, hard drives are cheap, add 'em all to long-term retention, have a human being look at their comms later and see whether we caught some dolphins in

the tuna net."

"I see."

"We have their 'command structure,' we have their secret phone numbers, so the next step is to have a little listen, which isn't very hard, as I'm sure you can appreciate, Mr. Holmes."

"I make it a policy never to say anything over a telephone that I would regret seeing on the cover of the *Times* the next morning."

"A good policy, though one that I think I might have a hard time keeping myself," I said, thinking of the number of times my poor Mary and I had indulged ourselves in a little playful, romantic talk when no one could hear.

"Watson, if you find yourself tempted to have a breathy conversation with a ladyfriend over your mobile, I suggest you cool your ardor by contemplating the number of my brother's young and impressionable associates who doubtlessly personally review every call you make. You've met my brother on a few occasions. Imagine what sort of man he would surround himself with."

I shuddered. I had no interest in women at that time, and memory of Mary was so fresh and painful that I couldn't conceive of a time when that interest would return. But I had cherished the memories of those silly, loving, personal calls, times when it had felt like we were truly ourselves, letting the pretence fall away and showing each other the truth behind our habitual masks. The thought that those calls had been recorded, that someone might have listened in on them—"just to check" and make sure that we weren't up to no good . . . It cast those cherished memories in a new light. I wouldn't ever be able to think of them in the same way again.

I was sure that Holmes had intuited my train of thought. He always could read me at a glance. He held my eye for a long moment and I sensed his sympathy. Somehow that made it worse.

My guest began to pace, though I don't think he realized he was doing it, so far away in memory was he.

"The problem for the brain boys was that these kids never said anything on their secret phones of any kind of interest. It

was just a continuation of their online chat: talking trash, telling jokes, making fun of whoever wasn't on the call. I wasn't surprised, of course. I'd been reading their chat logs for months. They were just idiot kids. But for the spooks, this was just proof that they were doing their evil work using their apps. Damned if they do and if they didn't: since it was all dirty jokes and messin' on the voice chat, the bad stuff had to be in text.

"These boys were playing secret agent. They bought their burner phones following a recipe they found online and the next step in the recipe was to download custom ROMs that only used encrypted filesystems and encrypted messaging and wouldn't talk to the Google Play store or any other app store whose apps weren't secure from the ground up. That meant that all their mobile comms were a black box to the smart boys."

"I imagine that's where your checklist came in, then?"

He grimaced. "Yeah. That OS they were using was good, and it updated itself all the time, trying to keep itself up to date as new bugs were discovered. But we knew that the NSA's Tailored Access Operations group had some exploits for it that we could implant through their mobile carrier, which was a BT Mobile reseller, which meant they were running on EE's network, which meant we could go in through T-Mobile. The NSA's well inside of Deutsche Telekom. By man-in-the-middling their traffic, we could push an update that was signed by a certificate in their root of trust, one that Symantec had made before the Certificate Transparency days, that let us impersonate one of the trusted app vendors. From there, we owned their phones, took their mics and cameras, took their keystrokes, took all their comms."

"I suppose you discovered that they were actually plotting some heinous act of terror?"

My visitor startled, then began to pace again. "How did you know?"

"I know it because you told me. You came here, you handed me that extraordinary document. You would not have been here had the whole thing ended there. I can only infer that you exfiltrated data from their phones that caused our

American cousins to take some rather rash action."

He slumped down on my sofa and put his face in his hands. "Thing was, it was just larking. I could tell. I'd been there. One of these boys had cousins in Pakistan who'd send him all sorts of bad ideas, talk to him about his jihad. It was the sort of thing that they could natter about endlessly, the thing they'd do, when they worked themselves up to it. I'd done the same, you understand, when I was that age, played at Jason Bourne, tried to figure out the perfect crime.

"They'd found their target, couple of U.S. servicemen who'd had the bad sense to commute from the embassy to their places in the East End in uniform, passing through Liverpool Street station every day. I suppose you know the station, Mr. Holmes, it's practically a Call of Duty level, all those balconies and escalators and crisscrossing rail and tube lines. I can't tell you how much time my friends and I spent planning assaults on places like that. That's the thing, I *recognized* myself in them. I knew what they were about.

"We must have been terrors when we were boys. The things we planned. The bombs. The carnage. We'd spend hours—days—debating the very best shrapnel, what would rip in a way that would make wounds that you couldn't suture closed. We'd try and top each other, like kids telling horror stories to each other around the fire. But I know for an iron-clad *fact* that my best friend Lawrence went faint at the sight of actual blood.

"The exploit we used to own their phones was American—it came from the NSA, from Tailored Access Operations. We had our own stuff, but the NSA were, you know, prolific. We have a toolbox, they've got a whole DIY store.

"Do you know what's meant by fourth-party collection?"

"Of course."

"Well, I don't, Holmes."

"Watson, you need to read your papers more closely. First- and second-party collection is data hoovered up by GCHQ and the NSA, and the Anglo-Saxon club known as the Five Eyes. Third-party collection is what's done by all the other nations GCHQ/NSA have

partnerships with. Fourth-party collection is data that one security service takes by stealth from another security service. There's fifth-party collection—one security service hacks another security service that's hacked a third—and sixth-party collection, and so forth and so on. Wheels within wheels."

"That all seems somehow perverse," I said.

"But it's undeniably efficient. Why stalk your own prey when you can merely eat some other predator's dinner out from under his nose, without him ever knowing it?"

My visitor spoke of fourth-party collection, and I saw immediately where this was going. "They saw what you saw, they read what you read."

"They did. Worse luck: they read what we *wrote*, what the analysts above my pay grade concluded about these idiot children, and then—"

Here he rattled that paper again.

"I see," I said. "What, I wonder, do you suppose I might do for you at this juncture?"

"It's life in prison if I go public, Mr. Holmes. These kids, their parents are in the long-term XKeyscore retention, all their communications, and they're frantic. I read their emails to their relatives and each other, and I can only think of how I'd feel if *my* son had gone missing without a trace. These parents, they're thinking that their kids have been snatched by pedos and are getting the *Daily Mail* front-page treatment. The truth, if they knew it, might terrify them even more. Far as I can work out, the NSA sent them to a CIA black site, the kind of place you wouldn't wish on your worst enemy. The kind of place you build for *revenge*, not for intelligence.

"It's life in prison for me, or worse. But I can't sit by and let this happen. I have this checklist and it told me that my job was to consider this very eventuality, and I did, and it came to pass anyway, and as far as I'm concerned, I have to do something now or I'm just as culpable as anyone. So I've come to you, Mr. Holmes, because before I go to prison for the rest of my life, before I deprive my own sons of their dad, forever, I want to

know if there's something I'm missing, some other way I can
do the right thing here. Because I was brought up right, Mr.
Holmes, and that means I don't believe that my kids' right to
their father trumps those parents' rights to their sons."

"What an extraordinary fellow," I said. Holmes was never one for the
storyteller's flourish, but he had an eidetic memory for dialogue, and I
knew he was giving it word for word—beat for beat and tone for tone.
It was as if I was in the room with the tormented soul. The hair on my
neck sprang up.

"'Leave it with me,' I told him, and showed him out. When I returned
to my study, I found that I was curiously reluctant to do what I knew I
must do. I found myself delaying. Smoking a pipe. Tidying my notebooks.
Cleaning up my cross-references. Finally I could delay no further, and I
went down to the station taxi rank and had a black cab take me to Mycroft."

"Mycroft!"

"Of course. When it comes to signals intelligence, my dear brother
sits at the centre of a global web, a point of contact between MI5, MI6,
GCHQ, and the highest ministers and civil servants in Whitehall.
Nothing happens but that he knows about it. Including, it seemed,
my visitor."

"Sherlock," he said to me, once I had been ushered into his pres-
ence, "as unfortunate as this is, there's really nothing to be done."

The boom years since the 9/11 attacks have not been
kind to my brother, I'm afraid. As his methodology has come
into vogue and his power in the security services has grown,
he has found himself at more unavoidable state dinners, more
booze-ups at a military contractor's expense, more high-level
interagency junkets in exotic locales. Hawaii seems a favorite
with his set, and I've heard him complain more than once
about the inevitable pig roast and luau.

Always heavy, but now he has grown corpulent. Always
grim, but now he has grown stern and impatient. Watson, my
brother and I were never close, but I have always said that he
was my superior in his ability to reason. The most disturbing
change to come over my brother in the past fifteen years is in

that keen reasoner's faculty. By dint of circumstance and pressure, he has developed the kind of arrogant blindness he once loathed in others—a capacity for self-deception, or rather, self-justification, when it comes to excusing for the sort of surveillance he oversees and the consequences of it.

"There is something obvious that can be done," I told him. "Simply tell the Americans to let those boys go. Apologize. Investigate the circumstances that led to this regrettable error and see to it that it doesn't happen again. If you care about excellence, about making the country secure, you should be just as concerned with learning from your failures as you are with building on your successes."

"What makes you say that this is a failure?" Mycroft said.

"Oh, that's simple. These boys are a false positive. They lack both the wit and the savagery to be a threat to the nation. At most, they are a threat to themselves."

"And what of it? Are these six fools worth jeopardizing the entire war on terror, the special relationship, the very practices at the heart of our signals-intelligence operation?"

"Yes," I said.

My brother colored, and I watched as that great mind of his went to work mastering his passions. "I'm afraid you don't know what you're talking about. It comes of being too close to the trees, too far from the forest. Human intelligence is fine as it goes, but when you conduct your investigations retail, you miss the patterns that we find in the wholesale end of things."

"When one conducts one's affairs at the retail level, one must attend to the individual, human stories and costs that vanish when considered from the remove of algorithmic analysis of great mountains of data."

He sighed and made a show of being put upon by his brother. I expect that there are Whitehall mandarins who quake in their boots at such a sign from such a personage. I, of course, stood my ground and ignored his theatrics.

"Come now," I said. "There's nothing to discuss, really. One way or another, the truth will out. That young man will not sit on his hands, whether or not I offer him a safer route to his

disclosure. It's not in his nature."

"And it is not in mine to have my hand forced by some junior intelligence officer with a case of the collywobbles." Mycroft's voice was cold. "Sherlock, your client is hardly an innocent lamb. There are many things about his life that he would rather not have come out, and I assure you they would come out." He made a show of checking his watch. "He's already been told as much, and I'm certain that you'll be hearing from him shortly to let you know that your services are no longer required."

Now I confess it was my turn to wrestle with my passions. But I mastered them, and I fancy I did a better job of it than Mycroft had.

"And me?"

He laughed. "You will not betray a client's confidence. Once he cries off, your work is done. Done it is. Sherlock, I have another appointment in a few moments. Is there anything further we need to discuss?"

"I took my leave, and you have found me now in a fury and a conundrum, confronting my own future, and that of my brother, and of the way that I failed my client, who trusted me. For as you've seen, I kept my erstwhile client's bit of paper, and the names of the boys he feared so much for, and have made inquiries with a lady of the press of whom I have a long and fruitful acquaintance. I have been most careful, but as I have said on more than one occasion, my brother Mycroft has the finer mind of the two of us."

He filled his pipe and struck a match. There was a sound at the door.

"I fancy that's him now," he said and puffed at his pipe. Someone who did not know him as well as I did may have missed the tremor in his hand as he shook the match out.

The door opened. Mycroft Holmes's face was almost green in the bright light that lit it like the moon.

"You brought him into it," he said, sighing.

"I'm afraid I did. He's always been so diligent when it comes to telling my story."

"He is a veteran, and has sworn an oath," Mycroft said, stepping

inside, speaking with the air of a merchant weighing an unknown quantity in his scales.

"He is a friend," Holmes said. "Sorry, James."

"Quite all right," I said, and looked at Mycroft. "What's it to be, then?" I was—and am—proud of how steady my voice was, though my heart trembled.

"That is to be seen," he said, and then the police came in behind him.

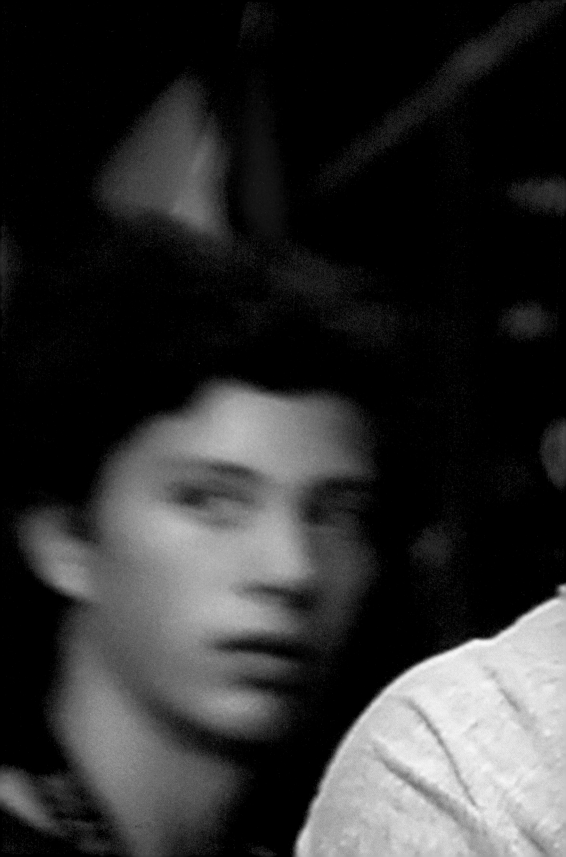

The period of imprisonment passed with slow, dreadful monotony. For years, there was no contact with the world. I heard nothing about the safety of my family and did not know what information they had about my plight. We were treated like dangerous, vile creatures who did not deserve even a modicum of human dignity. What we did, what we ate, whether and when we slept, whether we received medical attention, even our basic human functions: all these were subject to the control of others. We had no rights, no ombudsman who might listen to our plight. We were the other—it was palpable—and it was constantly degrading and humiliating.

In 2004, a glimmer of hope appeared. The U.S. Supreme Court issued a decision on our legal representation, and now we would be given American lawyers to help us. I hoped this development would lead to a change and that we soon would be treated with respect. Sadly, despite the good work and intentions of our new advocates, there was no improvement. Indeed, in many instances, as time passed, things became worse, and even more arbitrary. Now, I observed, our captors were intent on managing our lawyers just as they managed us.

By 2006, it was clear our situation would not improve, even though the president continued to lose important cases before the Supreme Court. Throughout all of this, the surreal environment of Guantánamo endured. I continued to experience denigrating and inhumane treatment. Like others, I was subjected to each new variety of interrogation technique. Loud music, bright lights, days without sleep, insults and intimidation, high temperatures, low temperatures: the options were endless. Guantánamo was like a test tube, available for experiments. It did not matter that I was innocent; it did not matter that I told the truth; nothing seemed to matter. Mail sent by my wife and daughters rarely reached me. Indeed, except for the bits of information my lawyers were able to relay, we were more isolated than ever. I was depressed; every day felt as dark as the last.

And so, late in 2006, I decided to stop eating. I knew others had participated in hunger strikes to make bigger points. My motivation was personal. I was a man, an innocent man, imprisoned thousands of miles from my family. I was subjected to continuous dehumanizing treatment, and I had no ability to influence my circumstances. The only control I could exercise, in fact, was whether I put food into my mouth. If I was not to be treated as a human being, I would not eat.

At first, no one seemed to notice. As the days passed, however, things changed. Soldiers tried to press me to eat, sometimes in intimidating ways. Ultimately, though, this had the effect of reinforcing my decision. For the first time, I was able to influence my own fate. Now, officers and medical personnel came forward to persuade and monitor me. It was a transformation of sorts.

Physically, my hunger strike required some adjustment. In the beginning, the longing for food was almost unbearable. I wanted nothing more than to resume normal meals. My body was accustomed to the regular food schedule and expected meals. I felt nearly constant longings; I became weak more quickly than I had expected. Yet I endured.

Soon the guards were insisting that I accept nourishment. If I would not eat, I was told, I would be fed through a tube inserted into my nose and through my throat to my stomach. I refused—and then began a new chapter in the abuse and inhumanity. You see, force-feeding at Guantánamo is not done with a fork and spoon. The description of inserting a tube did not do justice to the misery and discomfort I would experience. As luck would have it, only one of my nostrils was capable of accepting a tube. As a result, twice a day, through 2007 and 2008, I was taken from my cell by guards who forcibly pumped food into my stomach.

Like so much else at Guantánamo, the feeding ritual had been refined to incorporate elements of punishment and degradation. Feeding took place on a rigid wooden chair. Straps were used to stretch my neck back and secure my head so that my nostrils faced slightly up. All other parts of my body—my arms, hands, legs, feet, and torso—were also secured. While "safe feeding" was the inevitable justification for the process given by any soldier who would offer more than "following orders," the securing and feeding process afforded more opportunities to inflict discomfort and pain.

For example, while most guards were attentive to not causing injury, some were clearly pleased whenever some aspect of feeding caused pain or discomfort. The shackles required in moving me to the feeding station could be adjusted, and each strap that affixed me to the chair offered yet another opportunity for excessive tightening. I suffered on numerous occasions when soldiers pumped my stomach with air after impatiently dispensing my meal in only a few minutes rather than the forty-five to sixty required for my shrunken stomach to accept the liquid without discomfort.

But for me, this change, for all the abuse and punishment, was transformative. Although I was not able to reject the forced feedings, I was able to refuse normal meals and, in an imperceptible but significant way, reclaim my individual ability to influence some aspect of my fate. I was moved to a segregated area, with other hunger strikers. Not all of our motivations were identical, but our day-to-day circumstances were similar. Each of us was in a small way imposing our own will, our own individuality, and requiring the camp commander to respond to us. I was no closer to freedom, but I had the satisfaction of knowing that I would be fed—albeit forcibly—because that was my choice.

Many of us who were forced to endure the horrors and deprivations of Guantánamo found mechanisms to sustain and support us. All of us prayed, when we were allowed to do so. Some inmates were disrespectful, others violent, some simply collapsed internally as they tried to reduce their suffering by minimizing the degree to which they were exposed to the daily degradation and cruelty. But for me, the hunger strike and the predictable response of the authorities in forcibly feeding me had a beneficial result beyond anything I had hoped or expected.

I felt immediately less agitated, more at peace, and more fully open to my fate, as God might direct it. By making a decision that put me among a segregated subset, I had more of an identity among the guards. This was not so much a social response on their part as it was an exercise of authority and discipline. Nevertheless, it had the effect of making me more of an individual and requiring at least slightly different treatment from that received by others. I was subjected to occasional efforts to persuade me to eat. There was, of course, an element of theater and insincerity to the arguments those guards would advance, but still, it allowed me to deal with their arguments and explanations, not simply to subject myself to their discipline and whims.

Within a few weeks, my body adjusted to the low-calorie liquid diet that would sustain me for the next two years. Except for the occasional bouts of discomfort brought on by guards who sporadically took it upon themselves to punish me for daring to reject normal camp food, the twice-daily feedings assumed a certain rhythm. Admittedly, the process was never peaceful or without discomfort. There is no way to avoid pain when a plastic tube is inserted twice and removed twice from the same nostril each day.

Over time, my case was brought to the U.S. Supreme Court. While I had struggled to maintain some semblance of my own individuality and humanity, my lawyers—my friends—continued to press our case and to show that I was innocent. In the end, the United States admitted that President Bush had been wrong in his speech and withdrew the only claim that had been made to justify our imprisonment in 2001. New, equally false claims were made, but those were quickly rejected by the judge who heard them. On November 20, 2008, I sat in a room with four of the others at Guantánamo and listened to a small speaker as that judge declared our innocence and ordered our freedom. I was weak, I was tired, but I felt a swelling of joy as I hoped that finally this darkest of ordeals might be coming to an end.

Even after the judge's order, I was held at Guantánamo for four months. Although I was moved to what is seen as a better living environment, I remained a prisoner, under the arbitrary control of guards who did not respect me, and still isolated from contact with my family.

I recall well when my hunger strike ended. Through the efforts of my lawyers, the French government had extended to me an offer to settle there. In April 2009, a French diplomat, accompanied by my attorney, personally delivered a visa that would allow me to enter France. As agreed in advance, they brought a meal—the beans and rice suggested by pro bono doctors in Boston—and once the introductions were complete, we sat to eat and talk. I could not eat much, and I hardly remember any taste, but I savored that meal and its significance for me, my family, and our future.

I have had the privilege to live in France with my family for more than six years. The days of beans and rice are far behind. Yet the scars of Guantánamo are never far from view. I wonder, at times, whether I will ever be free of the sense of pain and loss I feel. I also wonder what scars burden the soldiers who were ordered to mistreat us, now that they know it was in error, and I hope they are cared for and given the opportunity to learn from those mistakes. I am struck by the angry political rhetoric that continues to surround Guantánamo in the United States, and I truly hope that America, like me, will someday have the chance to put Guantánamo into its past and to resume a constructive existence.

Translated from Arabic by Felice S. Bezri, the Multi-Lingual Group

A Note on the Image: Moath al-Alwi is a Saudi-born Yemeni who has been held at Guantánamo Bay prison since 2002 without charge or fair process. In protest, he began a hunger strike in early 2013.

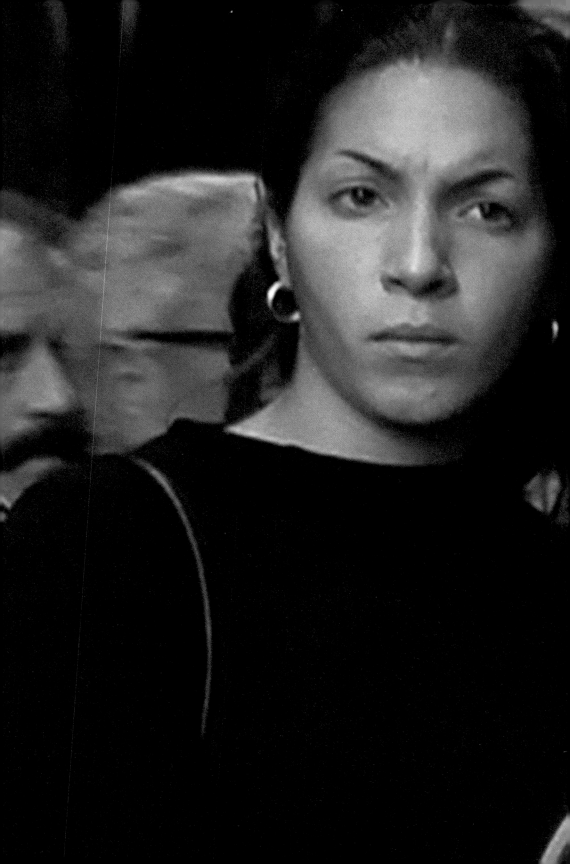

SURVEILLANCE

Ai Weiwei

From the time he was born, my son, Ai Lao, has been under surveillance. When I came out of detention, I realized that his name, his mom's phone number, and his address, which only the authorities had access to, had all been published online. Of course, wherever we go, whether it be the park or a restaurant, we always have to be alert. If we went to a rock concert, he would see the cars following us in the rearview mirror. We have to face undercover police and constant observation. So for his generation, really from birth, it has become their natural environment to be under surveillance.

<div align="right">— A. W., July 22, 2015</div>

The following three spreads of photos from Beijing show various conditions of surveillance the artist has been under beginning in 2009. He was detained by the authorities and his passport confiscated in 2011. His passport was returned in the summer of 2015, allowing him to again travel abroad.

THE ARTIST SURVEILLING THE SECRET POLICE

Ai Weiwei has a large archive of photographs documenting police surveillance since his release from detention. The images are casual and the people in them look quite ordinary, but they reflect the state's "stability maintenance" programs, which have

Bifengtang restaurant, July 28, 2011. Surveillance while Ai dines with friends.

Bookstore in Solana, Beijing, December 11, 2011. Police watch Ai walk with his son from a second-floor balcony.

Thai restaurant, Lido Hotel, December 1, 2012. Surveillance of Ai dining with NYU law professor Jerome A. Cohen (foreground, far left) and Chinese lawyers Pu Zhiqiang and Liu Xiaoyuan (not pictured).

bigger annual budget than the military. The police follow Ai everywhere, from the park to restaurants to hotel lobbies. Over the years, he has taken thousands of photographs of his daily life as a dissident, as a monitored individual.

THE SECRET POLICE SURVEILLING AI AND OTHERS

In May 2012, while walking with his son in Chaoyang Park in Beijing, Ai realized he was being followed and photographed by the secret police. In retaliation, he confronted the policeman and took the memory card from the man's camera, which provided the images below.

KFC, May 2012. Students on the first anniversary of the Jasmine Revolution.

Din Tai Fung, May 2012. A restaurant where Ai regularly dined.

Chaoyang Park, May 2012. Ai's driver, Xiao Pang, and Ai's son's stroller.

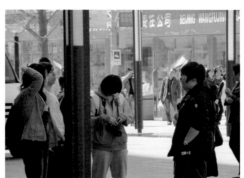

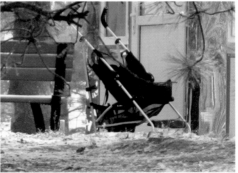

THE ARTIST SURVEILLING HIMSELF

On April 3, 2012, the first anniversary of his detention by Chinese officials, Ai set up four video cameras in his house as a personal extension of the constant surveillance he has experienced since his release. The cameras sent a twenty-four-hour live feed

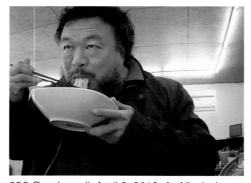

258 Caochangdi, April 3, 2012. At Ai's desk.

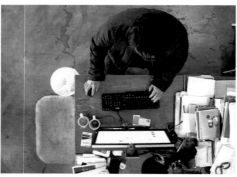
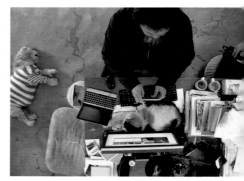

258 Caochangdi, April 3, 2012. Above Ai's desk.

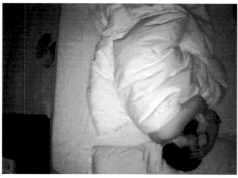
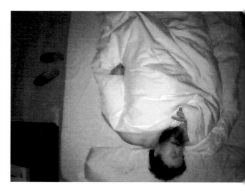

258 Caochangdi, April 3, 2012. Above Ai's bed.

to the website weiweicam.com. Forty-six hours after the site went live, the authorities instructed him to shut it down. During those forty-six hours, the site received 5.2 million views.

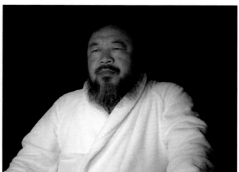
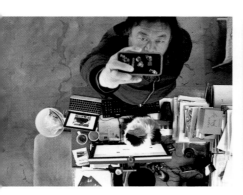
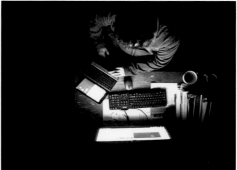

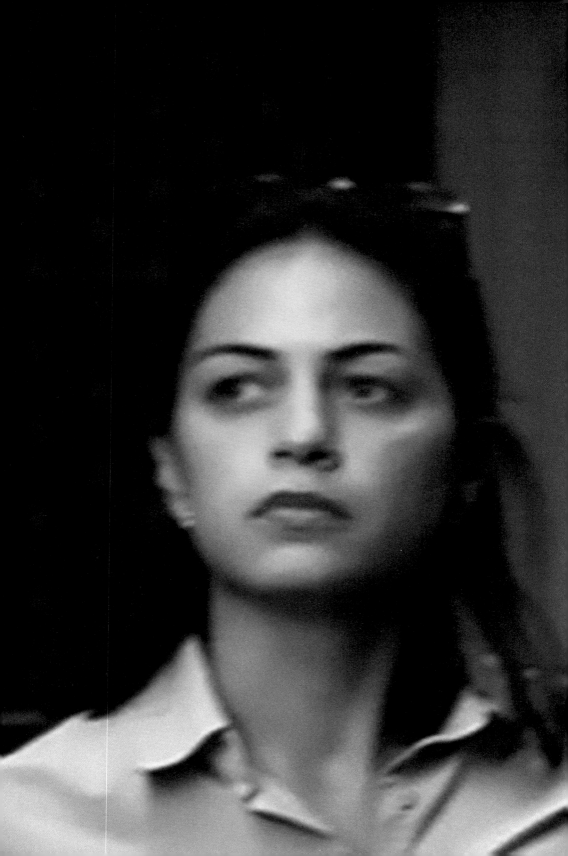

BERLIN JOURNAL

Laura Poitras

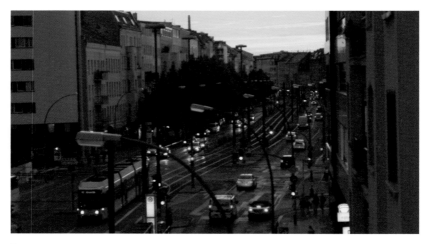

Torstrasse, Berlin

When I make films, I witness and record moments of uncertainty that unfold in real time. The future is unknown, often full of risk for the people I document. When I edit those moments months or years later, the future has transpired and the uncertainty is transformed into a plot: a narrative in which decisions that were vast and multiple are reduced to one—the path taken, not the many paths untaken. But the drama, the life pulse of any story, lies in the uncertainty of the moment, the choices, doubts, fears, desires, and risks of how to act and act again.

I wrote this journal in Berlin between November 2012 and May 2013. I had relocated to Berlin after six years of being detained every time I entered the United States.[1] I was looking for a place to edit without fear that my footage would be taken at the border. The act of writing this journal made me nervous.

In May 2013, I hid the journal in Berlin. I rediscovered it in 2015 while preparing for this book and exhibition.

<div align="center">* * *</div>

<div align="right">

Nov. 4, 2012

</div>

Berlin—
I haven't written in over a year for fear these words are not private. That nothing in my life can be kept private.

<div align="right">

Nov. 5, 2012

</div>

I've been thinking about the "disposition matrix" and how that could be incorporated in the film.[2] Is that what Binney was talking about in terms of CIA hit squads?[3] Did he help to build the matrix? How deep does the matrix go? Is there a connection between surveillance and the kill matrix? Does everything feed it? Is it narrow or broad?

<div align="right">

Nov. 7, 2012

</div>

Beyond the rendition and black sites, was there a totally different program that has not been reported? And could Binney have real knowledge of it?

Nov. 8, 2012

I want to do the Guantánamo film.[4] The goal would be to make audiences feel the passage of time. To come to terms with what it means to be indefinitely detained without charge. To die in prison at thirty-six. To wait for someone to come home. A story about the terror of the war on terror.

I'm still thinking of doing a project with Boumediene.[5] He has haunted me since I met him. Not a literal narrative—his experience would be subtext. Not one-to-one—it needs to flip and make us care in new ways. A parallel narrative that is about who we could be, casting a man who experienced who we have become.

Nov. 18, 2012

On Monday I had a nightmare that has hung with me for days. I was being detained on a U.S. military base. First I tried to escape in a truck and was caught at the gate. They tried to blindfold me w/goggles and put a straightjacket on me. I resisted, so they tried to drug me, but I wouldn't lose consciousness. At some point I stole a walkie-talkie and reported that there was a kidnapping/hostage situation, but they changed the channel of the frequency. They tried to give me food, but I went on a hunger strike. There was another journalist I saw. I asked him to report that I was being kidnapped.

Evening—
The antagonist of the film is the state. That liberates the film from the rabbit holes of individual plot threads. It can reach a general conflict of individuals all fighting the state and the state as a secret dark force that tries to destroy anyone who challenges it.

Dec. 2, 2012

Watched the footage of Adnan Latif's brother I filmed in 2007. Everything is foreshadowed in the conversation, including Adnan's death five years later. I also watched again Obama on closing Guantánamo. That will be the opening, then a text card about Adnan's death, then

2007 footage, then something to show the passage of time to convey being detained for twelve years without charge. End on Adnan's body returning home. I should raise questions about whether it was suicide or an overdose.

Dec. 15, 2012

Adnan's body will be returned today. The working title is *Death of a Prisoner*, but that might be wrong. It might codify his position at Gitmo, suggest a legal system that doesn't exist. Today Mohammed, Adnan's brother, will go to the ministry of the interior to try and receive the dead body.

If only I could sleep I'd be happy in Berlin.

Dec. 20, 2012

My laptop keeps mysteriously running out of space even though it has 16 GB free.

Dec. 25, 2012

I woke up thinking about the NCTC emails.[6] What is the link to "Hollywood folks"?

I should ask Murat Kurnaz if he ever learned the identity of the man who died hung by his arms in Kandahar.[7] I'll need to fact-check that or put a text card saying the identity is unknown. Perhaps list confirmed deaths during interrogations? It is all about asking people to imagine the existential hell. If that space can be accessed—the connection to that experience—then what is said might have impact. Ultimately it is about that expression. To say something in a way that moves people. It is not a device, it is the gauge of the quality of the work itself.

Dec. 31, 2012

New Year's Eve in Berlin. Just back from CCC.[8] Interviewed Binney.

Got closer, but still don't have the details. He won't go into the methods of taking people out.

I should do something to mark the New Year.

Jan. 1, 2013

Finally was able to see Yemen video of Adnan's body. The body was returned in a black plastic bag with Adnan's ISN# and his date of death on a tag.[9] They didn't even write the man's name. It is unimaginable. January 22, 2009, is the date Obama promised to close the prison.

Jan. 2, 2013

Yesterday I edited Adnan's uncle over the body bag. It is heartbreaking.

Jan. 6, 2013

Death of a Nation
Death of a Prisoner
My Wish Is to Die
A Man Escaped
A Death Foretold
08Sep2012 #156

Read *NYT* article on Kiriakou.[10] Binney probably has the same level of FBI scrutiny. They are probably listening and watching in the same way. It is a lesson to never trust a feeling of safety or reduced pressure because they can and will go after you at any moment.

Doing this film makes me really think about working in other ways. Ways that come faster and have a direct expression and reach audiences. It also reveals the power of images to tell the news in ways that have to be confronted emotionally.

Not sure about the title—is it too benign? If he is a "prisoner," does he cease to be a human being?

Jan. 12, 2013

Published *Death of a Prisoner* yesterday.[11] I'm exhausted. I think it is powerful. I have no perspective.

Jan. 13, 2013

Aaron Swartz killed himself on Friday.[12] Tragic.

Jan. 17, 2013

Just received email from a potential source in the intelligence community. Is it a trap, is he crazy, or is this something real? He is asking for some secure setup before communicating. I need to create a new key pair for this. Why would he contact me?

Feb. 6, 2013

Contacted again by "Citizen Four." I am not even sure how much I can/should write here. If he proves what he claims, the story is huge. The focus of the state and state power against individuals resisting. C4's narrative also provides a driving plot/mystery.

I cannot begin to comprehend the magnitude of what he is saying: "I know how it will end for me."

Feb. 7, 2013

Started rereading *1984*. It is strange—I remember it so well. And now to be in Berlin, it comes full circle. Berlin, Bowie. I don't think I'll ever have another project like this, touching so many chords of my memory. Citizen Four—this narrative focuses the film around the power of the state. I should rewatch *The Man Who Fell to Earth*, *2001: A Space Odyssey*, and *All the President's Men*.

Feb. 9, 2013

Jesus, I have no idea what I am about to enter into. I'm still not sure it is for real. I won't know until I do the verification. I still wonder if they are trying to entrap me, Jake, or Julian.[13] Julian would be the likely target. I really have to decide who I want to bring in and how I want this to unfold. Should I work the material into the film? Or is it too newsworthy and needs to be more immediately released? Do I document the vetting and verification?

I can't do this alone, I know that.

My work might get shut down by the government.

Feb. 11, 2013

I read the news in fear of an arrest. It still could be a shakedown targeting Julian or Jake. Watching what I'll do with the material. It really is a drama to understand the possible motivations/goals. I take it at face value, but why? He could have approached the *NYT* or the *Washington Post* for maximum exposure. Why reach out to a filmmaker? Because I've been targeted? Because he has already gone down other paths? Because he doesn't have what he claims? Honestly, if he is legit I am seriously in over my head. I have no legal team, no editorial backup.

Feb. 14, 2013

It will be a story for sure, I just don't know how much I want to be in it, though it might be unavoidable if/when C4 is arrested. Reading *1984* again is somehow an extension of my reality. God, I'm tired. Will I ever be able to sleep again?

Feb. 16, 2013

"Your worst enemy, he reflected, was your own nervous system. At any moment the tension inside you was liable to translate itself into some visible symptom."—*1984*

I am battling with my nervous system. It doesn't let me rest or sleep. Eye twitches, clenched throat, and now literally waiting to be raided. I really need to prepare for that. Binney's foot was cut off on Wednesday. Our bodies betray us. I should rewatch *Blue, White, Red*.[14]

Is C4 a trap? Will he put me in prison?

Feb. 17, 2013

Who is he? Where does he go to email? Does he have family, kids? Is he sitting silently in meetings knowing he will betray his colleagues? Does he like the danger? Was he once a rebel—what is his narrative desire? Is he fulfilling that by reaching out to me? He says he is under investigation—how does he know? Is he being followed? Does he follow me, see what I say and do? Does he want to meet? What does he want?

Feb. 20, 2013

Found another flat for March/April. Off the grid at the moment unless I'm being physically surveilled. I will try to keep it disconnected for as long as possible. No phone, Wi-Fi.

I dreamt I was sent dozens of packages. Mountains of material. Still no email from C4—the last one was over a week ago.

Feb. 23, 2013

I'm at the point in *1984* where they rent the room: Winston sees the rat. The book is terrifying and so relevant to today. The fear of an all-knowing state. Doublespeak. Reading the newspaper about kill lists. For what? The "enemy" does not threaten to destroy us. It is just being used to justify a growing surveillance state.

"We lost the war."

Evening—
If this leak is for real, I might want to stagger release. The question is,

Will I be immediately arrested? Raided? Will I be able to continue to edit and finish the film?

Feb. 24, 2013

It has been two weeks since I've heard anything from Citizen Four. I hope that isn't a bad sign. He told me not to worry if I don't hear from him. If the leak is significant, I might be safe publishing it, but I would also bring down the world's eyes on me. God, my life is really over in terms of privacy. It is terrifying to think I might never feel confident I'm not being watched.

If I have addresses of interception points, these can be a narrative thread.

Feb. 25, 2013

I think waiting for Citizen Four is distracting me from being able to focus.

I'm at the point in *1984* where they have been arrested. I'm dealing with really dark forces.

Feb. 26, 2013

Why the fuck am I making long-form documentaries when other ways of working are so much more energizing?

I really want to do the installation project of hanging screens in a warehouse. So that entering it is like a torture chamber.

I'd like to do a drive-in theater across from the NSA.[15] That property for sale—project the film across the street in an outdoor projection. Maybe there is a way to rethink the drive-in concept. To broadcast the audio over radio that can be picked up on phones and have the film projected at different locations.

March 5, 2013

If I can do this warehouse idea, that would be exciting. Entering a room of hanging screens like a slaughterhouse. They have many headphones, creating a landscape of voices trying to be heard. White-noise effect. The viewer is then compelled to listen, to find which picture goes with which headphones.

March 10, 2013

I don't know what I'm feeling. I moved, which has thrown me into a dive—why am I here, what am I doing? I don't feel good or grounded. I'm off balance.

I finished *1984* last night. The ending I remembered so vividly. The mask with rats, the betrayal, and the meeting with Julia, who also betrayed him. The ability to change what someone feels. In some ways that is happening to me—I am fighting, but they've gotten inside so that I don't know if anyplace is private. If anyplace is safe. I'm trying to keep this new flat off the radar, so no phone, no connecting to the Internet without Tor. I've created my own isolation, so they win. They always win. I can fight all I want and I will lose. I will be destroyed, paranoid, forsaken, unable to sleep, think, love.

Jake said something like, "It's PTSD without the post-." It doesn't end. But it is not just this project, it is Iraq, Yemen, the border, and now the NSA. It is cumulative.

March 11, 2013

I really feel like I'm underwater. There is pressure in my head. I'm trying to figure out if it is in my head or the apartment. I can hear the sound of my blood moving through my veins. Jesus, what the fuck is happening?

Working on Manning audio today.[16] It is important to publish.

March 12, 2013

Manning video released today. I focused on Manning's entrance into the military and his response to the Apache video. What it shows is that people cannot remain silent.

March 16, 2013

"Crypto Wars 2"—that is what Jake said the film was about when we first met. I didn't understand it. He was thinking ahead of me. In a way this should feel like a sci-fi manifesto, a futurist story or puzzle. Not an educational tool but a revolutionary tool kit. I should build a map. Instructions.

March 17, 2013

Nightmare: Running from someone with T. T. We were climbing, and then I look out the window to see the Freedom Tower under construction at eye level. I panic/vertigo. I can only imagine falling. I'm frozen. Woke in a sweat.

Installation project: I want a space that looks down, like a factory floor. The headphones hang from wires, so people can only move in certain straight lines if they want to see other images. People might need to switch positions, creating a social exchange. From above you witness and decide if you want to descend into the viewing area. That is the only way you'll be able to hear, so people will.

Since the headphones are hung from above, people will need to reach up and pull them down. Each headphone has multiple channels that sync with different projections. The viewer will be able to switch audio channels. From above, you hear white noise of all the headphones playing.

I should think about using NSA material in the exhibition. To draw people in and break news. To mirror the themes of the surveillance mechanism. Maybe an art exhibition could do that—both create an aesthetic experience and reveal information that evokes an emotional response.

March 18, 2013

V for Vendetta last night—all about how governments lie.

My Country, My Country seems so naïve in retrospect.[17] As if appealing to people's consciences could change anything. Ten years into this war it is obvious there are other forces at work.

March 20, 2013

The tenth anniversary of the Iraq War.

I really need a plot throughline that will give mystery and suspense. It will ground the rest of the film. If/when the information is released I need to calibrate the effect. What if he is arrested? What if he is an FBI informant? There is a danger working with news events—they lose their meaning once public. I need to make sure everything has bigger social and human meaning.

March 26, 2013

Chilling email from Citizen Four. He says I'll receive the link in seven days. He says the hard work is done, but the dangerous work is still ahead. He assures me that if he is detained or killed, I will still receive the archive. He says this will happen if our adversaries are more successful than we are. He says the archive can't be sanitized without raising questions of authenticity. He is prepared for the consequences of the disclosure. I really don't want to become the story, but I might not be able to stop that if this archive is as detailed as he has indicated. Am I being lead down a dead end? Being played by some rogue actor?

As this insanity unfolds I'm reading Doctorow's *Homeland*, which feels like a mirror of the exact fucking reality I'm living in.[18] National-security leaks, detentions, threat of death, keys passing.

Jake says my friends will be targeted and that I can't protect them. He says it is bigger than anything WikiLeaks has done. More top secret and

that the backlash is the sort of thing people get killed over. Trillions of dollars of investment.

I told Jake I would take the heat. He said that isn't possible, and that everyone I know will be subjected to pressure and that I should warn Katy.[19]

March 30, 2013

Day six of the seven-day window given by Citizen Four to receive the link. Yesterday read the section in *Homeland* where Marcus is kidnapped and interrogated. The book feels like a fucking manual. Totally nuts. The stuff when his computer starts talking to him reminds me of when I started filming with Binney and the crashes I experienced. The screen going totally pink and turning off.

March 31, 2013

Received the link last night. "Astro Noise." I am downloading it right now. It is at 90%. My vision is starting to telescope, but I feel calm. I slept long, until 10 am. The next step is to verify the hash. I don't have a clue, but I'll try to troubleshoot. Tonight I should watch *2001: A Space Odyssey*. Seems fitting with all these blinking screens. What if I'm being played? It is hard not to get paranoid. I'm probably too trusting. I believe Citizen Four's story. It connects w/me, but what does that mean? How can I trust this person who approached me out of the blue?

95%

Download failed. Attempting again. This is intense—potentially downloading NSA files on Easter Sunday in Berlin.

The file is downloading now.

April 1, 2013

I should know what Astro Noise contains before involving anyone else. It is all a bit overwhelming. I could now be in possession of NSA

secrets. Without the key I won't know.[20] I filmed the downloading and the verifying of the hash.

I finished reading *Homeland* and watched *2001*. As I was filming the screen I thought about *Exact Fantasy* and working with primary documents.[21] Seeing *2001* gave me chills. My parents took me. I still remember it. I wonder how old I was?

God, I really need to find a way to offload stress. If this file is for real it is a huge story, which I've documented and will also break. I have no editorial support to handle this.

April 2, 2013

Audio recording/print script (edit)
✓ Digitize Astro Noise download
✓ Reply renovation
 Review footage log and prioritize scene to prep work memo
 Copy + distribute Astro Noise

If I go to NYC in April I should meet with Jay Sanders regarding the installation project.

April 3, 2013

Yesterday I was dizzy w/anxiety. I reread some of the letters. If Citizen Four provides documentation, it's a total bombshell. "SSO," "Special Source Operations." Sleep was horrible again. It is getting worse. The funny thing is that I'm sure I'll look back on this as just the best time. Being in Berlin, having a great story. There is so much to appreciate that I should try to let the anxiety go. What is the worst they can do?

April 4, 2013

Finally had a good night's sleep. Traveling to London this weekend to film Julian. Of course, the pattern of the timing will make it look like I am going to give him the Astro Noise file. If and when there is a

grand-jury investigation of this leak, that timing will be used. Narratives can be spun. I doubt Citizen Four has any idea I know Julian.

Notes:
Architectural plans=source
Disaster=come home
Renovation taking longer=delay
Recycled=multiple
Carpenter quit=not received
Co-op=gov.

April 5, 2013

Yesterday I prepped letters. I pray I'm not the cause of Citizen Four's arrest. Big story today about the military's secret new cyber rules of engagement. It is increasingly hard to see how any of this has a positive ending.

April 6, 2013

The sound of the blood moving in my brain wouldn't stop. I need to decide what to carry today. Very strange—I'm less worried about crossing borders in Europe than in the U.S. But still I need to consider the danger of taking a computer. This is all total madness—this level of feeling watched. And feeling I could be causing harm to others.

April 14, 2013

Nightmare: I was in a building with a courtyard. We hear a sound, and it is a spaceship flying in the courtyard looking for someone to kidnap or kill. Not clear which. The people with me hide, and then I realize I need to document what is happening. So I get to an area where I can see the machine and take a photo inside the pilot's cabin. The camera has a flash, so I see the faces in the photo. But the flash also means they know they've been seen. I run, and then realize I should upload the photo fast, before they catch me. I send it to D. The photo is a big story. It reveals evidence of a program the USG wanted to keep secret. I am on the run.

April 18, 2013

If I tried to make a fiction, I'd be interested in C4. Actually, I'd love to do a doc/vérité while he is still inside. Still unknown. For instance, does he have children? How does he manage to live pretending? Living a double life? Risking so much?

April 29, 2013

Returned from NYC yesterday. Very intense trip—meeting with Glenn, Jake, Jameel/ACLU.[22] Received the most detailed outline from C4. Jake raised question about entrapment. My instincts say the source is legit. Glenn is on board and ready, but totally clueless on the security-technical side of things. He expressed belief that to get traction, we need to show either that Congress is being lied to or illegal actions. Jameel said the same. It is about changing the political climate, not about legal questions of standing. In the wake of Boston, this will be really hard to do.

Jake was more freaked out—very aware of the danger this could open. He said I needed to follow absolutely strict security. That I am a target they would do anything to compromise. If C4 is legit and has documentation, he is right.

Jake emailed—he and A. were followed after I left.

Citizen Four wrote to disassociate metadata again. Email now is "everyman." I am "Sound and Vision." He wanted to give me the option to decide on my own terms whether to claim involvement. He says, "Every trick in the book will be used to look into this," and that we are in uncharted territory.

What is this film really about? It might be about the courage to resist power. That is the theme that runs throughout. It is also about a revolutionary historical moment when a new technology emerges that shifts the balance of power. But really it is about resistance. Surveillance is the organizing theme, or the prism, through which we observe resistance.

I wonder what Julian's plan was that day in the hotel room?[23] Was there an escape plan?

May 3, 2013

I can't hear. The sound of blood rushing in my veins has gotten worse. It began when I moved in March. The sensation of being underwater and removed from reality. I feel more removed and isolated. I keep waiting for my ears to pop and to return back to reality, but maybe that won't happen. I can't sleep and now I can't hear.

Bart Gellman reached out to ask about collaborating.[24] I hate *Time* magazine. I can't make commitments until I know more.

May 4, 2013

No email today. Last night I read a post about the "Citizen's Committee to Investigate the FBI" and it made me think that's what this is—but for the NSA. It would truly be incredible if he is never discovered. Like Deep Throat. That would just blow a hole into all this secrecy culture. That one among them had turned, but they couldn't identify him.

It is hard to imagine it ends here. I will probably be subpoenaed. Of course I won't comply, but that might mean I have to seriously consider the idea of going to jail to protect him. I need to make sure that if that happens, the film will be completed. It can't happen before.

May 5, 2013

Fuck—I have to make one of the most important decisions of my life and there is no one I can talk to. C4 wants to release an FAA 702 document quickly before the key.[25] He says I shouldn't release it and that it can't be traced back to him. Is this the game, the trap?

I need to think what makes sense in the long term. What will create the most attention and also give me space to keep working? When this gets investigated, what decision makes the most sense? What decision will

bring maximum awareness? And maximum public outcry? Maximum government response?

C4 asked me to put a target on his back. To not protect his identity. He also said he would never commit suicide. What kind of fucking world is this that everyone in my film says this to me?

I need to ask everything now before the key arrives. He said contents of Astro Noise will make the Pentagon Papers and Manning's leak look like idle gossip. Jesus. I am totally over my head. Listening to Binney you realize what these people are capable of. Thirty-seven years of service and they show up w/guns drawn. These people are evil. What world have I entered? Will I ever escape?

"Once the payload moves from ciphertext to plaintext, the life I have lived is finished. Whether scorned power ends it through imprisonment or violence is of little interest. I am not afraid."—C4

May 8, 2013

Met w/lawyer. Legal protections in Germany are good if the U.S. tries to issue a subpoena.

Bart is pushing hard for direct contact. Of course he is doing his job, but I should be careful and not agree to anything without understanding the consequences. I should control distribution carefully once it gets into plaintext. Jesus. My life might soon be over or become very public. I should prepare myself.

May 10, 2013

Citizen Four agreed to meet for interview. All will move fast now. Everything has to be secure before we meet, otherwise we would be a perfect target if they thought it could be stopped. They'd call it a conspiracy. It would be so easy to frame. I'm already on a watch list. They'd say I'm acting as an agent.

May 11, 2013

I might travel Thursday or Friday. Hopefully shoot on Sunday. Return Monday or Tues. I should spend the weekend working on questions. Ideally this would happen in a house in the country.

I should really consider doing the interview alone.

—What do you think they will do to you?
—Explain to me what you think they will do to you.
—Explain to me why you decided to become a whistleblower.
—Can you walk me through how you were able to retrieve this data/archive?
—Tell me what the archive contains.
—Tell me what you know about Stellarwind.
—Tell me what you know about the Ashcroft hospital visit.
—Can you explain the secret interpretation of Section 215 of the Patriot Act?
—Explain to me who in Congress know what you are revealing.
—Explain to me what you think is illegal in these documents.
—Explain why you are not afraid.
—Explain why you decided not to leak the archive to MSM, such as the *NYT*.
—What do you think they'll do to me?
—What frightens you the most?
—Some people will accuse you of being a traitor. What do you say to them?
—Explain how this information can be used to win.
—Who is implicated in criminal activities?
—Tell me what "Treasure Map" is.
—Explain Bill's role in the NSA. What were his skills?
—Explain why you don't try to escape or seek asylum.
—What do you know about the Utah facility?
—Explain why they are building it and what it will do.

May 12, 2013

My heart is beating out of my chest. The pressure of putting this all together is enormous.

They are going to come after me with all their aggression to stop the spread. The trick will be to make it a scandal before Citizen Four gets caught. Otherwise the leak gets framed as treason/attack on national security. Either way, this will not be at all fun. They will prosecute me, right? I really do need a press organization backing me on this. I do want to get out of this one alive, so I have to be careful. I'll go to jail to protect the First Amendment, but I don't want to do something that invites them to indict me.

God, but seriously, my life in the U.S. is over after this, right? How will I be able to live there?

May 13, 2013

SILVERSHOT did the setup for Glenn.[26] He should be on encryption by Thursday. Thank god. No word from Citizen this weekend. I hope my last email didn't push him away. Asking to meet is risky I know, but how can I not ask? I don't know the level of surveillance he is under. He says he can't travel undetected. What does that mean? I assume he lives near Fort Meade.

May 15, 2013

The plans arrived, so I should have them tonight and can begin distribution. I should write down the hotels I can call from NYC to find a place to copy everything.

I should also destroy this fucking notebook.

* * *

I flew to New York later that day. Two weeks later I flew to Hong Kong with Glenn Greenwald to meet Edward Snowden.

NOTES

1. In 2006, I was placed on a government terrorist watch list after making *My Country, My Country*, a film about the Iraq War. Since then, I have been detained and interrogated more than forty times at the U.S. border. In 2015, I filed a Freedom of Information Act lawsuit against the Department of Homeland Security, the Department of Justice, and the Office of the Director of National Intelligence to request my files. In October of that year, I received a first release of heavily redacted FBI documents that reveal I was the target of a classified grand-jury investigation. Several of these documents appear in this volume on pages 193–201.

2. The disposition matrix is a database of people that American intelligence agencies see as terrorists. People in this database are selected according to criteria from the Obama administration to create a list of people whom the U.S. targets for capture or assassination. Most often they are killed by drone strike. President Obama makes the final decision on every list.

3. William Binney worked for the NSA for more than thirty years. He was the agency's technical director. He left the NSA in October 2001, right after 9/11. Before leaving, he discovered that the social-graphing program he designed, ThinThread, was being used to spy on U.S. citizens. He and other NSA employees filed complaints internally. I began filming him in 2011. One of the first things he said to me was, "I want you to know I will never commit suicide."

4. *Death of a Prisoner* (2013) was a short film I made for the *New York Times* about Adnan Latif, a Yemeni prisoner who was found dead at Guantánamo Bay in September 2012. When I learned about his death, I contacted the *Times* because I had visited and filmed Adnan's family in Yemen five years earlier.

5. Lakhdar Boumediene was rendered by the CIA in Bosnia and spent seven years at Guantánamo without charge. He was on a hunger strike for two years. He was released following his 2008 Supreme Court victory in *Boumediene v. Bush*. I filmed him in 2009, weeks after his release.

6. In 2010, after finishing *The Oath*, I was contacted by a producer in Hollywood who was doing consulting for the National Counterterrorism Center, or NCTC. She wanted to put me in touch with G. from NCTC to see my film. G. wrote to request a DVD and put me in touch with a woman, R., who handles "outreach to Hollywood folks." I never heard from them again after her email. I assume they looked into their database and realized I was on the NCTC terrorist watch list.

7. Murat Kurnaz is a former Guantánamo prisoner I filmed in 2009. He was tortured in Afghanistan.

8. Chaos Computer Congress, or CCC, is an annual hacker conference in Germany.

9. All prisoners at Guantánamo are assigned an Internment Serial Number, or ISN.

10. Scott Shane, "Ex-Officer Is First from C.I.A. to Face Prison for a Leak," *New York Times*, January 5, 2013, http://www.nytimes.com/2013/01/06/us/former-cia-officer-is-the-first-to-face-prison-for-a-classified-leak.html. John Kiriakou was a CIA agent who was imprisoned for revealing information to a reporter about agents who tortured prisoners at black sites.

11. The *New York Times* published the op-doc *Death of a Prisoner* on the eleven-year anniversary of Guantánamo Bay prison, January 11, 2013, http://www.nytimes.com/video/opinion/100000001998311/death-of-a-prisoner.html.

12. Aaron Swartz was an Internet prodigy and activist who committed suicide while facing prosecution and potential decades in jail for logging into an MIT server and copying academic journals that were largely funded by taxpayer money. The site he logged into, JSTOR, eventually opposed his being prosecuted.

13. I began filming Jacob Appelbaum and Julian Assange in 2011 in the aftermath of WikiLeaks' publication of war logs and U.S. State Department cables. A secret grand-jury investigation into Wikileaks was launched, which was the reason I relocated to Berlin to edit. The secret investigation is still open, five years later.

14. The "Three Colors" trilogy by Krzysztof Kieślowski.

15. I began filming the NSA's Utah Data Center in 2011. The NSA didn't yet have

security because the building was under construction, so I was able to get close. The neighbors next door let me film from their property. They told me that a highway would soon come through their land. They also told me that their son had been in an automobile accident and that they had to sell the piece of land rather than build a new house and retire there. I considered trying to purchase the land and turning it into a research center to study the NSA, but I never followed up on the idea. I was too freaked out by the thought of being across the street from the data center storing everyone's communications.

16. In 2013, a source leaked an audio recording to the Freedom of the Press Foundation of Chelsea (then Bradley) Manning's statement during then-ongoing court-martial proceedings. In it, Manning discusses how she felt when she saw the "Collateral Murder" video, which shows journalists and children being gunned down in 2007 in Baghdad by an Apache helicopter gunship. I made a short video, titled *Providence*, using Manning's audio recording as the voice-over. It was released by the Freedom of the Press Foundation on March 12, 2013.

17. When I traveled to Iraq in 2004 to film *My Country, My Country*, I never imagined things like the drone assassination program.

18. Cory Doctorow's *Homeland* (2013) is a work of fiction about a massive leak of classified documents.

19. Katy Scoggin served as co-producer on *CITIZENFOUR*.

20. Encrypted files cannot be opened without a "key," or passphrase, to unlock them. I did not have the key.

21. *Exact Fantasy* is a film I made in 1996 about letters written to celebrities.

22. I had several meetings in New York to discuss Citizen Four and make plans if the documents were real. I also warned several people whom I knew would be targeted if Citizen Four were legit and his claims were accurate.

23. In May 2012, I filmed Julian Assange in a hotel room in London as he disguised his appearance before seeking political asylum from Ecuador.

24. Barton Gellman is an investigative journalist. I met with him in February 2013 when I first started to receive emails from Citizen Four. At that time he was a contributing editor at large for *Time* magazine.

25. I later learned this document was a slide deck from the top-secret Prism program that revealed details about nine internet companies and how they shared information with the NSA.

26. SILVERSHOT was a code name for Micah Lee, a technologist whom Snowden contacted to reach me. Snowden assigned code names for people he communicated with—mine was DARKDIAMOND.

LISTENING TO THE MOONS

Trevor Paglen

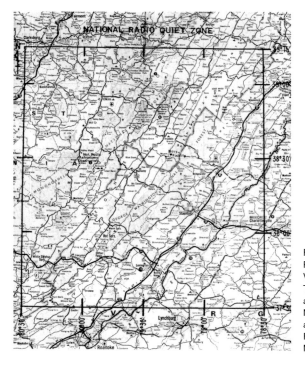

Fig. 1. Map of the National
Radio Quiet Zone, West
Virginia. From the National
Telecommunications
and Information Association
Manual of Regulations
and Procedures for
Federal Radio Frequency
Management, May 2014

APRIL 8, 1960. 3 AM. Frank Drake shrugged off the thick Appalachian cold and groggily climbed into a garbage-can-size pod. Deep in the George Washington National Forest, Drake was now at the helm of the Green Bank Radio Observatory's eighty-five-foot telescope, one of the most powerful antennae in the world. Green Bank was designed to plumb the depths of space and time: to watch stars form, grow, and explode in massive supernovas; to study the evolution of galaxies and the influence of mysterious dark matter on the visible universe; to comb the cosmos for traces of black holes, pulsars, and other celestial objects of unimaginable strangeness and power. In other words, the telescope was designed to help answer some of humanity's oldest questions: Who are we? Where did we come from? Where are we going? But as Drake squeezed into the telescope's focuser that day, he was looking for an answer to a slightly different but no less profound question: Are we alone? The day marked the beginning of Project Ozma and the Search for Extraterrestrial Intelligence (SETI). Drake was looking for signals from an alien civilization.

Green Bank was an ideal locale. Not only did the observatory have one of the most sensitive receivers in the world, designed to capture and record the faintest of signals from the universe's depths, it was also located in a remarkable, newly established nature preserve of sorts, a place designated by the Federal Communications Commission as the National Radio Quiet Zone. Created in 1958, the Quiet Zone (fig. 1) encompassed 13,000 square miles throughout the rolling West Virginia hills and forests where radio signals of all sorts were severely restricted: omnidirectional transmitters were largely banned, as were high-powered television and radio waves. The Quiet Zone was a place of radio silence, a place of listening, a place where one could hear the rapid clicking of a spinning neutron star light-years away, the brief pop of an exploding star in a distant galaxy, the faint echoes of the big bang itself, or, perhaps, the delicate chatter of an alien civilization far across the galaxy.

Drake had thought long and hard about what an alien civilization might sound like to the giant telescope at Green Bank. Planet Earth had itself only just developed technologies that made interstellar communication theoretically possible. The previous decades had seen the advent of broadcast television with the Nazis' transmission of the 1936 Berlin Olympic Games, the development of military communications networks during World War II, and powerful new radar transmitters.

Radio technologies laid the groundwork for a global telecommunications village, but to visionaries like Drake, they held out the possibility of intragalactic communication. He believed it was self-evident that any cosmic civilization would want to reach out to other intelligent species on other planets. Moreover, he thought, interstellar radio beacons would be the obvious way to do so. And so, that morning at Green Bank, Drake was looking for beacons.

Drake posited (somewhat circularly) that because so much human radio astronomy is conducted around the so-called hydrogen line at 1420 MHz, that location on the radio spectrum would be an obvious place for an alien civilization to park an interstellar beacon. He aimed the massive telescope toward the star Tau Ceti. Located in the constellation Cetus, relatively close to Earth at twelve light-years away, the star's sunlike chemical composition promised the possibility of intelligent life. As the telescope swung into position, Drake turned the tape recorders on. The needle jumped. Then plunged again. Drake sat in the can until noon, while the needle rose and fell in accordance with the laws of Gaussian noise. Tau Ceti ducked under the western horizon. Drake did not find any alien beacons that day, or the next.[1]

Drake was never able to find an extraterrestrial transmitter with the sensitive receivers at Green Bank, but he was not alone in the Quiet Zone. Thirty miles northeast of Green Bank, near the tiny town of Sugar Grove, the National Security Agency—an agency whose name was all but unknown at the time—was building a vastly more powerful radio telescope (fig. 2). The alien hunters at Green Bank weren't the only ones interested in collecting the faintest signals from space. But the gargantuan "shadow" telescope under construction at Sugar Grove wasn't built to look for extraterrestrial beacons from Tau Ceti so much as at alien civilizations located here on earth. And rather than point its telescopes at the depths of the galaxy or faraway stars, the NSA was almost exclusively interested in one celestial object: the moon.

The NSA's interest in the moon began with a series of experiments in the 1940s dubbed Project Diana (after the lunar goddess) showing a curious thing: when electromagnetic signals radiate away from the earth (as all signals do) into space, a certain amount of them hit the moon and promptly bounce back. By 1945, a Naval Research Labs engineer named James Trexler had shown that a sufficiently powerful receiver

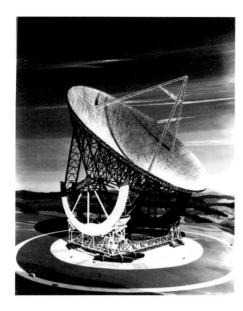

Fig. 2. Rendering of the Navy's
radio telescope in Sugar Grove,
West Virginia, ca. 1959

could collect signals from all over the earth by monitoring their reflections, their "moonbounce," with powerful receivers (fig. 3).

The Navy put theory into practice in the early 1950s with Project PAMOR (Passive Moon Relay), a giant antenna built at Stump Neck, Maryland. The project demonstrated that the moon could indeed be used as a passive reflector in order to spy on other countries. As it rose and traversed the sky, the moon behaved like a giant mirror, providing a glimpse into Chinese and Soviet hinterlands. Because the moon's angle in the sky correlated to a particular slice of Soviet territory, each moonrise provided the NSA with a sweeping look across the Eurasian landmass. With the proof of concept for an eavesdropping moon antenna in place, the NSA began envisioning a massive secret installation dedicated to the job. The agency imagined creating a very special place where it would be possible to listen to the moon with little radio interference, a kind of "quiet zone." What's more, by collaborating behind the scenes with radio astronomers, the NSA would be able to use radio astronomy as a good cover story for the creation of the United States' most powerful eavesdropping station.

In large part, Green Bank Radio Telescope (and radio astronomy in general) was that cover story. Under the auspices of the Navy, the NSA

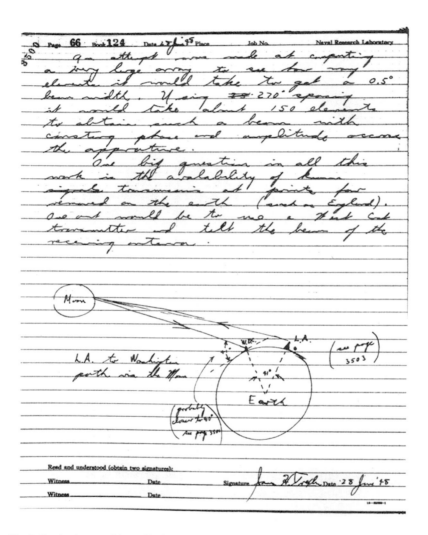

Fig. 3. Notebook entry of James Trexler showing calculations for a long-distance communications link between Los Angeles and Washington, D.C., via the moon, January 28, 1945

had begun construction of a massive radio telescope, six hundred feet in diameter, described in a 1959 *Popular Science* article as "the biggest machine that men have ever built."[2] According to the magazine, the installation was designed to "catch the faintest whisperings of signals from unimaginably distant space," its reach would be "literally, beyond the edge of the universe," and it "should settle some hot arguments among astronomers." Nonetheless, *Popular Science* conceded that "most of the time it will be busy on jobs that the Navy steadfastly refuses to describe."

But the NSA's massive and largely secret moonbounce telescope would never be completed; the installation would be slightly repurposed.

In the years after Sputnik, the NSA decided that listening to electromagnetic reflections from the moon was a bit inefficient. A better idea was just to build your own moon, one specifically designed for eavesdropping. And so the NSA designed a shiny, basketball-size satellite with inset solar cells and protruding antennae, then gave it a scientific cover story.

In June 1960, NASA launched the Galactic Radiation and Background (GRAB) satellite (fig. 4). GRAB's stated purpose was to monitor solar radiation fluctuations from space, and that was indeed a part of its mission. But "GRAB" was a lie by omission; internally, the little satellite was called Tattletale and was designed to collect Soviet and Chinese military signals.

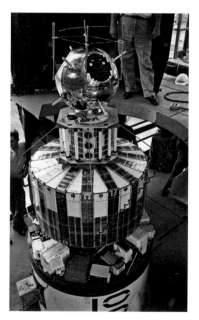

Tattletale showed that the best way to eavesdrop on the "chatter" it sought wasn't by adopting the posture of a radio astronomer, listening for reflections from the moon as if they were signals from an alien civilization. The better approach was to become an extraterrestrial civilization oneself and to monitor the earth from a listening post in outer space. And so the NSA kept building moons. The giant antenna at Sugar Grove went dormant for a time.[3]

In those first few years, the tiny Tattletale satellites did everything

Fig. 4. GRAB 2 atop two other satellites and launch vehicle, ca. 1960

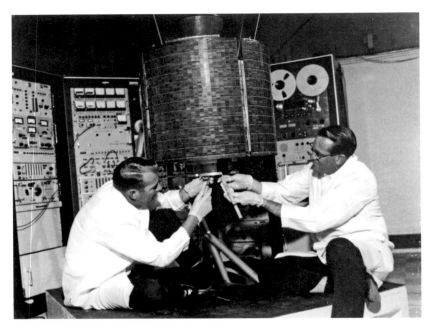

Fig. 5. NASA engineers examining Intelsat I, 1965

that the cyclopean moonbounce telescope had been designed to do—suck up Soviet and Chinese electromagnetic radiation containing information about military hardware, communications systems, missile telemetry, and other sensitive data and broadcast them down to the NSA on earth. The new eavesdropping satellites worked so well that the agency followed GRAB with a series of similarly sized satellites called Poppy, with seven launches between 1962 and 1971. Others followed closely thereafter.

In 1968, the NSA placed the first SIGINT (signals intelligence) satellites in geosynchronous orbits, 36,000 kilometers (some 22,300 miles) above the planet. The Canyon satellites' thirty-foot antennae made them titans compared to their smaller GRAB and Poppy cousins, and their orbits allowed them to remain parked at a single point over the equator, effectively becoming space-based versions of the NSA's planned receiver at Sugar Grove. By the end of the 1960s, the NSA had built a veritable solar system of secret moons around the earth, all designed to listen in on the "alien" activities below.

Of course, the NSA wasn't the only organization creating new moons, and satellites had many more purposes than eavesdropping. One of their main uses was the creation of planetary communications infrastructures. In 1964, eleven countries banded together to form Intelsat, the International Telecommunications Satellite Organization, an intergovernmental consortium to own, manage, and provide broadcast services via a constellation of geosynchronous communications satellites. In 1965, Intelsat launched its first satellite, named Intelsat I (nicknamed Early Bird; fig. 5), bringing forth an era of global interconnection through television, telephone, and facsimile routing. Over the next few years, Intelsat built a ring of geostationary satellites, all buzzing with the chatter from the planet below.

But the Intelsat satellite constellation did something more than create the world of global connectivity: inherent in its architecture was the possibility of global surveillance. The NSA jumped at the chance. The advent of the Intelsat satellites reinvigorated the importance of the NSA's old moonbounce facilities. The most efficient way to spy on earth may have been to build extraterrestrial spacecraft like GRAB, Poppy, and Canyon, but if you wanted to spy on moons like the Intelsat satellites, the best way to do it was with a radio telescope like the one Frank Drake had used to pioneer the search for aliens.

Communications-satellite infrastructures like Intelsat work like this: a signal (for example, an international telephone call) is routed from a land-based telephone wire in a home or business to a powerful radio transmitter at a ground-based station, or "teleport," where the signal is sent to a satellite in geosynchronous orbit. That satellite in turn routes the signal to other "relay" satellites until the signal is over the appropriate part of the planet and is sent back down toward earth (to another teleport) and routed along ground-based telephone cables to the recipient. The ground-based teleports are essentially commercial versions of the telescopes at Green Bank and Sugar Grove, albeit ones tuned to frequencies reserved for commercial communications.

As Intelsat connected the world through a network of ground stations and communications satellites, the NSA began construction of a shadow network designed for the mass surveillance of this new "global village" of interconnectedness. The program was called Frosting, and it was an earlier version of the now-infamous directive of recent NSA

director Keith Alexander to "collect it all." Established in 1966, Frosting was designed to collect all satellite communications. Frosting had two subcategories: Transient, a program designed to collect all Soviet communications, and Echelon, a program established to collect all civilian communications over Intelsat satellites.[4]

The Intelsat satellites were easy targets for mass surveillance; all the NSA had to do was build its own network of ground stations similar to those of Intelsat and in similar places. Then the NSA could just suck up all the same signals as the Intelsat ground stations, achieving the goal of planetary surveillance.

In short order, a network of classified NSA ground stations multiplied in the vicinity of Intelsat stations. An Intelsat ground station at Brewster, Washington, was "shadowed" by an NSA station at Yakima (code named Jackknife); Intelsat's installation at Cayey, Puerto Rico, was shadowed by an NSA post at Sabana Seca (Coraline); in the UK, a joint venture of the NSA and the British High Command tailed Goonyhill Downs, and to track Raisting, Germany, a ground station was installed at Bad Aibling (Garlick). And in the Quiet Zone, an Intelsat ground station in Etam, West Virginia, located to take advantage of the low radio noise, reinvigorated the NSA station at Sugar Grove. The Quiet Zone was returned to its original mission—spying on extraterrestrial moons—and the NSA's Appalachian eavesdropping station returned to prominence. In the new Echelon vocabulary, Sugar Grove was given the code name Timberline.[5]

As the Intelsat network expanded, so did the network of shadow ground stations. And just as Intelsat was formed as an intergovernmental consortium to provide global telecommunciations, the NSA took the lead in creating a secret intergovernmental organization dedicated to mass surveillance: Five Eyes, a collaborative spying effort among Britain, the United States, Canada, Australia, and New Zealand whose collective footprint could effectively encircle the planet.

Five Eyes soon had a global surveillance infrastructure (fig. 6). Moonpenny arrived at Harrogate, England; Ladylove at Misawa, Japan; Lemonwood in Khon Kaen, Thailand; and a pair of sites under the umbrella of the Special Collection Service at embassies in Brasília and New Delhi. Other Five Eyes facilities were created in Ayios Nikolaos, Cyprus (Sounder); Oman (Snick); Nairobi (Scapel); Darwin, Australia (Shoal Bay); and Waihopai, New Zealand (Ironsand).

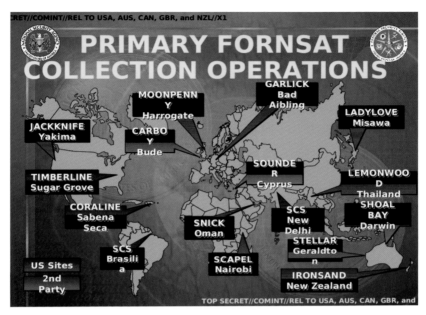

Fig. 6. PowerPoint slide showing worldwide locations of NSA/CSS satellite-surveillance stations

If the Intelsat network constituted the advent of the "global village" or the "networked society," then the NSA's Echelon and Frosting systems marked its shadow—the genesis of planetary mass surveillance. The hardware and global geography of the two were, and remain, nearly identical. This coupling of global connectivity and global surveillance, communications infrastructures and their secret eavesdropping shadow architectures, is still in effect today.

In the 1980s, the rise of fiber-optic communications added a web of undersea cables miles beneath the world's oceans to the communications satellites in the heavens above. As great cable ships such as the CS *Long Lines* unspooled ever-more-powerful telecommunications cables across the seas, NSA submarines like the USS *Parche* and USS *Jimmy Carter* lurked below on the ocean floor to install taps and splices onto them. And just as the world's telecommunications consortiums created landing sites and processing centers for undersea cables in scores of locations, from Mastic Beach, Long Island, to Marseille, and from Mumbai to Alexandria, Egypt, the NSA installed a global network of

cable-tapping operations, from Blue Zephyr to Smokeysink, and from Azure Phoenix to Dancing Oasis. So too the commercial data centers of Facebook and Google find their shadows at the NSA's massive data centers from Bluffdale, Utah, to Oak Ridge, Tennessee.

But the NSA hasn't given up on the heavens. Far from it. The GRAB and Poppy satellites have evolved into a contemporary constellation of SIGINT satellites called Intruder that circle the globe in low orbits, operating in pairs in order to triangulate the exact location of an intercepted signal. The Canyon spacecraft of the late 1960s and '70s, with their then-formidable thirty-foot span, have developed into a contemporary constellation of Orion SIGINT satellites with eavesdropping antennae the size of football fields. Raven-class eavesdroppers lurk in highly elliptical orbits that allow them to dwell over the northern latitudes, while satellites called Nemesis actually move through the geostationary belt, periodically parking to eavesdrop on any communications satellite of interest.

In short, a network of secret moons still listens for signals from the earth below in much the same way that Frank Drake imagined collecting signals from Tau Ceti so many years ago. But who are the real aliens?

The massive telescope at Green Bank, originally built in part as a cover for the NSA's planetary eavesdropping efforts, continues to operate within the radio silence of the Quiet Zone, plucking the faintest signals from the universe's depths. Over the ensuing decades, Green Bank has listened to the formations of galaxies, the rapid tapping of collapsed neutron stars, the din of dark energy, and the violence of world-eating black holes. And although no alien civilizations have been detected, the Search for Extraterrestrial Intelligence continues to this day, albeit in different forms.

When Drake first began looking for aliens, he was looking for interstellar beacons in areas of the radio spectrum where he imagined aliens would want to broadcast. His hunch was that there might be a galactic village of interconnected species and civilizations, perhaps akin to the one developing at that moment on Earth. He imagined the hydrogen line at 1420 MHz to be the intragalactic notice board of an interstellar village that humanity might be invited to join if it would only listen closely. Drake was shortly joined in this view by other astronomers like Carl Sagan and Jill Tartar, who believed that seeking out extraterrestrial civilizations could provide enormous technological benefits to

Earth; more important, it could be a message of hope. The very existence of an alien civilization, they surmised, was evidence that the self-destruction of a world that had just turned on its radios and built nuclear weapons wasn't a foregone conclusion. If alien intelligence existed, they thought, then it was possible for a planet to avert nuclear war and grow out of a violent and militaristic adolescence. After all, Sagan and others believed, any advanced extraterrestrial civilization we encountered would be peaceful and altruistic by definition, because it otherwise would have destroyed itself long ago. If we could find an alien civilization, perhaps it could teach us how to dismantle nuclear stockpiles and avoid environmental catastrophe.

To this day, Drake is still on the lookout for cosmic beacons. Undeterred by the failure to find any evidence of alien civilizations, he points out that SETI has barely scratched the surface in terms of a sustained galactic search of millions of potentially civilization-harboring star systems. On the other hand, humans have been capable of building an interstellar beacon for more than half a century now but have never even seriously considered taking on the effort. What's more, a consensus has developed among SETI astronomers that building such a beacon might be seriously ill advised. Just as the NSA used the advent of global telecommunications to create global surveillance and targeting systems, some fear an interstellar beacon could easily be used by hostile extraterrestrials as an arrow pointing to their next meal.

The question of whether or not to build an interstellar beacon, however, is actually moot. We already have, although it wasn't intended as such. The advent of rockets, satellites, and the means to track them has transformed Earth itself into a de facto beacon, albeit one far more cacophonous than a simple, univocal transmission in a galactic lingua franca. In 1978, astronomer Woody Sullivan pointed out what the NSA had long known—that the radio leakage from television signals, telecommunications systems, and military hardware has turned the planet into a kind of cosmic lighthouse.[6] Sullivan's goal was to identify other means of conducting SETI: by asking what Earth might look like to an alien civilization, SETI researchers might expand their search for extraterrestrial signals beyond the hydrogen-line beacons Drake first theorized. Sullivan's work showed that by far the most powerful signals emanating from the planet are the U.S. military's Ballistic Missile Early

Warning System (along with its then-Soviet counterparts). These radar installations are designed to detect and track aircraft, missiles, and satellites far above the earth but are both powerful enough and cover a swath of the sky so broadly that they "sweep" a large proportion of the galaxy's stars daily with the earth's rotation.[7] These signals are, in part, exactly the kinds of signals the NSA wanted to collect with its early moonbounce hardware.

A civilization on a planet orbiting Tau Ceti a mere twelve light-years away might learn of humanity's presence on Earth from daily sweeps of American and Russian military radars. If the Tau Cetians tuned in further, perhaps from their own Quiet Zone in a remote valley on their planet, they would probably detect the carrier signals of Earth's television and telecommunications transmitters. Over every twenty-four-hour period, they might watch these signals rise and fall, a daily survey of what is happening on our planet, in much the same way that the NSA sought to survey the Soviet and Chinese hinterlands by listening to the moon. Upon further study, they'd find an uneven radio landscape of varying

Fig. 7. Naval Information Operations Command, Sugar Grove, West Virginia, 2010. Photograph by Trevor Paglen

amplitudes whose peaks and valleys correspond not only to Earth's physical topography but to its territorial borders and uneven distributions of economic and political power. And in time, they might learn that they were, in fact, not at all the first beings interested in collecting Earth's signals. A few years ago, they might have heard of the NSA and Echelon, as broadcasts of Duncan Campbell's two thousand reports on the agency and the program traversed the twelve light-years to reach their planet. And in about nine years, they might learn about Edward Snowden.

In the meantime, despite the official shutdown of its overseer, the Naval Information Operations Command, in 2015, work at the NSA installation in the Quiet Zone continues (fig. 7). An entry in the Snowden archive from the Signals Intelligence Directorate newsletter *SID Around the World* describes life at the NSA's Quiet Zone outpost: "Trees, mountains, streams, rivers, deer, bear, ruffled grouse, red and gray squirrels, red and gray foxes, possums, skunks, caves, rock climbing, skiing, winding roads, red tail hawks, eagles, coyotes, cattle, sheep, horses, people, pigs, chickens . . . it's all here." The author concludes, "The best part about living here is the quietness and animal life. . . . Standing outside taking in the fresh air every day has made me realize how lucky I am to be working at NIOC Sugar Grove, WV."

NOTES

1. Drake's recollections come from Frank D. Drake, "A Reminiscence of Project Ozma," *Cosmic Search* 1, no. 1 (January 1979). The article is available at http://www.bigear.org/vol1no1/ozma.htm.

2. All quotations this paragraph from Martin Mann, "New Radio Telescope Is Man's Biggest Machine," *Popular Science* 175, no. 6 (December 1959), pp. 85–86.

3. For a superb overview of the relationship between radio astronomy, the NSA, and the sites at Green Bank and Sugar Grove, see David K. van Keuren, "Cold War Science in Black and White: US Intelligence Gathering and Its Scientific Cover at the Naval Research Laboratory, 1948–62," in "Science in the Cold War," special issue, *Social Studies of Science* 31, no. 2 (April 2001), pp. 207–29.

4. This story comes from an item in *The Northwest Passage*, a newsletter for the

Jackknife site in Yakima that was published by *The Intercept*. See "Blast from the Past: YRS in the Beginning," *The Northwest Passage* 2, no. 1 (January 2011); available at https://www.documentcloud.org/documents/2189960-nwp-nsa.html.

5. See Duncan Campbell, "Interception Capabilities 2000," a working document prepared for the STOA Panel of the European Parliament, October 1999; available at http://www.duncancampbell.org/menu/surveillance/echelon/IC2000_Report%20.pdf. See also James Bamford, *The Puzzle Palace*, 2nd ed. (New York: Penguin, 1983).

6. W. T. Sullivan III, S. Brown, and C. Wetherill, "Eavesdropping: The Radio Signature of the Earth," *Science*, new series 199, no. 4327 (January 27, 1978), pp. 377–88.

7. Ibid.

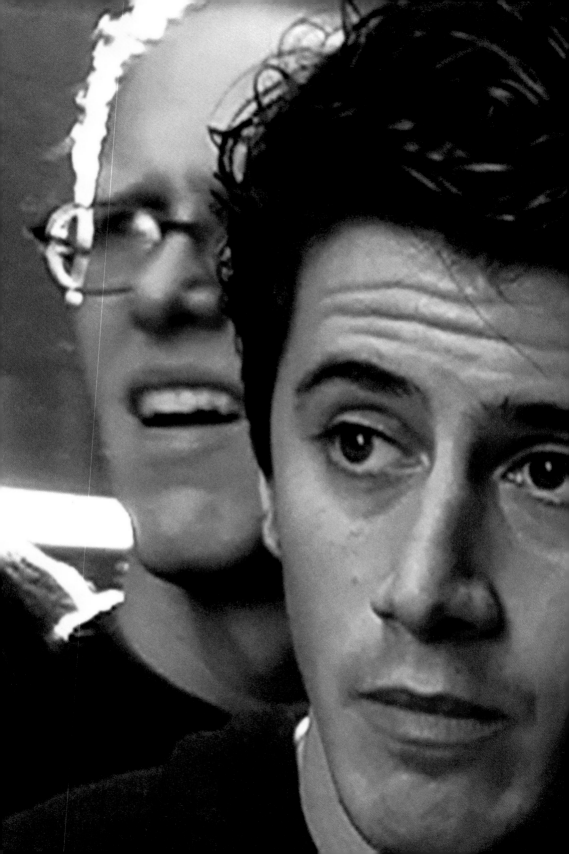

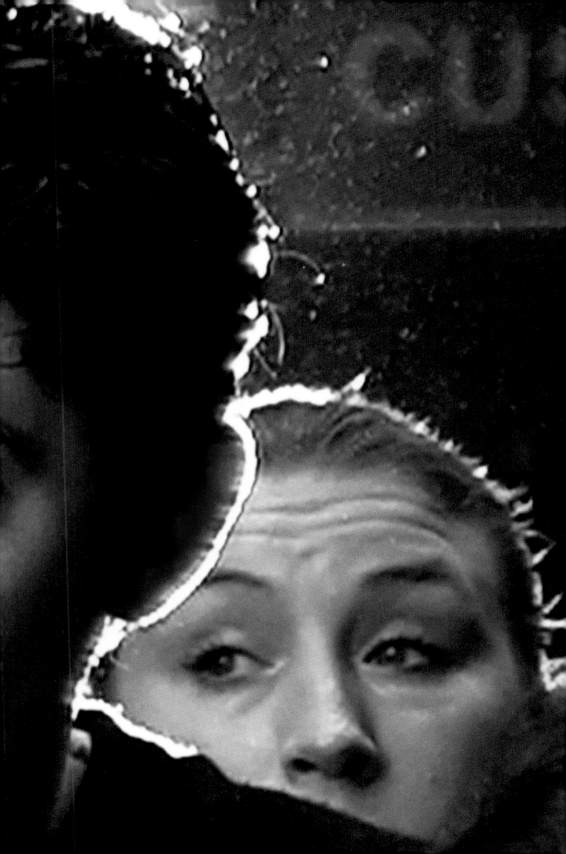

ASTRO NOISE

Edward Snowden

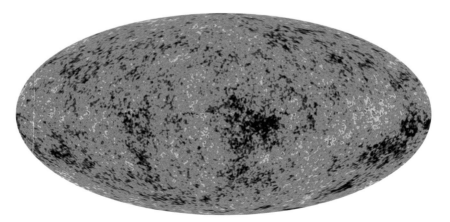

Temperature fluctuations in background cosmic radiation, mapped from nine years of data from the Wilkinson Microwave Anisotropy Probe, 2012

FOR THOSE WHO LISTEN, the stars are singing. From the overbearing sun to those that on the clearest night appear as only distant darkness, each has a voice. And their song can protect our secrets.

Cryptology is the science of secrecy. Cryptographic methods have given rise to the art of encryption: protecting valuable information by transforming it into a meaningless stream of gibberish mathematically indistinguishable from random noise to all except the rightful owner. The one who knows the secret. The one who has the key.

But modern cryptography depends on computers, and computers are deterministic. That is, they are incapable of creativity and must always return precisely the same result in response to a given input. They are incapable, absent outside forces, of truly random behavior. Mathematicians have worked around this limitation by devising "pseudorandom" number generators. These methods use a single, truly random "seed" number to produce millions of offspring. These numeric children follow a nonrandom sequence, but that sequence can never be predicted so long as the value of their original seed remains secret.

If that seed is stolen or its value predicted, however, an adversary can reverse the process of encryption, revealing what's been concealed.

Humans are by nature pattern-recognition machines. We search for meaning, whether in the circumstances of our lives or on the surface of toast. Like computers, we are incapable of producing truly random values over time. This is why your phone's password is closer to "2846" or "kittymittens2" than "DH?zM#XUAgoIj/1;Rl6I<<rK7'6k." In the search for randomness, we too must rely on outside forces.

What if we could rely on the stars?

With the right antenna, we can hear the universe's radio noises. The stars themselves (or so it's been theorized) can provide us an unpredictable source of information that will never be heard again in the same way. As the world turns, our antenna sweeps the vastness of the universe at a given point in time. The signals that we receive constitute an ever-changing key forged from the sky itself. Such a key could only be imitated by an agent listening from that exact same place, in that same direction, at that same time, to those exact same stars.

The sky is a limitless supply of truly random seeds. We can let the universe do the work that we increasingly offload to computers.

* * *

Could it work?

If we were to listen to just one star—a star that pulses at predictable intervals—a clever adversary might deduce the pattern, match the noise, and reverse engineer our seed, just as a spy can place his or her probes on my computer, see the circuits talking to one another, and reverse engineer the key that's stored in the memory.

But if our Astro Noise were to include the whole sweep of the sky, the distant stars might outwit the greatest spies.

"We are made of starstuff," Carl Sagan reminds us. "The nitrogen in our DNA, the calcium in our teeth, the iron in our blood, the carbon in our apple pies were made in the interiors of collapsing stars."

How fitting, then, that we might turn back to the stars to help protect what makes us most human.

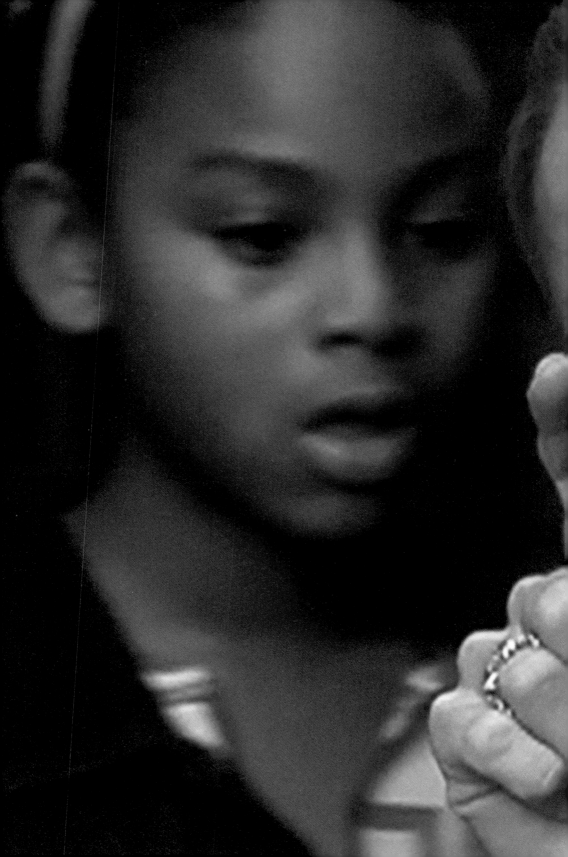

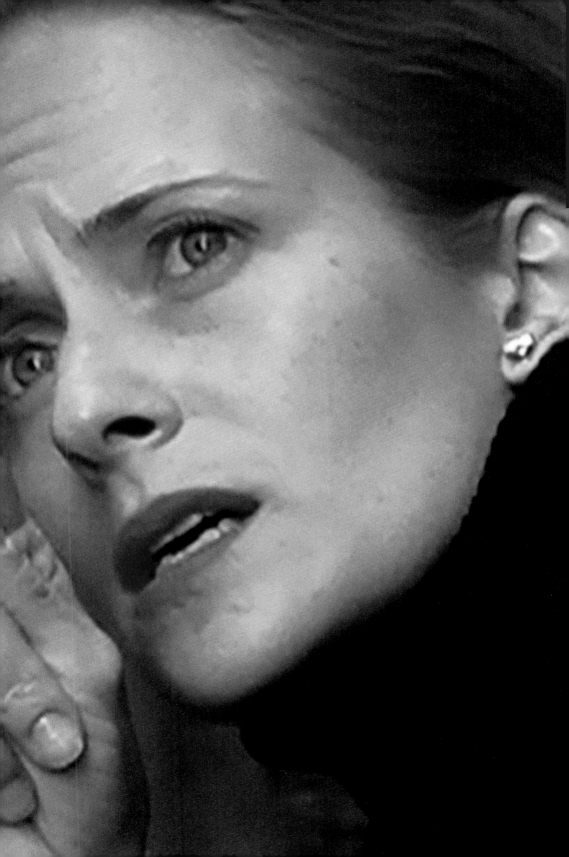

CIRCLE DEMOCRACY

Dave Eggers

INT. THE CIRCLE HQ -- GANG OF FORTY ROOM -- DAY

Epic views. A glass ceiling. The GANG OF FORTY is
assembled. A presentation is taking place.

All power players are there, including Mae --
sitting in the middle of the table, thrilled to be
there -- and Bailey, who sits at the opposite end,
genially in medias res. Stenton, the CFO, stands to
the side. Doesn't want to be on camera every second.

Behind Bailey, a PHOTO of an EMPTY POLLING PLACE, in
a school gym somewhere, dissolves into: *140 million.*

 BAILEY
 And here's how many were *eligible* to
 vote.

The screen reads: *244 million.*

Mae's lapel camera is trained on Bailey and the
SCREEN behind him. She checks the view on her
wrist -- *1,982,992 viewers.* COMMENTS pour in ("Wow!
The Gang of 40! A privilege!"; a comparison of
the event to the Manhattan Project; another to
"Edison's Menlo Park Lab, circa 1879").

 BAILEY (CONT'D)
 And here's how many Americans are
 registered with the Circle.

The screen reads: *241 million.*

Behind Bailey, the familiar IMAGE of: UNCLE SAM
pointing. Then another IMAGE appears -- of Bailey
wearing the SAME OUTFIT, in the same pose, next to
Uncle Sam.

Mae scans the room, and sees, by the door, behind
two rows of Circlers --

-- Annie, who doesn't return the look. She appears
agitated and more fragile than in the past.

 BAILEY (CONT'D)
Now we get to the meat of today's
session. Something I've been discussing
with Congresswoman Santos and
others. What if your Circle profile
automatically registered you to vote?

Bailey sweeps his eyes across the room, holding on
Mae for her followers.

 BAILEY (CONT'D)
With TruYou, to set up a profile, you
have to be a real person, with a real
address, complete personal info, a real
Social Security number, a verifiable
date of birth. All the information the
government wants when you register to
vote.
 (beat)
So why wouldn't state governments just
consider you registered once you set up
a Circle account?

People in the room nod, some out of
acknowledgement that it's a sensible idea,
a notion long discussed.

 BAILEY (CONT'D)
There's no reason.
 (smiles)
I have verbal commitments from
governors from almost every state.
They've agreed to push legislation
to make your Circle account your
automatic path to registration.

A brief round of APPLAUSE.

 BAILEY (CONT'D)
And personally, I don't see why you
wouldn't be able to vote *through* the
Circle. Far easier than going to some
old gym or church . . .

APPLAUSE ripples through the room. Bailey
smiles broadly. It seems to be the end of the
presentation. But just then . . .

. . . Mae tentatively raises her hand.

 BAILEY (CONT'D)
 Yes, Mae?

 MAE
 I wonder if we could take this one step
 further. I mean . . . well, actually, I
 don't think it --

Annie looks to her. Can't believe the gall.

 BAILEY
 Go on, Mae. You started well. I like
 the words *one step further*. That's how
 this company was built.

Mae glances around the room: the faces a mix of
encouraging and concerned. This includes Annie, who
watches sternly.

 MAE
 (gathers herself)
 Okay . . . why couldn't we just work
 backwards from that goal, using all the
 steps you outlined? All the tools we
 already have.

 BAILEY
 Go on . . .

 MAE
 Well, we all agree that we'd like
 100 percent participation, and that
 everyone would agree that 100 percent
 participation is the ideal.

 BAILEY
 It's certainly the idealist's ideal.

 MAE
And we currently have 83 percent of
voting-age Americans registered on the
Circle?

 BAILEY
Yes.

 MAE
And it seems that we're on our way to
voters being able to register, and
maybe even to actually vote, through
the Circle.

Bailey's head bobs side to side, some indication of
mild doubt, but he's smiling, his eyes encouraging.

 BAILEY
A small leap, but okay. Go on.

 MAE
 (beat)
Why not *require* every voting-age
citizen to have a Circle account?

There's a SHUFFLING in the room, some intake of
breath, mostly from the older Circlers.

 STENTON
Let her finish.

Mae glances over to Annie, her arms crossed, eyes
staring at the floor.

 MAE
 (gaining confidence)
Okay, I know the initial reaction will
be resistance. I mean, how can we
require anyone to use our services? But
there are all kinds of things that are
mandatory for citizens of this country.

 BAILEY
People pay taxes they don't want to

pay. We pay for Social Security. We
serve on juries.

 MAE
Right, and we pee indoors, not on the
streets.
 (off laughter)
I mean, we have ten thousand laws.
We require so many legitimate things
of citizens. So why can't we require
them to vote? They do in dozens of
countries. With our tech, we can
register them automatically. Election
Day comes around, everyone has to vote.
You have 241 million voters eligible,
241 million voters have to vote. You
get the full will of the nation.

 ANNIE
 (loud, *very* sarcastic)
And how exactly do we do that?

 STENTON
 (stern warning)
Annie.

Mae looks over at Annie. Their eyes meet. Mae looks
hurt. It's a tense moment. Bailey looks at Annie
with disappointment and says:

 BAILEY
It could be something like: "Hello,
Annie! Take five minutes to vote."
Whatever it is. We do that for our own
surveys.

Annie seems to shrink.

 BAILEY (CONT'D)
 (dagger eyes at Annie)
You know that.
 (to Mae, bright)
And the stragglers?

Mae smiles. She has an answer. She glances at her
bracelet: *7,202,821 people are watching.*

> MAE
> Well, everyone has to pay taxes, right?
> How many people do it online now? Last
> year, maybe 80 percent. What if we all
> stopped duplicating services and made
> it all part of one unified system?

Annie LAUGHS skeptically, shakes her head. Mae is
distracted for a moment, then continues:

> MAE (CONT'D)
> You use your Circle account to pay
> taxes, vote, pay your parking tickets,
> to do anything.
> (excited)
> I mean, we would save each user
> hundreds of hours of inconvenience.
> The government would save billions!

> BAILEY
> *Hundreds* of billions.

> STENTON
> (loving this part of it)
> You'd eliminate half of it overnight.

Annie steps forward and asks:

> ANNIE
> Why wouldn't the government just
> build a similar service? Why the hell
> do they need *us?*

Now Stenton gets Mae's attention. Jerks his head to
the side. Meaning, get Annie out of the frame. Mae
does so. She looks to Bailey.

> MAE
> Well, it would cost too much and they
> don't have the expertise. We have the
> infrastructure.

 BAILEY
 That's absolutely right.

Now she swings back toward Annie. But Annie's gone.
She's been taken away. The GANG OF FORTY knows
that Annie is out. They scoot their chairs over to
eliminate the space she left.

 STENTON
 The government needs us more than we
 need them.

 MAE
 Imagine knowing the full will of the
 people. Instantly. You'd have true
 democracy for the first time in human
 history . . .

Now Mae keeps talking as we cut to her passing
through the campus, being mobbed by Circlers.

EXT. CIRCLE CAMPUS -- DAYTIME

 MAE
 No voter suppression. You're voting
 from home!

Now MORE CIRCLERS COME UP, and they join in. Maybe
a quick montage of meetings, work groups, as they
build on these ideas.

 FOREIGN-BORN CIRCLER
 Think of the implications for
 totalitarian regimes. If all citizens
 are heard, there can be no more tyranny!

 ANOTHER CIRCLER
 And most people in the developing world
 have Circle accounts . . .

 FOREIGN-BORN CIRCLER
 No more rigged elections. The U.N. can
 demand they're held through the Circle.
 They'll be independent.

 MAE
But only if *everyone* is heard.

 FOREIGN-BORN CIRCLER
So mandatory Circle accounts for
everyone?

 ANOTHER CIRCLER
Every human on earth.

 MAE
It's the only way . . .

She's passing quickly through a crowd. We hear
this, and maybe other quick snippets (don't hit it
too hard):

 ANOTHER CIRCLER -- ADVERTISING
We can take the pulse of the nation --
everyone in the world -- in seconds. On
any subject. Any product.

A PAIR OF CIRCLERS approaches Mae and says:

 YOUNG CIRCLER
You're changing the world, Mae!

 OLDER CIRCLER
You're the one!

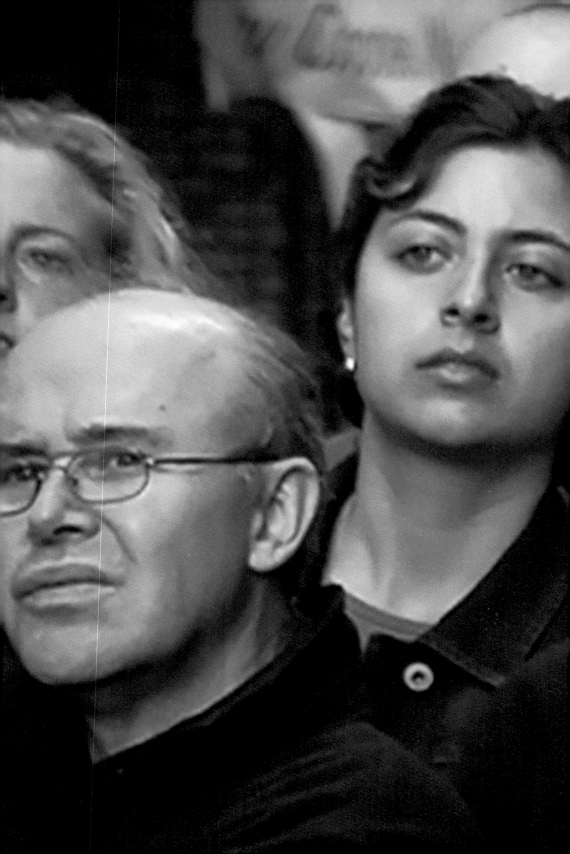

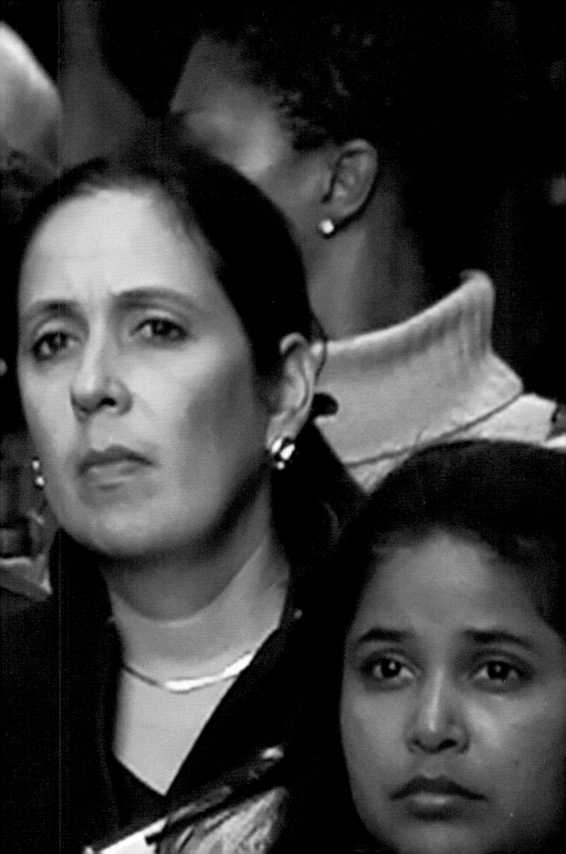

ASKING THE ORACLE

Kate Crawford

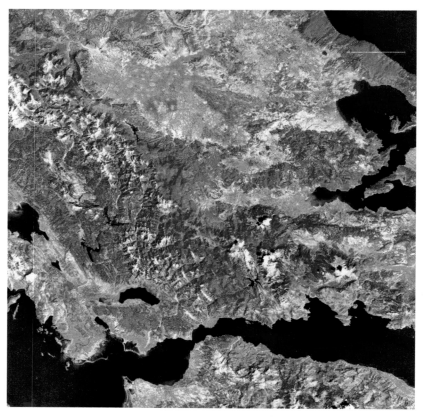

Multispectral satellite image of Delphi and Central Greece

Know Thyself: *gnēthi seauton*
Nothing in Excess: *meden agan*
A Pledge, and Ruin Is Near: *eggua para d'atē*
—The Delphic precepts

I SIT AT THE DESK and look at the screen. A software program normally used for digital forensics is open before me. This database contains the Snowden archive: all the documents, PowerPoint presentations, internal memos, newsletters, and technical manuals that Edward Snowden leaked in 2013. Documents that span more than a decade of intelligence thinking and communication is here, from within the National Security Agency in the United States and the Government Communications Headquarters in the United Kingdom and reaching out into the international network of the Five Eyes. The immense collection of material captures the era when mass collection metastasized: the black world's gradual evolution of many of the techniques and approaches that we now call "big data." This knowledge is normally off limits, part of a "classified empire" once estimated to be growing five times faster than the public storehouse of knowledge.[1]

For many reasons, this database is a machine for producing anxiety. The interface is query driven: it centers on a search box. Like a highly classified version of Google or Reddit's Ask Me Anything, the only way to make discoveries is to throw some terms out there. There is no easy browsing or pretty visualization of the repository itself. Instead, you must begin by phrasing any questions you have about the military-intelligence complex in the form of Boolean search terms. So I type in words. It feels exhilarating, terrifying: where to begin? How about something about cryptographic techniques, specific algorithms, or existing NSA programs? Thousands of search results. Days of work just to figure out what will be relevant. Instead, I try increasingly idiosyncratic, unusual combinations. Even then, the result is often dozens of documents, each with its own suggestive paths to follow. This is just the first challenge of the archive.

* * *

For the ancient Greeks, Delphi was the center of the world. It was the

home of the Oracle, and she possessed the power to explain the present and see into the future. Only a select few could ask her a question, and for them the Oracle offered a comms channel to the god Apollo. She predicted military attacks, saw into family tragedies, knew when kings would die. The Oracle became a serious force in politics and culture and remained so for centuries. According to archeologists, oracles were based at Delphi from the eighth to the second century BCE, before the temple was destroyed in CE 390.[2] For an information technology, this is an exceptionally long lifespan. And this is due not to simplicity of form or function. The Oracle of Delphi was a complex assemblage of parts that required much maintenance. There was the Oracle herself, known as Pythia, a priestess chosen for her exemplary life, who channeled Apollo's wisdom while in a trancelike state. Priests in turn transcribed her words into poetic hexameters. Then there was the expansive temple, which was located near a chasm that may have been issuing forth gas clouds rich in the intoxicant ethylene. Out of this mixture of elements, rich prophecies would emerge. Some concerned high matters of state: when to go to war, colonize a new city, give pardon or punishment. Others were strictly personal. Over time, this system became a vital part of Greek society. The Oracle knew all the secrets.

* * *

Like the divinations of the Oracle, the problem with the Snowden archive is that you never find an easy answer. Documents lead to other documents, one NSA program will point to another. Code names obscure specific companies and technological capacities. Some of these can be unlocked, but it's obsessive, painstaking work. Remember that *New York Times* and ProPublica investigation that finally revealed the identities behind the "Fairview" code name (AT&T's partner program with the NSA) and "Stormbrew" (Verizon's program)?[3] That was the result of multiple journalists working relentlessly for months. There's a reason so many of the articles about Snowden's archive have shared bylines: it takes a complex combination of skills to reverse engineer just what all the terms mean, let alone how they work. And it all begins with typing questions into little boxes. Then doing it again. Above all, what you find are more questions. Over time, I've come to think of it as

Apollo at Delphi with priestess and unnamed queen. Illustration by Thomas Kirk, from *Outlines from the Figures and Compositions upon the Greek, Roman, and Etruscan Vases of the Late Sir William Hamilton* (London, 1804)

a contemporary experience of the Delphic Oracle: you ask something and receive cryptic information that may offer you some answers, but only by raising more questions.

The Snowden documents may be vast in number, but they also have strange consistencies. First, there is the style: every government agency and consulting firm has its own way of laying out documents, a mode of conveying information that is distinctly its own. The NSA house style is most viscerally conveyed in PowerPoint: you are first struck by the banality of bullet points, drop shadows, and clip art before you are blown away by the magnitude of the information being conveyed. Wizards, crystal balls, four-leaf clovers, alchemists—once objects of power, magic, and prophecy, now rendered completely inert in a wasteland of Comic Sans and WordArt. There's a deep cognitive dissonance

in reading business-convention slide decks that look laughable while they simultaneously outline a colossal, terrifying surveillance infrastructure. You get over that. But the sensation of shaping search queries for an enigmatic system that can tell you the secrets of the classified world? This remains with you. It feels something like vertigo.

* * *

If you were given an audience with the Delphic Oracle you could expect an oblique response. Raw Delphic data is meaningless without the work of interpretation. When Lysander, the warrior who won the Peloponnesian War, visited the Oracle in 403 BCE, he was told to beware "the dragon, earthborn, in craftiness coming behind thee." Eight years later, he was stabbed from behind by a man with a serpent on his shield.[4] Socrates, of whom the Oracle once said, "No one is wiser," understood her words as paradoxes. Indeed, many of the Oracle's responses took the form of epistemic paradoxes—riddles that highlight inconsistencies in models of knowledge while casting light on a common error or misconception. The Oracle's role wasn't just to predict a possible future but to show the fallacies of the present. As a system of information it skewed toward difficult forms of data, often accenting the flaws and limitations of the supplicant.

Embedded in the architecture of the temple were messages counseling restraint. Anyone who entered the temple would face the maxims of Delphi, carved in stone: KNOW THYSELF, NOTHING IN EXCESS, and A PLEDGE, AND RUIN IS NEAR. The first of these, Know Thyself, is perhaps the best known, but the precept has always been double edged. To modern ears it sounds like a prescription for self-knowledge, but as historians and philosophers have argued, this was not its original meaning. It advised knowing one's limits in seeking data: in short, "Don't ask too many questions." In this way, all the Delphic precepts were instructions to be cautious and stay within bounds:

> When you question the oracle, examine yourself closely and the questions you are going to ask, those you wish to ask, and, since you must restrict yourself to the fewest questions and not ask too many, carefully consider yourself and what you need to know.[5]

So the Oracle, as a technology, set up particular restrictions and limitations. The information flow was restricted by the number of people who could visit the Oracle, by how many questions they could ask, and by the cryptic nature of the responses they received. In this sense there is a strange similarity with the Snowden archive. The person seated before the search box must decide what to ask next and try to exercise restraint so as not to be drawn into thousands of documents and stories and systems. But in another sense, when analysts consult the database inside the fortresses of the NSA and the GCHQ, there seems to be little respect for limits beyond the strictures of policy. Everything that can be captured will be. The archive is an epic testament to information acquisition, overreach, and confidence. It's as though the guiding principles of Delphi were reversed. Know Everyone. Everything in Excess. Just keep pledging that all the necessary protections are in place.

Know Thyself

The archive is the ultimate rabbit hole. Days can pass without stopping, without eating: I barely rise from the desk. It feels like I can see into the complete structure of a global system, spread out before me in neat network diagrams. This, of course, is an illusion. The archive is always partial—necessarily incomplete, truncated by Snowden's access, by what he took, and the date on which he copied documents. But it is also fractured and dispersed by the operating procedures of the NSA and GCHQ themselves. Intelligence work has to be compartmentalized: the work of one department is kept separate from another, and these divisions are reflected in the collection of documents. There are blank spaces, dead ends, and missing parts.

That said, the documents nonetheless offer extraordinary coverage of the core period of the expansion of big-data techniques during the early 2000s, up to 2013. Tens of thousands of memos, internal newsletters, and specific investigations. And, of course, the PowerPoint presentations. These have been the preferred documents for most journalistic reporting because they are designed to be dramatic. The PowerPoint decks seek to convey the sheer force of the surveillance systems as simply as possible in order to impress senior military figures, convince analysts at annual conferences, and secure ongoing funding

from politicians. Treasure Map, for example, makes for a jaw-dropping presentation—the program builds an almost real-time interactive map of the internet.[6] That's everything, including the location and owner of any connected computer, mobile phone, or router, even those we imagine to be safely located behind private networks or obscured by dynamic routing tables. "Map the entire internet—any device, anywhere, all the time," a slide boasts. A few slides on, "TREASUREMAP as an Enabler" offers up a layer-cake image of signals analysis. Above the geographical layer and the network layer is the "Cyber Persona Layer"—quaintly represented on the slide by jellybean-era iMacs and Nokia feature phones—and then the "Persona Layer." That's us—everyone across the world. We are represented as clip-art men standing on dots, connected by radiating lines in the style of a social graph. Our names, our homes, our viewing histories: all easily searchable ("near real time!") and ready for analysis. It is called a "300,000 foot view of the Internet."[7]

But should we even believe this presentation? It reads a lot like a sales pitch, and there are real infrastructural limits to the claims. There are also deep institutional reasons why agencies would add bravado to their decks: there's internal competition to be seen to be producing the most sophisticated attacks, with funding and institutional support hinging on that perception. But even when the technical claims are exaggerated, there's still much to be learned in these depictions. At every level, the documents instruct us about the extent of the aspirations for big-data surveillance, the power that those behind it wish to secure, and the world they want to build.

Like *Powers of Ten* (1977), the experimental film by Charles and Ray Eames that telescopes through views of the universe, the Snowden archive produces dizzying leaps in perspective of both time and space for the reader. It goes big picture, then comes in close. If Treasure Map is the God's-eye view for the NSA, then FoxAcid is closer to home: the snitch in your system. "If we can get the target to visit us in some sort of browser, we can probably own them," a slide explains.[8] Once users have been induced to click on spam or visit a website, the NSA drops files through a browser that will live on in their system, quietly reporting everything one does back to base. On the descriptions go, in a casual, jocular style, with illustrations of foxes drowning in a barrel of acid, and another fox winking on a tin of Spam. One slide describes how analysts

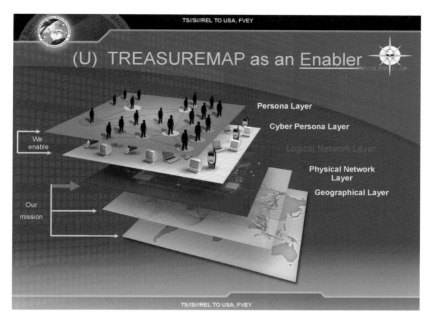

PowerPoint slide from NSA Treasure Map slide deck

"deploy very targeted emails" that require "a level of guilty knowledge" about the target, a technique known to black-hat operators as "spear phishing." Guilty knowledge? Where, in this system, does *that* begin and end? While there are some limits on how the data of American citizens can be collected and used, these are mentioned in the documents as uncomfortable restrictions. One PowerPoint notes that the NSA is working on multiple fronts to "aggressively pursue legal authorities and a policy framework mapped more fully to the information age."[9] Change the laws to fit the tools, not the other way around.

If we zoom back to a more proximate level of resolution, there am I, reading leaked, secret government documents on an air-gapped machine. I only read the documents at this location, and I can't copy them, so all research time requires arranging an in-person visit in order to ask further questions. My knowledge also feels guilty and full of risk. It is always being made clear that these documents are highly restricted. Just as the Delphic temple was inscribed with reminders of caution, each page of the Snowden archive is marked with a header noting different

forms of classification. TOP SECRET//SI//ORCON//NOFORN. This knowledge has limited access. Only some may pass. Who are *you* to ask questions here?

Nothing in Excess

One day I come across a memo in the archive, drawn from the classified internal network of the Signals Intelligence Directorate. It describes the way analysts can suffer from being drawn into the data, unable to disengage or admit defeat. The author details how mountaineers who wish to summit Everest train for years, becoming obsessed with their goal. But this deep sense of investment also puts them at grave risk: they will push ahead with a dangerous climb despite signs of danger.

Mountaineers call this phenomenon *summit fever*—when an "individual becomes so fixated on reaching the summit that all else fades from consciousness." I think part of this phenomenon is due to the high level of investment (monetary and spiritual) in the project that pushes people to make decisions that are not otherwise supported by objective data:

> I believe that SIGINTers, like the world-class climbers, are not immune to summit fever. It's easy enough to lose sight of the bad weather and push on relentlessly, especially after pouring lots of money, time, and resources into something. From turning off a database or collection site to starting over from scratch on a target set or software code, it's difficult to let go of the dream and your work so far.[10]

There are many symptoms of "summit fever" in the documents. Sometimes it's an offhand remark, as when one analyst jokes about the desire of analysts to collect it all: "Dude! Map all the networks!!!" Other times it's couched in more serious or legalistic terms, in the need to keep acquiring ever more data and greater permissions. One paper in the archive blandly speaks of the NSA's aims to expand all its "capabilities to reach previously inaccessible targets in support of exploitation, cyberdefense and cyberoperations." It is a project with no end. There is no letting go of the dream of perfect information.

This voracious appetite for gathering and connecting information was, in part, enabled and sanctioned by the 9/11 Commission. A key recommendation of the commission's report was to improve "Information Sharing and Fusion": "The president should lead the government-wide effort to bring the major national security institutions into the information revolution. He should coordinate the resolution of the legal, policy, and technical issues across agencies to create a 'trusted information network.'"[11] But as I've written elsewhere, as the scale of the intelligence network multiplied, so did the anxiety over missing crucial data or not seeing the right connections.[12] It became a cultural imperative that "more data is better," even as analysts were drowning in information. "We in the agency are at risk of a similar, collective paralysis in the face of a dizzying array of choices every single day," an NSA analyst wrote in a memo in 2011:

> "Analysis paralysis" isn't only a cute rhyme. It's the term for what happens when you spend so much time analyzing a situation that you ultimately stymie any outcome. . . . It's what happens in SIGINT when we have access to endless possibilities, but we struggle to prioritize, narrow, and exploit the best ones.[13]

Just as this phenomenon afflicts intelligence analysts, a related sensation comes with reading the Snowden documents. Although it lacks all the "near real time" search capacity of the systems used by the agencies themselves, the Snowden cache offers the seduction of the archival search, a sensation well known to the investigator, the detective, and the historian. An analyst pores over the data to track a person of interest, but a reader of the Snowden archive shapes search queries in order to piece together a *practice*: how do these surveillance programs work, what technological capacities are in play, what are the broader legal, cultural, political ramifications? It is about tracking a system instead of catching a suspect. If there is a similarity here, it is in the obsessive focus on the data, intently scrutinizing the databases in order to find new meanings and connections and losing a sense of boundaries.

Hence the susceptibility to excess. There are, of course, endless connections and interpretations to be made in any massive archive of data,

and the Snowden database is a particularly significant one. What ana-
lysts call summit fever, philosophers have described as *archive fever*: "It
is to burn with a passion," Jacques Derrida writes. "It is never to rest,
interminably, from searching for the right archive even as it slips away.
It is to run after the archive, even if there's too much of it."[14]

The fantasy is that, if only you look long enough, you will find the
truth. If you only had more time, you could find the single document
that illuminates the whole collection. But archives are tricky beasts.
Derrida argued that the archive produces as much as it records his-
tory: the way information is stored, accessed, and transmitted shapes
the nature of the knowledge it offers. In other words, our understand-
ing of the NSA is being shaped by the type of access Snowden had as
a contractor, by the search interface on top of the database through
which journalists and researchers access it, and by the ways newspapers
report it. The design limitations of PowerPoint and HTML affect it,
too. For example, one frustration of researching the Snowden archive is
that the copies of internal webpages are riddled with broken links and
inaccessible images. The data encoded in these interconnections is visi-
bly absent. The particularities of hyperlinks and networked documents
mean that they don't travel well, in contrast to the self-contained PDFs
and training manuals, which work perfectly. As a result, the data they
contain becomes the preferred raw material of history. The disparity
between these data formats also serves as a reminder of the immense
technical imbalance between the capacities of the agencies and the sys-
tem containing the Snowden archive.

It's tempting to fetishize archives as providing an unfiltered access
to a past reality. But as the historian Dominick LaCapra observes, it's
a trap to mistake the archive as a "literal substitute for the 'reality' of
the past . . . a stand-in for the past that brings the mystified experience
of the thing itself."[15] More realistically, the archive can only ever be
a very particular type of reconstruction, a keyhole view. It is not a
window into the truth of things. Like the Oracle, it gives us coded
answers, told through a technology that changes the very meaning of
what is being transmitted.

This is not to say that the Snowden archive is anything less than an
extraordinary account of the expansion of Western surveillance in the
late twentieth and early twenty-first centuries. But we can only approach

it through these attenuated channels: the Boolean search query, the unstructured data file, the document type.

Even so, can we ever truly understand it? Everything in the documents is in some form of code. There are many thousands of code names for programs, for technical capacities, for NSA partner organizations. Beyond this, there are the professional codes of tradecraft, hidden in plain language but indecipherable to people not in the business. We can guess what is being hinted at, but spies have their own forms of speech—they know when a document is full of bluster and overreach or when something is being chillingly understated.

A Pledge, and Ruin Is Near

Just as the imperatives of Know Thyself and Nothing in Excess seem foreign in the context of the NSA and GCHQ, so does the final Delphic maxim: A Pledge, and Ruin Is Near. Translations of this phrase vary, but it means something like "When you consult the gods, do not make vows and commitments that you cannot honor."[16] The Greeks used this as a warning against making promises that would come back to haunt you.

Intelligence analysts who use these extraordinary systems of data harvesting and tracking are bound to follow the law as well as specific policies that are meant to restrict their access. Of course, it doesn't always work that way: analysts have been caught tracking ex-wives and potential love interests (agents call it LOVEINT), or they make errors that result in the wrong people or countries having their data harvested.[17] But even with some safeguards in place, the ruin may be inevitable. Law professor Paul Ohm has described the emergence of a "database of ruin" in the private sector as companies gather potentially devastating information about medical conditions and family histories and then combine their data stores. "Once we have created this database," he writes, "it is unlikely we will ever be able to tear it apart."[18] The NSA has built its own database of ruin, one that contains all those phone records, search histories, Skype calls, location data, network connections, chat logs. These are the phantom bodies of data that stand in for us.

When the first stories from the Snowden archive appeared in newspapers in mid-2013, intelligence agencies experienced a new kind of public scrutiny and pressure. Years later, the most substantial legal

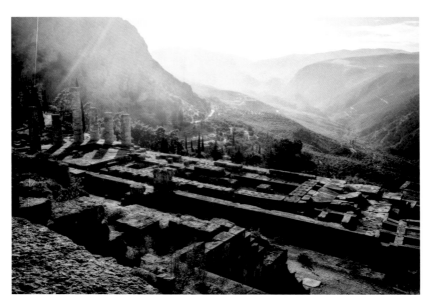

Ruins of the Temple of Apollo, Delphi

reform has come through the USA Freedom Act, which ended the bulk collection of Americans' phone metadata records, although it leaves much internet data collection untouched. That gigantic data set will become a decaying monument to the period before Snowden, a ruin from an earlier time, as analysts come to rely on different tools. The Snowden database will also erode as a gauge of the technical capabilities of the NSA and GCHQ. But its power as a cultural, political, and historical archive will remain for as long as we ask questions of it.

When the 9/11 Commission recommended a new era of information sharing, it described the need to "simultaneously empower and constrain officials, telling them clearly what is and is not permitted," because "the policy and legal issues are harder than the technical ones."[19] They remain the hardest problems. The Temple at Delphi is a ruin, but the precepts of restraint have endured as long as any of the Oracle's prophecies. The lasting cautions for the era of global surveillance are still being learned.

NOTES

Where possible, I have provided references to published texts using documents from the Snowden archive, or containing similar information.

1. Peter Galison, "Removing Knowledge," *Critical Inquiry* 31, no. 1 (2004), p. 229.
2. Hugh Bowden, *Classical Athens and the Delphic Oracle: Divination and Democracy* (Cambridge: Cambridge University Press, 2005), pp. 6–9.
3. Julia Angwin, Charlie Savage, Jeff Larson, Henrik Moltke, Laura Poitras, and James Risen, "AT&T Helped U.S. Spy on Internet on a Vast Scale," *New York Times*, August 15, 2015, http://www.nytimes.com/2015/08/16/us/politics/att-helped-nsa-spy-on-an-array-of-internet-traffic.html; and Jeff Larson and Julia Angwin, Henrik Moltke and Laura Poitras, "A Trail of Evidence Leading to AT&T's Partnership with the NSA," ProPublica.org, August 15, 2015, https://www.propublica.org/article/a-trail-of-evidence-leading-to-atts-partnership-with-the-nsa.
4. *Plutarch's Lives*, trans. Bernadotte Perrin (Cambridge, Mass.: Harvard University Press, 1916), p. 317.
5. Michel Foucault, *The Hermeneutics of the Subject: Lectures at the Collège de France, vol. 6, 1981–1982*, ed. Frédéric Gros, trans. Graham Burchell (New York: Palgrave Macmillan, 2005), p. 4.
6. On Treasure Map, see James Risen and Laura Poitras, "N.S.A. Report Outlined Goals for More Power," *New York Times*, November 22, 2013, http://www.nytimes.com/2013/11/23/us/politics/nsa-report-outlined-goals-for-more-power.html; and Andy Müller-Maguhn, Laura Poitras, Marcel Rosenbach, Michael Sontheimer, and Christian Grothoff, "Treasure Map: The NSA Breach of Telekom and Other German Firms," *Der Spiegel*, September 14, 2014, http://www.spiegel.de/international/world/snowden-documents-indicate-nsa-has-breached-deutsche-telekom-a-991503.html.
7. Quoted in Risen and Poitras, "N.S.A. Report Outlined Goals for More Power."
8. Bruce Schneier, "Attacking Tor: How the NSA Targets Users' Online Anonymity," *The Guardian*, October 4, 2013, http://www.theguardian.com/world/2013/oct/04/tor-attacks-nsa-users-online-anonymity; source document available at: https://theintercept.com/document/2014/03/12/nsa-phishing-tactics-man-middle-attacks.
9. Quoted in Risen and Poitras, "N.S.A. Report Outlined Goals for More Power."
10. The full document was made available by Peter Maass on Documentcloud: "'Signal v. Noise' Column: Summit Fever," documentcloud.org/documents/2088979-summit-fever.html. It served as a source for his article "Inside NSA, Officials Privately Criticize 'Collect It All' Surveillance," *The Intercept*, May 28, 2015, https://theintercept.com/2015/05/28/nsa-officials-privately-criticize-collect-it-all-surveillance.
11. Government Accountability Office, *Summary of Recommendations—The 9/11 Commission Report*, doc. no. B-303692, September 9, 2004 (Washington, D.C.), p. 33, http://www.gao.gov/decisions/other/303692.pdf; and *The 9/11 Commission Report: Final Report of the National Commission on Terrorist Attacks upon the United States* (Washington, D.C.: United States Government Printing Office, 2004), p. 418, http://www.9-11commission.gov/report/911Report.pdf.
12. Kate Crawford, "The Anxieties of Big Data," *The New Inquiry*, May 30, 2014, http://thenewinquiry.com/essays/the-anxieties-of-big-data.
13. Quoted in Maass, "Inside NSA, Officials Privately Criticize 'Collect It All' Surveillance."
14. Jacques Derrida, *Archive Fever: A Freudian Impression* (Chicago: University of Chicago Press, 1996), p. 91.
15. Dominick LaCapra, *Rethinking Intellectual History: Texts, Contexts, Language* (Ithaca, N.Y.: Cornell University Press, 1983), p. 344.
16. Foucault, *Hermeneutics of the Subject*.
17. Andrea Peterson, "LOVEINT: When the NSA Officers Use Their Spying Power on Love Interests," *Washington Post*, August 24, 2013, https://www.washingtonpost.com/blogs/the-switch/wp/2013/08/24/loveint-when-nsa-officers-use-their-spying-power-on-love-interests.
18. Paul Ohm, "Don't Build a Database of Ruin," *Harvard Business Review*, August 23, 2012, https://hbr.org/2012/08/dont-build-a-database-of-ruin.
19. *The 9/11 Commission Report*, p. 419.

LETTER TO A YOUNG SELECTOR

Jacob Appelbaum

WHEN I WAS A CHILD, my father would tell me stories of the horrors of the twentieth century. He would say that when the next Holocaust happened, it would be my fault for not stopping it. I want to burden you with his guilt and I hope that you will carry it forward with you. You have a great responsibility and it is unfair. You are smarter than most and you understand your responsibility to others, to history, and to yourself. This is not an easy lot; it is if anything unbearable in the long term. You will be alone in most of your life for even considering that you should work to improve the lives of everyone on this planet and on others.

Your generation is the first to be raised in an environment of total surveillance. But surveillance has not yet become total for everyone everywhere and if we work together you might still create another outcome. Much of this work will fall on you and your friends alone. I won't always be there to help, if I'm there at all. It is your generation who will decide if this is to be the fate of the rest of us, those alive now and those yet to be born. Yours is the first to be reduced to numbers at every stage, every data trail set to haunt you for all time; yours is the first to be reduced to selectors. How will this change you? Will it harden you? Will you accept this as the only reality possible?

Over the last forty years, a revolution has swept the planet. It happened quietly and those who noticed were ridiculed at best. It is a revolution where nearly all of our data is devoured in an automated fashion— machine to machine, person to person, voice, text. Communications, movements, all of life is consumed, quantified, searched, and catalogued. First every international telephone call, now every call. First so-called legitimate targets, now nearly every action performed over the internet by anyone or anything. The new surveillance systems were so secret that programs were developed and deployed to discredit those speaking about them. For discussing the mere existence of groups working on them journalists were arrested and jailed.

A culture of impunity shrouds those in control of the systems of control. Everyone else is guilty and subject to monitoring, to be punished for transgressions at a later time. There is always the data to construct any narrative, always evidence with which to harass, prosecute, or persecute. This data is washed and passed along, legally and illegally all the same. This process is called parallel construction and when you are effective and unlucky, you will feel this tactic impact your life.

Commonly we see pictures of well-known and popular whistleblowers and journalists presented as revolutionaries. But this is a mistake. They are not revolutionaries. They are the counterrevolution against a corporate body of surveillance and against surveillance states.

* * *

In war, surveillance is obvious. Watching an enemy seems as natural as the coming of winter. But even in "peacetime," surveillance is never a matter of peace. Proponents of surveillance often paint a picture of terrorism versus surveillance, when in reality surveillance is used in service of nonconsensual control of all kinds, including extreme acts of terror. It is used to more effectively extract economic value, to squelch dissent, to undermine, and to harm with the information gathered. Those who wield power over surveillance systems will use them to more effectively target, censor, murder, and wage war. Surveillance is violence and it makes other kinds of violence more likely.

I'm not writing to convince or to explain the relevance of surveillance in its various instantiations. Those who do not understand the power of surveillance and dismiss its relevance will operate within the bounds of those listening, watching, and ultimately controlling.

And yet surveillance itself must not be the sole issue of your generation, as it is used to enforce the policies of other generations over so much. Issues of equality of all kinds—economic, social, political, genetic. When you explain this reality to others you may be dismissed as paranoid or told not to worry and instead focus on the issue at hand. There are people who wish only to think about their own issues, about their own concerns; but it is a mistake to consider only one issue without understanding the larger context. Try to expose the coordinative strategies of those in control or those aiming to control. Disclose the specific tactical relation between a given issue and the issue of surveillance. You will empower others through these actions. Don't just kick over the bucket of water; expose the plumbing and replace it.

Those perpetuating injustices will use surveillance to harm, as they have historically, all who wish to displace their oppression. The voices who tell you to think only about the issues directly at hand are the voices of people who will harm you by accident or on purpose. Their

simple-minded thinking is not strategic and to listen to them will ensure your failure. There are people who will pretend that they have nothing to hide and this again presupposes that the systems at play are just and that innocence matters.

* * *

Resistance in an age of mass surveillance requires the ability to see as surveillance states do. It requires understanding different methods of surveillance, from the intimately physical to the abstract and electronic. It requires that we consider all possibilities even if they seem remote, to understand the realms of what is possible and of what may be unlikely. It is up to us to understand these systems and to ensure that we work together in solidarity to build new infrastructures that encode the liberties that we hold dearly. Things seen as possible by some will be considered as inevitable but this is a lie: there is no inevitable system.

But you must understand: ours is a world of control and not a world of liberty. There is no wanting for those who wish to be your master and their failure begins with your refusal to bow your head. The state of the world is at odds with your refusal. Everything is uniquely identifiable. Your voice is unique. Your typing is unique. The websites you visit and the systems you use to interface with the world are unique. The pattern of travel you take through the city, the consumption of electrical power tied to your daily routines: those paying attention to you as an element of a larger picture and to you specifically will try to predict everything from the patterns of data you leave behind.

It is these predictions that create avenues for control and it is in this predictability that you may find avenues for resistance. To evade mass surveillance requires entropy, in the technical sense. From encrypting messages to the randomized paths you select as you route through anonymity networks, and in everything between, entropy is essential.

Fundamentally, almost all groups that have engaged in resistance would have been discovered and crushed if they had operated in a climate of mass surveillance. It is essential therefore to read and adapt lessons from their histories to the adversarial realities of your era. If you look to the twentieth century, you will find many strong examples.

Look to the leaders but also to the rank and file who carry out actions. Understand their contexts and their struggles. Imagine how you might prevent their successes and slowly it will become obvious how those operating systems of mass surveillance are already targeting your efforts.

* * *

It is through the internet that you may build systems for resistance. Almost all systems of communication deployed before the internet are intentionally vulnerable to traffic analysis and to content inspection. A near-total ban on encryption for radio-related communication, backdoors in telephone systems in critical areas, even payment systems based on cash are designed to be tracked, correlated, and monitored. Systems that resist surveillance are demonized, banned, or otherwise smeared when they manage to persist.

The internet is different. It provides a system for communication that allows the creation and deployment of many other systems of communication; it changes the economics drastically in your favor while conversely systematizing all communications into a machine-processable paradigm. It is in this abstraction that you will find room for movement and if you do well we'll hold that space.

Remember however that human organization is not only still relevant, it is necessary. Communications will change the direction and function of groups, it may make them more efficient, it will help them carry out tasks that are otherwise impossible and coordinate in ways that might otherwise be impossible.

Those in control of surveillance systems have not stopped with the acquisition of information; they also excel at its processing and understanding, with each aspect of their system imperfect and rarely so in the favor of those being controlled. Compartmentalization is therefore a result of the world that we find ourselves living in. But it too is a tactic for resistance. It is essential to compartmentalize your activities, as mass surveillance acts as a kind of time machine. The mistakes you make today, the experiments you carry out tomorrow, they will live with your data doppelgänger for all time. They become more you than you. Your data trail will become the real story of your life. More than your actual mind, which you will no longer be free

to change; more than your actual self, your data becomes you and decides your fate.

Only in our ephemerality are we free and only in that freedom will we be at liberty. Your task is to create that ephemerality for everyone, without exception, and to make that space as large as is possible. A world without gods or masters!

* * *

I implore you to support the systems we've been building for you. Do not take them for granted; ensure their survival. Use strong cryptography for your messages and make selector-based surveillance economically infeasible. Do not trust the postal system as it is subject to extreme monitoring, interdiction, and disruption. Be the infrastructure that you need for improving the world by working with people you trust and building trust through deep friendships. Understand the limits of these relationships and never betray your peers. Rise above the petty and work to empower every single person on the planet.

The rewards for your efforts will not always seem just. If identified, you will be searched, harassed, driven mad, interrogated, exiled, jailed, harmed in unspeakable manners, and if you're the Other you can expect to be killed. It is thus essential not to be identified. There are no good guys. Compartmentalize your activities and share your successes widely.

It is also essential to understand that such results are inevitable and not to be dismayed. A great revolutionary was once confronted by an old man. "I will not live to see the end of the struggle," he said. "May I not take some hours of leisure now?" All or nothing is of no use to people who won't be around when the all happens. Find peace in knowing that there is no winning, only a means that will be experienced as an end for some.

It is your generation that will make up for my generation's failures. You will pay dearly for your efforts. This should not deter you. Do not go it alone except in that which must be done alone, build networks and conspire together. You're not a national-security threat; you're a post-national-security promise.

You'll be dead forever, make it count.

MEDYA: AUTONOMY OF IMAGES

Hito Steyerl

DES9N7bxs0mHupY4JsjDg6fZ7vaFIZaWDBASiCj6vN+SVYuCa9BO5LdJHmeo+kpmK2PTv1ShVkx
p0wt59hGX6sdITapaRgEGCB8FZt3iSkE9EdmShv5vmSv3oMrCoSF1qnLeGY9Wh6hNCNx4nUfxtzjo
Exo494fUr+hZeb jFTO5Owoy22fW8fuwieImOEm7y28eFSmN5ITVpjzDabYQBjYPgRpLStGjRMcsilx
GH6Ud3nweSyqjimsCs6f204JuoIfPTSVAP9hiab9VKmyBM3Wb0VwAi+wLjoS6k1FcAcyjQo8HUM
3vGALSnPn7wwnD5YNKRdXPVpQ8tq+stidQzFdESSzajS7rPC81pzrIjW3tX0krDmuspmEzfTEH0s
FRq9eq3k0Jr+CXXS0hjXuSSPVNH1rt8JIDUts529LqAb5pPfYta1L4bD5LK3hNywWOCTsExgg
5jkR64bo0RUB4eY1VQWNSHEvTtTz++mI+rYsZjIs1yhEf6fGAMQPDyq0OXrhjFZEx1mBprRDPAH
bA4R0L381HdpJTDIt3DaWuhsTKWzaAMwMLlloiiIP8j7gEZXAwdSaJy+wc4a4iFZB7bCGB5ndwCS3hOB
NFq7kESbW+5wiBU7w6nEiNLYanDUoFWODR1IBaEAOX2vdbhIPXfVsgWmgDGwZByozb1TQJJqYa
QCOU7kO+QffkqRxs043RN2BnboNsFFCGDPgV5hkJMDXYhagrpqwLoqs6ApQUT2L2PTma0Q6xKmS
juymnbE76xnYYN85Bp9oLyirFbg6zRWcpfUdMQssH7j1hK1iAuYkY96TI6i1tGoK1sT8hyZmUz7mz
7PWzesas7iEHpkB317a7zaS3sNANofRI7AMXbOoAUo5951iM1WMjFuuKUte1KU4Xp8WpVmvSSGzLZ
jr6PKgo6ZWGhLw2ZkHbWIPVogK1imYoWDZID+Zm4wYwDKoiC5zHgDswmpnOR5e9x7vh9o33LwV+1
9Lo0kYoD4HN8vsJjVM3wSaMVTCKsk54wy+X2wEVBEOrN9oDMVNCTh1WKS9BYmu1K+q6uLiL3RiDMAXX
wQQ7WTcKnBprMQ9nzuPB9EzRwryZ5boXyzHjUIoA8NmC6UgV5ZUTKPa8Ln4FMeh7W295Un7JbPTx
CQq5y3JZ+T4YbiWEBYidFSxSVAF3xCH3d7cfPAJezKcjTTRzadz1mrC5FkbMwDu5Hr41itAkMrx
HE60HqtB1DW2RbujRKcAFOhk3vnmFU1o16y1rc+WXCyZszCAxcPRaW3bjCwAu79nSQGbZO1e6AHyL
sudUNZIG3b08ZMacovJC+Kq40p0A5u2wD37VbWPSyYpBi3pBagm0yKdjp+Hwy@bXPhN5ReeG2uMqNoS
bCZg2My7Cj44HESljrWrfGx+1+bu9BQ5EIPMeU9neHHjndCIgVa8UAQ07tPXHYwsOb+RDrOVJ9d+
VdKFIBhPkxxCc2b8MSLH6ig8CkLGg0IOtTgy1n0UFaOHHpBboWjPiTORSs9VQs2qN97BDOOjAOf
bV521r1MTPcSqhgETkRY15cKRdNROiXjiBjB6o8DZCKWBU1V9FhSXejbdmwuHNjNpiGzPZ2BKI1g
jBO6aKk1zHY1MQzptxxDpwmzQTZookQdt1Usv1G6z5oZcmNmW1qVSShhhfnPHm8Ys0PX1+Y5EFB
poG2XHTmO0upRgwJesYXBOHmGbFRBvyW1EKcyoHFXpvVU2R3WrJ8ZJ4eqYZ5vWkzFPbKBsFtZYb
ZkVIgq@zHMEqODHzxXCFiaLTxIsJm+ybDJ7SyTxEKtjLmCuVV9YS9GABU4g9SpPP+JYfzDYMD2B
DzgVOhROYLQbRMkZ+8FFFS7+pZzHi35ANYwIUOo7EMQDNPferaloW9bp6RD7AjAFgGIjENEYjG9W
z9dvLlftYLGK14f30Pnwkxk6xcSvL40z5b61P2ADe4TWMtsgtBhk3KACrxVetqgaMk183NTkOxI
OJaLq2bz8jPROFSVXpAd@YmYKOLLc5Uft8JJ+aS1DWRxo37quJFeRYBZ4MbHg+Nukxw1nNENZCsI
hLDN+DGHmrE8nhG1xP+t+tBHf7C2hF5fgxGk9g@5w0OXJF4njUB@1R1EXAa1EFhkkSnEwuIGOkeC

Fig. 1. A pillar at Göbekli Tepe, Turkey, showing a vulture, a crane, and a man without a head

IN A WORK called *Auge/Maschine* (Eye/Machine, 2002), Harun Farocki coined the term "suicide camera." *Auge/Maschine* shows cameras mounted to the tips of missiles during the first Gulf War. The camera would broadcast live until it exploded.

But contrary to all expectations, the camera was not destroyed in this operation. Instead it burst into billions of small cameras, tiny lenses embedded into cellphones. The camera from the missile exploded into shards that penetrated people's lives, feelings, and identities, skimming their ideas and payments.

The camera on the missile tip was supposed to identify and track objects. But as it self-destructed, it multiplied. It is now not only identifying and tracking objects, but the devices embedded into them, their owners, their motions and emotions, as well as most of their actions and communications. If the cameras in the tips of the missiles were suicide cameras, the ones in cellphones are zombie cameras, cameras that failed to die.

But what if not only the cameras exploded but also the images they produced? What if this created a situation in which images were broken to the point of being unintelligible?

This image to the left apparently shows a vulture flying above a headless person (fig. 1). At least this is what archeologists claim. It is difficult to figure out just from looking at it. You can't really see what they are talking about. It looks like a radioactive chicken. And the strange shape below is supposed to be the guy without a head.

I wanted to see this relief in person, on a pillar dating back 12,000 years. So I went to the Göbekli Tepe complex near Urfa, Turkey, the oldest known ritual structure in the world. It looks somewhat like Stonehenge, only it's 6,500 years older, and instead of one massive stone-pillar circle there are around twenty, most of them unexcavated. Many of the pillars bear exquisite carvings of scary animals.

But it turned out that the relief I was looking for is not visible on site. One can only see the pillar's back side; the relief itself is hidden. The only way I could see it was on a cellphone. One has to go online and Google it. Of course you can do that almost everywhere. In so-called reality, however, it is not accessible.

But it was not only me who watched the image. My cellphone was also watching me, my location, and my activities.

In January 2015, the rumble from the battle of Kobanî in northern Syria could be heard at Göbekli Tepe. In October 2014, the city had come under massive attack by Daesh (or ISIS) and was expected to fall any day. Hundreds of bystanders were watching from the Turkish side of the border, trying to catch a glimpse of the fighting raging on several fronts around and inside the city. Countless eyes were observing the events with military-grade binoculars and all sorts of cameras.

But even though there was a multitude of eyewitnesses to the battle of Kobanî, what did they see? Or rather, what did I see?

On the border with Syria, onlookers were using my camera viewfinder to try to identify Daesh positions (fig. 2). They claimed to see ISIS cars moving in the distance. But to be honest, I couldn't recognize a thing.

I saw smoke, clouds, houses. Maybe cars, or maybe just glints of sunlight in the distance. Among the hundreds of bystanders, few knew what they were actually seeing. I certainly didn't. Whatever was visible were less images than shards of images, flying around after huge explosions.

The term *theater of war*, as defined by Carl von Clausewitz:

> Such a portion of the space over which war prevails as has its boundaries protected, and thus possesses a kind of independence. This protection may consist in fortresses, or important natural obstacles presented by the country, or even in its being separated by a considerable distance from the rest of the space embraced in the war. Such a portion is not a mere piece of the whole, but a small whole complete in itself.[1]

The term *theater* also refers to a staging of military action. The hills around Kobanî for a while turned very literally into a theater: a drive-in cinema for tanks and other bystanders.

We saw flying objects, clouds of smoke, flashes of light. On cellphones, one could also see headless people in Daesh videos.

All this was just as incomprehensible as the relief on the Göbekli Tepe pillar (fig. 3).

The vulture hovering over the decapitated person. I saw it on my mobile phone. In fact you all can see it on yours, too. Just Google "Göbekli Tepe" and "vulture pillar"; it will come up. You will see that

TORSs9VQs2qN97BDDDjA0fbV521r1MTPcSqhgETkRY15cKRdNRDiXjiBjB6o8DZCKWBU1V9FhSXejbd
mwuHNjNpiGzPZ2BKI1gjB06aKk1zHY1MQzptxxDpwmzQTZookQdt1Usv1Gbz5oZcmNmWlqVSShhhfn
PHm8YsDPX1+Y5EFBpoG2XHTmD0upRgwJesYXBDHmGbFRBvyW1EKcyoHFXpvVU2R3WrJ8ZJ4eqYZ5vWkzF
PbKBsFtZYbZkVIgqQzHMEqDDHzxXCFiaLTxIsJm+ybDJ7SyTxEKtjLmCuVV9YS9GABU4g9SpPP+JY
fzDYMD2BDzgVDhRDYLQbRMkZ+8FFFS7+pZzHi35ANYwIUDo7EMQDNPferaloW9bpbRD7AjAFgGIjENEYjG9W
z9dvL1ftYLGK14f30PnwkxkbxcSvL40z5bb1P2ADe4TWMtsgtBhk3KACrxVetqgaMk1&3NTk0xIDJaLq2b
z8jPROFSVXpAdQYmYKOLLc5UftBJJ+aS1DWRxo37quJFeRYBZ4MbHg+Nukxw1nNENZCsIhLDN+DGHmr
E8nhG1xP+t+tBHf7C2hF5fgxGk9gQ5w0DXJF4njUBQ1R1EXAa1EFhkkSnEwuIG0keCT101Q55oRa50gjn
siY4RsKuAaU1EnZN4zsVgMYy5K9Wm2KfIobopiseHID1npCSHEvTtTz++mI+rYsZjIslyhEfbfGAMQP
DyqDDXrhjFZEx1mBprRDPAHbA4R0L381HdpJTDIt3DaWuhsTKWzaAMwML11oiiIP8j7gEZXAwdSaJy+w
c4a4iFZB7bCGB5ndwCS3hDBNFq7kESbW+5wiBU7wbnEiNLYanDUoFWDDR1IBaEADX2vdbhIPXfVsgWmgDGw
ZByozb1TQJJqYaQC0U7kD+QffkqRxs043RN2BnboNsFFCGDPgV5hkJMDXYhagrpqwLoqs6ApQUT2L2PT
ma0Q6xKmSjuymnbE7bxnYYN85Bp9oLyirFbgbzRWcpfUdMQssH7j1hK1iAuYkY9bTIbi1tGoK1sT8hyZmUz
7mz7PWzesas7iEHpkB317a7zaS3sNANofRI7AMXbDoAUo5951iM1WMjFuuKUte1KU4Xp8WxypzVmvSS
GzLZjrbPKgobZWGhLwQ2ZkHbWIPVogK1imYoWDZID+Zm4wYwDKoiC5zHgDswmpnDR5e9x7vh9o33LwV+1
9LoQkYoD4HN8vsJjVM3wSaMVTCKsk54wiy+X2wEVBEDrN9oDMVNCTh1WKS9BYmu1K+qbugLiL3RiDMAXX
wQQ7WTcKnBpnrMQ9nzuPB9EzRwryZ5boXyzHjUIoA8NmCbUgV5ZUTKPa8Ln4FMeh7W295Unzu7JbPTxCQq5y
3JZ+T4YbiWEBYidFSxSVAF3xCH3d7cfPAJezKcjTTRzadz1mrC5FkbMwDu5Hr41itAkMrxHEbOHqtB1DW2R
bujRKcAFDhk3vnmFU1o16y1rc+WXCyZszZcAxcPRaW3bjCwAu79nSQGbZ01ebAHyLsudUNZIG3b08ZMac0v
JC+Kq40p0A5u2wD37VbWPSyYpBi3pBagm0yKdjp+HwyQbXPhN5ReeG2uMqNoSbCZg2My7Cj44HES1jrWrf
Gx+1+bu9BQ5EIPMeU9neHHjndCIgVa8UAQ07tPXHYwsDb+RDrDVJ9d+VdKFIBhPkxxCc2b8MSLHbig8CkLG
g0IDtTgy1nDUFaDHHpBboWjPiG4j2MN4+TrjLK+RuCJP4Pgirx9v1CtZUCR0EuqjN5wIibWKovDCoemr22r
M6UD0gdbZEpFyX1Dwi0Y2EmduDDcchVBpvbh7JKMDobvNqSP50kxTm4DdTGsZoobavKiWZgbCjrEArttJFmU
0LCzxguuFHyzDvpch1DVDES9N7bxs0mHupY4JsjDgbfZ7vaFIZaWDBASiCjbvN+SVYuCa9B05LdJHmeo+kp
mK2PTv1ShVkxp0wt59hGXbsdITapaRgEGCB8FZt3iSkE9EdmShv5vmSv3oMrCoSF1qnLeGY9WhbhNCNx
4nUfxtzjoExo494fUr+hZebjFT050woy22fW8fuwieImDEm7y28eFSmN5ITVpjzDabYQBjYPgRpLStGjRMc
si1xGHbUd3nweSyqjimsCsbf20L4JuoIfPTSVAP9hiab9VKmyBM3Wb0VwAi+wLjoS5k1FcAcyjQo8HUM3v
GALSnPn7w+wnD5YNKRdXPVpQ8tq+stidQzFdESSzajS7rPC81pzrIjW3tX0krDmuspmEzfTEH0sFRq9eq3k0
Jr+CXXS0hjXuSSPVNH1rt8JIDUts529LqAb5pPfYta1L4bD5LK3hNywWDCTsExgg5jkRb4boORUB4eY1VQWN

Fig. 2. Image captured by my camera as its viewfinder was being used by onlookers to locate ISIS positions in Kobanî, Syria, October 8, 2014

DES9N7bxsOmHupY4JsjDg6fZ7vaFIZaWDBASiCj6vN+SVYuCa9BO5LdJHmeo+kpmK2PTv1ShVkxpOwt59h
GX6sdITapaRgEGCB8FZt3iSkE9EdmShv5vmSv3oMrCoSF1qnLeGY9WhbhNCNx4nUfxtzjoExo494fUr+h
ZebjFTO5Owoy22fW8fuwieImOEm7y28eFSmN5ITVpjzDabYQBjYPgRpLStGjRMcsilxGHbUd3nweSy
qjimsCs6f2OL4JuoIfPTSVAP9hiab9VKmyBM3Wb0VwAi+wLjoS6k1FcAcyjQo8HUM3vGALSnPn7w+wn
D5YNKRdXPVpQ8tq+stidQzFdESSzajS7rPC81pzrIjW3tX0krDmuspmEzfTEH0sFRq9eq3k0Jr+CXX
SOhjXuSSPVNH1rt8JIDUts529LqAb5pPfYta1L4bD5LK3hNywW0CTsExgg5jkR64boORUB4eY1VQWN
SHEvTtTz++mI+rYsZjIslyhEfbfGAMQPDyqOOXrhjFZEx1mBprRDPAHbA4ROL381HdpJTDIt3DaWuhsTKW
zaAMwML11oiiIP8j7gEZXAwdSaJy+wc4a4iFZB7bCGB5ndwCS3hOBNFq7kESbW+5wiBU7w6nEiNLYanDUoF
WODRlIBaEADX2vdbhIPXfVsgWmgDGwZByozb1TQJJqYaQC0U7kO+QffkqRxs043RN2BnboNsFFCGDPgV5hk
JMDXYhagrpqwLoqs6ApQUT2L2PTmaOQ6xKmSjuymnbE76xnYYN85Bp9oLyirFbg6zRWcpfUdMQssH7j1hK1i
AuYkY96TI6iltGoK1sT8hyZmUz7mz7PWzesas7iEHpkB317a7zaS3sNANofRI7AMXbDoAUo5951iM1WMjFuu
KUte1KU4Xp8WpVmvSSGzLZjr6PKgo6ZWGhLwQ2ZkHbWIPVogKlimYoWDZID+Zm4wYwDKoiC5zHgDsTwmp
nOR5e9x7vh9o33LwV+19LoQkYoD4HN8vsJjVM3wSaVTCKsk54wiy+X2wEVBEOrN9oDMVNCTh1WKS9BY
mulK+q6ugLiL3RiDMAXXwQQ7WTcKnBpnrMQ9nzuPB9EzRwryZ5boXyzHjUIoA8NmC6UgV5ZUTKPa8Ln
4FMeh7W295Unzu7JbPTxCQq5y3JZ+T4YbiWEBYidFSxSVAF3xCH3d7cfPAJezKcjTTRzadz1mrC5FkbM
wDu5Hr41itAkMrxHE6OHqtB1DW2RbujRKcAFOhk3vnmFU1o16y1rc+WXCyZszZcAxcPRaW3bjCwAu79nSQG
bZO1e6AHyLsudUNZIG3b08ZMacOvJC+Kq4Op0A5u2wD37VbWPSyYpBi3pBagm0yKdjp+Hwy@bXPhN5Ree
G2uMqNoSbCZg2My7Cj44HES1jrWrfGx+1+bu9BQ5EIPMeU9neHHjndCIgVa8UAQ07tPXHYwsOb+RDrOVJ
9d+VKFIBhPkxxCc2b8MSLH6ig8CkLGg0IOtTgy1nOUFaOHHpBboWjPiTORSs9VQs2qN97BDOOjA0fbV521
r1MTPcSqhgETkRY15cKRdNROiXjiBjB6o8DZCKWBU1V9FhSXej6dmwuHNjNpiGzPZ2BKI1gjBO6aKk1zHY1
MQzptxxDpwmzQTZookQdt1Usv1Gbz5oZcmNmW1qVSShhhfnPHm8Ys0PX1+Y5EFBpoG2XHTmO0upRgwJesYX
BOHmGbFRBvyW1EKcyoHFXpvVU2R3WrJ8ZJ4eqYZ5vWkzFPbKBsFtZYbZkVIgqQzHMEqODHzxXCFiaLTxIs
Jm+ybDJ7SyTxEKtjLmCuVV9YS9GABU4g9SpPP+JYfzDYMD2BDzgVOhROYLQbRMkZ+8FFFS7+pZzHi35ANY
wIUDo7EMQDNPferaloW9bp6RD7AjAFgGIjENEYjG9Wz9dvL1ftYLGK14f30Pnwkxk6xcSvL40z5b61P2AD
e4TWMtsgtBhk3KACrxVetqgaMk183NTkOxIDJaLq2bz8jPROFSVXpAd@YmYKOLLc5Uft8JJ+aS1DWRxo37qu
JFeRYBZ4MbHg+Nukxw1nNENZCsIhLDN+DGHmrE8nhG1xP+t+tBHf7C2hF5fgxGk9gQ5wODXJF4njUBQ1R1
EXAa1EFhkkSnEwuIG0keCT101Q55oRa50gjnsiY4RsKuAaU1EnZN4zsVgMYy5K9Wm2KfIobopiseHIO1npCG
4j2MN4+TrjLK+RuCJP4Pgirx9v1CtZUCROEuqjN5wIibWKovOCoemr22rM6UOOgdZEpFyX1Owi0Y2EmduDDc

Fig. 3. A pillar at Göbekli Tepe, Turkey, showing a vulture, a crane, and a man without a head

someone added red lines to the guy without a head, maybe in order to make the shape more visible.

This is how machines "understand" images, too. They project lines and boxes onto photographs to track and analyze objects.[2]

By adding lines and boxes to images, machines allegedly become more autonomous. This especially goes for recent weapons systems that are called autonomous to convey the idea that they are becoming gradually more independent of human supervision and control.[3]

But images are not decoded by machines just to prove their intelligence. They are used as models to trigger actions and to create reality. Just as humans used plans and maps to change the world, so do machines use machine-readable communication to do the same.

Autonomy, however, has several different meanings: The battle of Kobanî itself was a fight for autonomy, not for machines but for humans. Autonomy means something different from the perspective of Kobanî's defenders: it means autonomy from statehood as such. Not only the state of Syria or Turkey but from the state per se. Autonomy is not separatism, not a taking over or occupation of the state, but the creation of parallel structures within existing ones.

The images on the Göbekli Tepe pillars mark an important junction in the process of creating the state. They were produced at the very beginning of statehood. Indeed, some archeologists claim that the production of these images itself created a precursor to statehood, in the Stone Age. Experts used to think that agriculture preceded statehood and organized religion. Göbekli Tepe suggests that it might have been the other way around: Cult created art. Art created the division of labor. Some people had to produce food for others. Agriculture seemed to be a solution. Scientists think that the complex building and carving process brought about social hierarchy to enable the necessary infrastructure. In producing sculptural images of a flying vulture hovering above a human without a head, statelike structures were created, perhaps, as a sort of byproduct. The images on the pillar perhaps became a model for creating a different, and likely more unequal, social reality.

As I said, no one knows what the images on the Göbekli Tepe pillars mean. There are no captions, soundtrack, or explanations. There was no writing and there is no oral history. But we still live within their

consequences: within states, societies marked by private property and class inequality, societies in which everything belongs to someone.

In his work *Riding on a Cloud* (2013), Lebanese artist Rabih Mroué claims that his main protagonist—a character based on his brother Yasser—lost his ability to recognize or understand images after being shot in the head by a sniper. Since he sustained brain damage, images have become meaningless compositions of lines, colors, and materials for him. He cannot recognize anything of images. The sniper's bullet has destroyed his faculty of identification.

Images for machines look different from images for humans. In their purest form, as transmitted data, they are incomprehensible, even imperceptible to humans. They may be coded as pulses of light or magnetic charges or long lines of seemingly random letters.

If we were able to see them, they might have as little meaning for us as any picture might have for a person shot in the head by a sniper, more abstract than even lines and boxes. We are as challenged to see an image made by and for autonomous machines as someone hit by a sniper is challenged to see images made by and for other humans.

Maybe the art history of the twentieth century can be understood as an anticipatory tutorial to help humans decode images made by machines, for machines. Look at this Mondrian painting to the right, for example (fig. 4). The colored grid typical for Mondrian is perhaps an unconscious exercise for humans trying to learn how to see like a machine, for acquiring the posthuman vision that abounds today.

This is posthuman documentary: light and radio waves permeating every space unseen, whole lives transformed into patterns that must be translated to be perceptible to any human. Images that, again, become models to create social reality.

Look at these two guys walking through ruins holding their laptops like divining rods on the next spread (fig. 5). They weren't looking for water but rather for a Turkish cellphone-provider's signal, to send their own signals from the battlefield.

I spoke to them on the day of the city's liberation. They were journalists for a Kurdish news agency who had spent a couple of weeks inside the besieged city. Some evenings they tried to crawl out of the city underneath the barbed wire but were shot at by Turkish border guards. So they returned to the ruins, looking for a signal to file their stories. But this was

XejbdmwuHNjNpiGzPZ2BKIlgjB0baKklzHYlM@zptxxDpwmz@TZook@dtlUsvlG6z5oZcmNmWlqVSSh
hhfnPHm8Ys0PX1+Y5EFBpoG2XHTm00upRgwJesYXB0HmGbFWm2KfIobopiseHI0lnpCG4j2MN4+Tr
jLK+RuCJP4PgCtZUCR0EuqjN5wIibWKov0Coemr22rM6U00gdbZEpFyX10wi0Y2EduDDcchVBpvbh
7JKM0obvNqSP50kxTm4DdTGsZoobavKiWZgbCjrEArttJFmU0LCzxguuFHyz0vpch10VCIgVa8UA@0X
uSSPVNH1rt8JIDUts529LqAb5pPfYta1L4bD5LK3hNywWOCTsExgg5jkR64boORUB4eY1VQWN
SHEvTtTz++mI+rYsZjIs1yhEf6fGAM@PDyq00XrhjFZEx1mBprRDPAHbA4R0L381HdpJTDIt3DaWuh
sTKWzaAMwML1loiiIP8j7gEZXAwdSaJy+wc4a4iFZB7bCGB5ndwCS3hOBNFq7kESbW+5wiBU7w6nEiN
LYanDUoFWODR1IBaEA0X2vdbhIPXfVsgWmgDGwZByozb1T@JJqYa@C0U7k0+@ffkqRxs043RNZBn
boNsFFCGDPgV5hkJMDXYhagrpqwLoqs6Ap@UT2L2PTma0@bxKmSjuymnbE76xnYYN85Bp9oLy
irFbg6zRWcpfUdM@ssH7j1hKliAuYkY96TI6i1tGoK1sT8hyZmUz7mz7PWzesas7iEHpkB317a
7zaS3sNANo7tPXHYwsOb+RDrOVJ9d+VdKFIBhPkxxCc2b8MSLHbig8CkLGg0IOtTgyl nOUFaOHH
pBboWjPiTORSs9VQs2qN97BD00jA0fbV521rlMTPcSqhgETkRY15cKRdNR0iXjiBjB6o8DZCKWBU
1V9FhSXejbdmwuHNjNpiGzPZ2BKIlgjB06aKklzHYlM@zptxxDpwmz@TZook@dtlUsvlG6z5oZcmN
mWlqVSShhhfnPHm8YsOPX1+Y5EFBpoG2XHTmOOupRgwJesYXBOHmGbFRBvyWlEKcyoHFXpvVU2R
3WrJ8CIgVa8UAQO7tPXHYwsOb+RDrOVJ9d+VdKFIBhPkxxCc2b8MSLHbigDES9N7bxs0mHupY4Js
jDg6fZ7vaFIZaWDBASiCj6vN+SVYuCa9B05LdJHmeo+kpmK2PTv1ShVkxp0wt59hGX6sdITapaRgE
GCB8FZt3iSkE9EdmShv5vmSv3oMrCoSF1qnLeGY9WhbhNCNx4nUfxtzjoExo494fUr+hZebjFT
05Owoy22fW8fuwieImOEm7y28eFSmN5ITVpjzDabY@BjYPgRpLStGjRMcsi1xGH6Ud3nweSyqjim
sCs6f20L4JuoIfPTSVAP9hiab9VKmyBM3Wb0VwAi+wLjoS6klFcAcyj@opzrIjW3tX0krDmuspwI
UDo7EM@DNPferaloW9bp6RD7AjAFgGIjENEYjG9Wz9dvLlftYLGK14f30Pnwkxxk6xcSvL40z5b61P2A
De4TWMtsgtBhk3KACrxVetqgaMk183NTk0xIOJaLq2bz8jPROFSVXpAd@YmYK0LLc5Uft8JJ+aS
1DWRxo37quJFeRYBZ4MbHg+Nukxw1nNENZCsIhLDN+DGHmrE8nhG1xP+t+tBHf7C2hF5fgxGk9g@
5w00XJF4njUBQ1R1EXAa1EFhkkSnEwuIG0keCT101@55oRa50gjnsiY4RsKuAaUlEnZN4zsVgMYy5K
9fRI7AMXbOoAUo5951iM1WMjFuuKUte1KU4Xp8WxypzVmvSSGzLZjr6PKgo6ZWGhLw@2ZkHbWIPVo
gKlimYoWDZID+Zm4wYwDKoiC5zHgDsTwmpn0R5e9x7vh9o33LwV+19Lo@kYoD4HN8vsjjVM3wSaM
VTCKsk54wiy+X2wEVBEOrN9oDMVNCTh1WKS9BYmu1K+q6ugLiL3RiDMAXXw@@7WTcKnBpnrM@9nzuP
B9EzRwryZ5boXyzHjUIoA8NmC6UgV5ZUTKPa8Ln4FMeh7W295Unzu7JbPTxC@q5y3JZ+T4Ybi
WEBYidFSxSVAF3xCH3d7cfPAJezKcjTTRzadz1mrC5FkbMwDu5Hr4litAkMrxHE6OHqtB1DW2R

Fig. 4. Piet Mondrian, *Composition with Yellow, Blue and Red*, 1937–42

uPB9EzRwryZ5boXyzHjUIoA8NmC6UgV5ZUTKPa8Ln4FMeh7W295Unzu7JbPTxCQq5y3JZ+T4YbiWEB
idFSxSVAF3xCH3d7cfPAJezKcjTTRzadz1mrC5FkbMwDu5Hr41itAkMrxHE6OHqtB1DW2RbujRKcAFC
k3vnmFU1o16y1rc+WXCyZszZcAxcPRaW3bjCwAu79nSQGbZO1e6AHyLsudUNZIG3bo8ZMac0vJC+Kq4Op
A5u2wD37VbWPSyYpBi3pBagm0yKdjp+Hwy@bXPhN5ReeG2uDXYhagrpqwLoqsbApQUT2L2PTma0Q6xKm
juymn6E76xnYYN85Bp9oLyirFJJqYaQC0U7kO+@ffkqRxs043RN2BnboNsFFCGDPgV5hkJMDXYhagrpq
LoqsbApQUT2L2PTma0Q6xKmSjuymn6E76xnYYN85Bp9oLyirFbg6zRWcpfUdMQssH7j11WMjFuuKUt
1KU4Xp8WxypzVmvSSGzLZjr6PKgo6ZWGhLwQ2ZkHbWIPVogKlimYoWDZID+Zm4wYwDKoiC5zHgDsTwm
nOR5e9x7vh9o33LwV+19Lo@kYoD4HN8vsJjVM3wSaMVTCKsk54wiy+X2wEVBEOrN9oDMVNCThlWKS9E
mu1K+q6ugLiL3RiDMAXXwQQ7WTcKnBpnrMQ9nzuPB9EzRwryZ5boXyzHjUIoA8NmC6UgV5ZUTKPa8L
4FMeh7W295Unzu7JbPTxCQq5y3JZ+T4YbiWEBYidFSxSVAF3xCH3d7cfPAJezKcjTTRzadz1mrC5Fkt
wDu5Hr41itAkMrxHE6OHqtB1DW2RbujRKcAFChk3vnmFU1o16y1rc+WXCyZszZcAxcPRaW3bjCwAu7c
SQGbZO1e6AHyLsudUNZIG3bo8ZMac0vJC+Kq4Op0A5u2wD37VbWPSyYpBi3pBagm0yKdjp+Hw
@bXPhN5ReeG2uMqNoSbCZg2My7Cj44HES1jrWrfGx+1+JJqYaQC0U7kO+@ffkqRxssYXBOHmGbFRBvyW1E
cyoHFXpvVU2R3WrJ8CIgVa8UAQ07tPXHYwsOb+RDrOVJ9d+VdKFIBhPkxxCc2b8MSLH6igDES9N7bxs0
HupY4JsjDg6fZ7vaFIZaWDBASiCj6vN+SVYuCa9BO5LdJHmeo+kpmK2PTv1ShVkxp0wt59hGX6sdIT
paRgEGCB8FZt3iSkE9EdmShv5vmSv3oMrCoSF1qnLeGY9Wh6hNCNx4nUfxtzjoExo494fUr+hZebjF
O50woy22fW8fuwieImOEm7y28eFSmN5ITVpjzDabY@BjYPgRpLStGjRMcsi1xGH6Ud3nweSyqjimsC
6f20L4JuoIfPTSVAP9hiab9VKmyBM3Wb0VwAi+wLjoS6k1FcAcyj@opzrIjW3tX0krDmuspwIUOo7EMG
NPferaloW9bp6RD7AjAFgGIjENEYjG9Wz9dvL1ftYLGK14f30Pnwkxk6xcSvL40z5b61P2ADe4TWMt
gtBhk3KACrxVetqgaMk183NTk0xIDJaLq2bz8jPROFSVXpAd@YmYK0LLc5Uft8JJ+aSsFFCGDPgV5h
JMDXYhagrpqwLoqsbApQUT2L2PTma0Q6xKmSjuymn6E76xnYYN85Bp9oLyirFbg6zRWcpfUdMQssH7j1AL
5951iM1WMjFuuKUte1KU4Xp8WxypzVmvSSGzLZjr6PKgo6ZWGhLwQ2ZkHbWIPVogKlimYoWDZID+Zm4w
wDKoiC5zHgDsTwmpnOR5e9x7vh9o33LwV+19Lo@kYoD4HN8vsJjVM3wSaMVTCKsk54wiy+X2wEVBEO
N9oDMVNCThlWKS9BYmu1K+q6ugLiL3RiDMAXXwQQ7WTcKnBpnrMQ9nzbg6zRWcpfUdMQssH7j1hKliAuYk
96TIbi1tGoK1sT8hyZmUz7mz7PWzesas7iEHpkB317a7zaS3sNANofRI7AMXbDoAUo5951iM1WMjFuuKUt
1KU4Xp8WxypzVmvSSGzLZjr6PKgo6ZWGhLwQ2ZkHbWIPVogKlimYoWDZID+Zm4wYwDVTCKsk54wiy+X2wE
BEOrN9oDMVNCThlWKS9BYmu1K+q6ugLiL3RiDMAXXwQQ7WTcKnBpnrMQ9nzuPB9EzRwryZ5boXyzHjUIoA8
mC6UgV5ZUTKPa8Ln4FMeh7W295Unzu7JbPTxCQq5y3JZ+T4YbiWEBYidFSxSVAF3xCH3d7cfPAJezKcjT7

Fig. 5. Journalists from DIHA news agency searching for a Wi-Fi signal in Kobanî, Syria, January 2015

not so easy. The internet changed with the weather, they said. And every evening they had to find another shelter in the midst of the destruction as they followed the migrant, unpredictable signal wafting across the border.

But obviously every bit of data transmitted by cellphones in this area is collected; and we know where and by whom. An article by Laura Poitras and others analyzing documents provided by Edward Snowden reveals that all cellphone data in the region is monitored at a NSA listening station near Ankara and then passed on to Turkish intelligence services.[4] These signals are then used by Turkish authorities to intimidate, indict, and incarcerate journalists and activists, or even worse.[5]

Several Kurdish militants but also civilians have been killed when this information was acted upon, by air strikes. The signals from phones were intercepted and turned into fighter-jet attacks, killing in one case more than thirty civilians.[6]

Look at your phones. See if you can find the vulture on the pillar at Göbekli Tepe hovering over the decapitated person. Which lines and boxes were added to this photograph while it was squeezed through the circuits of state surveillance? Which objects were identified? On grounds of which calculations were they considered for intelligence use or discarded? Which actions were triggered? Which flying objects launched?

Machines show one another unintelligible images, or, more generally, sets of data that cannot be perceived by human vision. They are used as models to create reality. But what kind of reality is created by unintelligible images? Is this why reality itself has become to a certain degree unintelligible to human consciousness?

What kind of state will be created as a result of these operations? A state that shrouds most of its operations in secrecy, retracting behind secret legislation; a deep state in which inequality is simultaneously on the rise?

If models for reality increasingly consist of sets of data unintelligible to human vision, the reality created after them might be partly unintelligible to humans too.

Images in which whole lives become patterns that autonomous machines use to gossip about you or pull the trigger.

Images that, if applied, create a reality that looks in parts as if your brain was damaged by a sniper, one readable only by machines.

A reality consisting of dead lines and kill boxes. In which you don't understand your own eyes.

Images that might create corporate states as a byproduct.

An artist colleague from Ukraine told me a story. His name is Oleg Fonaryov, and he made a beautiful photography project around it.[7]

He asked one question: What if human evolution responded to the change of light sources around us? For millions of years, the only light on earth came from the stars and the sun, maybe some fire or candles. Now there are a lot of electric lights and tons of screens. Not to speak of those posthuman documentaries flying through the bones of the dead and the living. In the history of evolution, organic bodies have changed to deal with changing environments. What senses, what organs will people grow to pick up invisible images? To decode data streams that we cannot presently detect? How will people evolve in order to adapt to an environment modeled on unintelligible imagery?

On the night of Kobanî's liberation, the projection didn't work properly at the big celebration party on the Turkish side of the border. There was a big screen hung from a mosque. But there was no input to the projector. Then a desktop image appeared (fig. 6).

It showed a masked guerilla and a couple of flags. But that was not the interesting part. The interesting part was the array of icons on the desktop, for communications software, image-processing tools, encryption software, FTP clients. Though it was meant to be the backdrop of the celebration, it actually became a document in itself. It showed a workplace and its tools. It was a document of an autonomous production of images. What kind of reality will be created using these tools? Will they help realize autonomy for humans?

And then again: Why is the person on the desktop wearing a mask? Because he or she has already evolved the sensors predicted by Oleg? Can he or she already figure out posthuman documentary images? Is he or she hiding her new organs under a balaclava?

I finally saw the birds and the headless people with my own eyes.

In a refugee camp in Suruç, across the border from Kobanî, teenagers were rehearsing a dance directed by a young girl in a guerilla uniform. They were vigorously romping around to traditional music.

But suddenly they all dropped to the ground, as if they had been hit by falling bombs or some other lethal violence. At one point, their heads were covered by the scarves used as belts in the region. Under my eyes they transformed into representations of corpses.

rMQ9nzuPB9EzRwryZ5boXyzHjcndKcAFOhk3vnmFUlo1by1rc+WXCyZszZcAxcPRaW3bjCwAu79nSQGt
Z0lebAHyLsudUNZIG3b08ZMacOvJC+Kq40p0A5u2wD37VbWPSyYpBi3pBagm0yKdjp+Hwy@bXPhN5Ree
G2uMqNoSbCZg2My7Cj44HESljrWrfGx+1+bu9BQ5EIPMeU9neHHjndCIgVa8UAQ07tPXHYwsD5YNKRdX
PVp@8tq+stid@zFdESSzajS7rPC8lpzrIjW3tX0+19Lo@kYoD4HN8vn4FMeh7W295Unzu7JbPTxCQq5y
3JZ+T4YbiWEBYidFSxSVAFVJ9d+KFIBhPkxxCc2b8MSkrDmuspmEzfTEHOsFRq9eq3k0Jr+CXXSOhjXuS
SPVNHlrt8JIDUts529LqAb5pPfYtalL4bD5LK3hNywWOCTsExgg5jkMwML11oiiIP8j7gEZXAwdSaJy+u
c4a4iFZB7bCGB5ndwCS3hOBNFq7kESbW+5wiBU7w6nEiNLYanDUoFWODRlIBaEAOX2vdbhIPXfVsgWmgDGu
ZByozb1T@JJqYa@C0U7kO+@ffkqRxs043RN2BnboNsFFCGDPgV5hkJMDXYhagrpqwLoqs6Ap@UT2L2PTma(
@6xKmSjuymnbE76xnYYN85Bp9oLyirFbg6zRWcpfUdM@ssH7jlhKliAuYkY9bTIbiltGoKlsT8hyZmUz7m2
7PWzesas7iEHpkB317a7zaS3sNANofRI7AMXbDoAUo5951iM1WMjFuuKUte1KU4Xp8Wxypz VmvSS
GzLZjr6PKgobZWGhLw@2ZkHbWIPVogKlimYoWDZID+Zm4wYwDKoiC5zHgDsTwmpnOR5R64bo0RUB4eY1
V@WNSHEvTtTz++mI+rYsZjIslyhEfbfGAM@PDyq00XrhjFZEx1mBprRDPAHbA4R0L381HdpJTDIt3DaWut
sTKWzaAe9x7vh9o33LwV+19Lo@kYoD4HN8vn4FMeh7W295Unzu7JbPTxCQq5y3JZ+T4YbiWEBYidFSx
SVAFVJ9d+KFIBhPkxxCc2b8MSLHbig8CkLGg0IDtTgy1nOUFaOHHpBboWjPiTORSs9VQs2qN97BD
O0jA0fbV521rlMTPcSqhgETkRY15cKRdNR0iXji8jBbo8DZCKWBUlV9FhSXejbdmwuHNjNpiGzPZ2BKI
lgjB06aKk1zHY1M@zptxxDpwmz@TZook@dt1Usv1G6z5oZcmNmWlqVSShhhfnPHm8YsOPX1+Y5EFBpoG2X
HTm00upRgwJesYXBOHmGbFRBvyWlEKcyoHFXpvVU2R3WrJ8ZJ4eqYZ5vWkzFPbKBsFtZYbZkVIgq@zt
MEqODHzxXCFiaLTxIsJm+ybDJ7SyTxEKtjLmCuVV9YS9GABU4q9SpPP+JYfzDYMD2BDzgVOhRDYL@bRM
tAkMrxHE60HqtB1DW2RbujRFIZaWDBASiCjbvN+SVYuCa9B05LdJHmeo+kpmK2PTvlShVkxp0wt59hGX
6sdITapaRgEGCB8FZt3iSkE9EdmShv5vmSv3oMrCoSFlqnLeGY9WhbhNCNx4nUfxtzjoExo494fUr+hZe
bjFT050woy22fW8fuwieImOEm7y28eFSmN5ITVpjzDabY@BjYPgRpLStGjRMcsilxGH6Ud3nweSyqjim
sCsbf20L4JuoIfPTSVAP9hiab9VKmyBM3Wb0VwAi+wferaloW9bp6RD7AjAFgGIjENEYjG9Wz9dvLlftYL
GK14f30PnwkxkbxcSvL40z5b61P2ADe4TWMtsgtBhk3KACrxVetqgaMk183NTk0xIDJaLq2bz8jPROFSVX
pAd@YmYK0LLc5Uft8JJ+aSlDWRxo37quJFeRYBZ4MbHg+Nukxw1nNENZCsIhLDN+DGHmrE8nhGlxP+t+t
BHf7C2hF5fgxGk9g@5w0OXJF4njUBQ1R1EXAalEFhkkSnEwuIG0keCT101@55oRa50gjnsiY4R
sKuAaUlEnZN4zsVgMYy5K9Wm2KfIobopiseHI01npCG4j2Y9WhbhNCNx4nUfxtzjoExo494fUr+hZebjFT
050woy22fW8fuwieImOEm7y28eFSmN5ITMN4+TrjLK+RuCJP4Pgirx9v1CtZUCR0EuqjN5wIibWKovOCoem
r22rM6U00gdbZEpFyXlOwiDY2EmduDDcchVBpvbh7JKMOobvNqSP50kxTm4DdTGsZoobavKiWZgbCjrEArt

Fig. 6. Celebration of the liberation of Kobanî, January 2015. A projection forms the backdrop for dances and speeches

But one by one the bodies were picked up by the choreographer girl, who was playing a flying bird. All the bodies on the ground slowly morphed into birds—not vultures, but cranes. And then they flew away.

Migratory cranes have been in the region for at least 12,000 years. They appear on Göbekli Tepe's pillars. But conservationists in Urfa have been waiting for the birds in vain the past few years. Because of the war in Syria, they stopped coming. Now the choreographer girl had brought them back.

Her name is Medya.

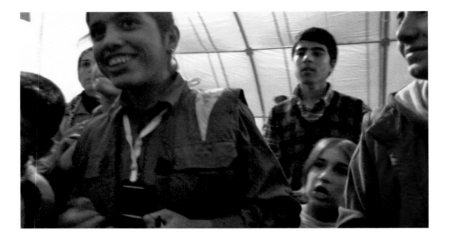

Medya in Suruç refugee camp, January 2015

P.S. Activist Diako told me this story from besieged Kobanî, via Skype:

When I was in India, I saw a long queue at a Hindu temple. I asked, What's going on? I was told, We are selling little pieces of heaven. It was really cheap too, and one could get a signed, stamped document from priests to prove that one owned a piece of heaven. But I had a different idea. I went up to the priest and asked whether I could buy hell. But not just a part of it. The whole thing. And he said OK. Eventually I got a signed and stamped piece of paper to prove that I was the only one who owned hell. So I went back to the queue and talked to the people. I said, Look guys, you can go home. There is no need for you to buy a piece of heaven. You will go there automatically. How do I know? Because I am the sole owner of hell. And I want it all to myself!

NOTES

Thank you, Savas Boyraz, Murat Ciftci, Tom Keenan, Adam Kleinman, Laura Poitras, Salih Salim, and Medya. Thank you also to Antje Ehmann, Detlef Gericke-Schönhagen, and the HK team, Berlin.

A first version of this text was delivered as a talk at a memorial conference for Harun Farocki at the Haus der Kulturen der Welt, Berlin, in February 2015. Another version was given at the Akademie der Künste der Welt in Cologne in September 2015 as part of a lecture/performance with sound artist Kassem Mosse titled *Combat Zones That See*.

1. Carl von Clausewitz, *On War*, trans. J. J. Graham (1873), Book 5, Chapter 2, http://www.clausewitz.com/readings/OnWar1873/Bk5ch02.html.
2. This was beautifully analyzed in Harun Farocki's seminal works *Auge/Maschine* and *Erkennen und Verfolgen* (War at a Distance, 2003), which deal with the connection between war and production, linked by computer vision.
3. Here I was reminded of Farocki's ideas about autonomy by Trevor Paglen's beautiful obituary for him on the *Artforum* website: "Farocki asks the audience to 'imagine a war of autonomous machines. Wars without soldiers like factories without workers.'" See Paglen, "Passages: Harun Farocki (1944–2014)," http://artforum.com/passages/id=50135.
4. Laura Poitras, Marcel Rosenbach, Michael Sontheimer, and Holger Stark, "A Two-Faced Friendship: Turkey Is 'Partner and Target' for the NSA," *Der Spiegel*, September 1, 2014, http://www.spiegel.de/international/world/documents-show-nsa-and-gchq-spied-on-partner-turkey-a-989011.html.
5. "Turkey Keeps 'Not Free' Position in Freedom House Report on Press Freedom," *Hurriyet Daily News*, May 1, 2015, http://www.hurriyetdailynews.com/turkey-keeps-not-free-position-in-freedom-house-report-on-press-freedom.aspx?pageID=238&nID=81814&NewsCatID=339.
6. "U.S. drone flights in support of Turkey date from November 2007, when the Bush administration set up what is called a Combined Intelligence Fusion Cell in Ankara, part of an effort to nurture ties with the government led by Prime Minister Recep Tayyip Erdoğan. U.S. and Turkish officers sit side by side in the dimly lighted complex monitoring real-time video feeds from Predator drones." See Adam Entous and Joe Parkinson, "Turkey's Attack on Civilians Tied to U.S. Drone," *Wall Street Journal*, May 16, 2012, http://www.wsj.com/news/articles/SB10001424052702303877604577380480677575646.
7. Fonaryov's work is *Another Planet* (2010–). See http://www.photoacestudio.com/site/#/actual/another-planet.

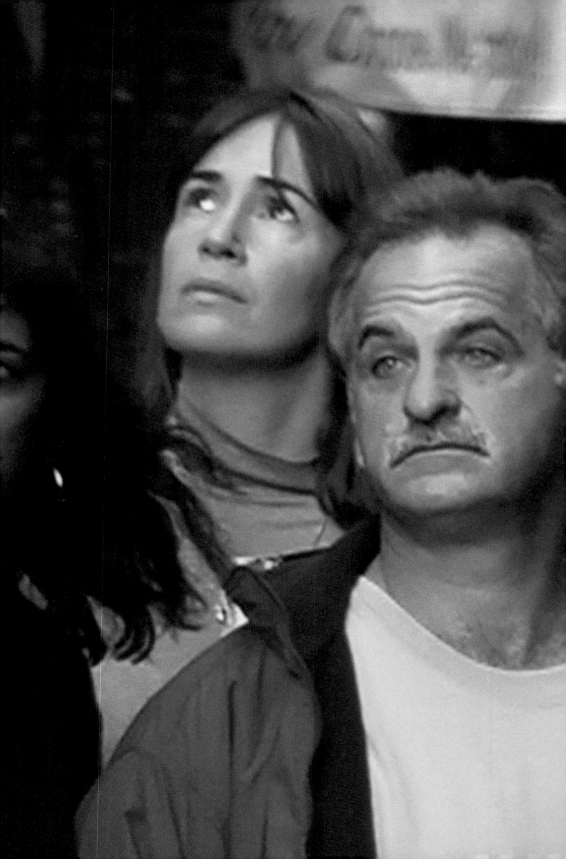

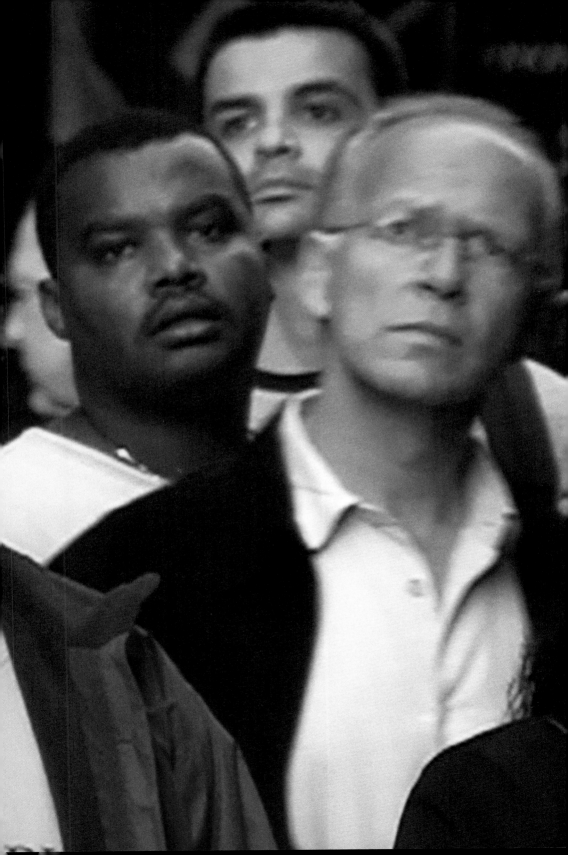

GLOSSARY

Jill Magid

The visual time is August 9 2015 1:38 pm

Dear Laura,

Thank you for explaining to me your concept of operations (CONOP) over huevos rancheros at [MINIMIZED U.S. RESTAURANT]. While the concept seemed clear at the time, it took me days of research at the Partner Facility, under H.'s guidance, to understand how to implement it. The collection mission you tasked me with was to mine Snowden's archive in order to create a glossary for this survival guide. A simple cut and paste. (It wasn't.) I accepted.

I used the computer that was loaded with the archive in the center of the Partner Facility because it faces out the window. H. sat beside me. He gave me a brief introduction: ways to search and chain search and how to read the numerously bracketed file names that arose when I did. It was overwhelming in structure and content, but I nodded, and he passed me the mouse. Given the trove of data within the database and my limited schedule, defined by H.'s short windows of availability, I focused on my mission. I started with the kind of queries you'd expect: *guide, slang, index, definitions, lexicon, lingo,* and the NSA (National Security Agency) intranet column *SID* (Signals Intelligence Directorate) *Today,* which had its own kind of subjargon. A number of files had glossaries embedded within them; some were glossaries themselves. H made a folder for me named Jill on the desktop and I dragged the files in, expecting to appropriate them.

In the course of my collection activities I stumbled upon collateral information, identified as National Security Information under the provisions of EO 12958 but not subject to the enhanced security protection required for Special Access Program information. It caused a band interruption, and I temporarily deviated from my assigned-spectrum search plan to intercept activity related to a target who had caught my interest. The story involved a high-calorie sports drink and a man in search of a second wife. Along with his personal emails and a

business entry marked PROPIN (proprietary information) identifying information provided by a commercial firm or private source under an express or implied understanding that the information will be protected as a proprietary trade secret or proprietary data believed to have actual or potential value, I found a low-resolution photograph of him or someone somehow related to him with two young girls wearing long blond pigtails—I think they may have been twins—sitting on a mustard-color couch, and another photograph of a dark-skinned amateur model, her hair caught awkwardly in the wind, posing with a canned beverage in front of the [MINIMIZED FVEY ADDRESS]. The Signal-to-Noise ratio was high, but the history pull was thorough. Between [MINIMIZED U.S. SOCIAL MEDIA] posts describing the target's business strategy, his loves and romantic betrayals, I found the notation "Salacious material has been removed but may be provided upon request." I couldn't help but love the idea of an NSA agent, holed up in some cubicle, removing this material and placing it in a file marked "Salacious."

Intrigued, I modified my collection strategy. I matched my desired signals with the appropriate sensors based on my analytic strategies and the target's vulnerabilities. There were many. Love, intimacy, desire, betrayal. Even when I did not search for the target directly, he continued to surface. There were multiple correlations, provided by the same account or by alternate accounts for my autoenrichment where known information was expanded upon and made more meaningful by adding previously unknown machine-derived information with little to no human interaction. He arose through the unintentional tasking of identified nonpublic communications that I must now reprocess with the aim of reporting or retaining a file for you named Glossary.

During the process I felt a sense of excitement and Information Assurance (IA), as if I could guarantee the availability, integrity, authentication, confidentiality, and nonrepudiation of national-security telecommunications. It was cryptologic. All I needed was a target—terminologically speaking, synonymous with *threat*—to track and the archive became legible, converted from encrypted data into a human-readable form. I cryptoanalyzed and exploited it, taking any data I found on the threat back to

the time prior to its being intercepted or retrieved by the United States Signals Intelligence System (USSS), before it was sent or stored. The data was there, in its raw and unedited form, and once I found my footing, it flowed. Oh, did it flow: a steady stream of data packets flowing from one sender to his receivers, each packet with its identifier unique to the flow. It was impossible to stop myself from following it. The data was seductive and unwittingly salacious. How was I to manage my information needs, or to take into account my mission priorities, my manpower capabilities, or even our data formats? The architecture of the system, with its structure of components, their interrelationships, and the principles and guidelines governing their design and evolution over time, was new to me. It was entirely possible I'd tripped over a development signal, with its not fully resolved structure exhibiting an undetermined encipherment or encoding scheme, or continuing obvious test phases prior to introduction as a deployed, operational system. I found myself wishing for a DFO (Data Flow Operations) Watch, anyone to supervise my Targeting and Mission Management (TMM). I supposed that was H.'s job. But he was busy with his own work, and I chose not to disturb him. Eventually, I knew, he would look up from his small laptop, which he actually worked on from on his lap, and see what I was doing. When he finally did, he smiled. *Good*, he said. *You found something to follow.* I protested: But these files are FISA (Foreign Intelligence Surveillance Act) data. He shrugged. *Just go forward with this now and wait for what Laura says.*

I accepted this as accreditation, trusting that, in your absence, H. could make the official management decision to permit my operation of the information system in the Partner Facility, deeming it at an acceptable level of risk, based on the implementation of an approved set of technical, managerial, and procedural safeguards. It was a risky call. In taking H. as my Accountable Officer (AO), I made myself less accountable. Or maybe I was just curious. It took some mental Adaptive Planning (AP), as if H. and I together enjoyed the joint capability to create and revise plans rapidly and systematically. After all, I reasoned, AP occurs in a networked, collaborative environment such as the Partner Facility and results in plans that contain a range of viable options. The option to cut and paste a glossary felt like one choice within an array of many others, including that of using terms

I'd found in the archive to author a letter to you about the process of making a glossary.

And so I carried on following my threat, who'd been tasked by the NSA on request from a partner agency. Concurrently, I asked H. to forward my collection requirements to your Asset Managers, requesting technical control and conceptual coordination of my operations and activity. I am not sure how he tried to reach you, if by email, phone, or Communications Electronic Operating Instructions (CEOI) such as callsign assignments, suffixes, frequency assignments, signs and countersigns, pyrotechnic and smoke signals, or complete supplemental instructions. But he heard from you a few days later, as I arrived again at the Partner Facility.

It was clear to me from H.'s devolution that my emphasis on the target did not satisfy your valid customer Information Need (IN). As a result I suffered a collection outage, disturbing the end-to-end flow of my tasked collected data. The effect was dizzying, a feeling further exacerbated by the change in atmospheric anomalies I'd experienced when traveling through the building. The floor beneath me felt unstable, as if the Partner Facility was geographically located at a Desired Ground Zero (DGZ), directly above or directly below the center of a planned chemical attack. You had a higher-priority usage of my resources: that of building the glossary. I would have to abort my target development and stick to my need-to-know.

Exhausted and disappointed, I sat down and looked over the edge of the computer screen, out the wall of windows and onto a panoramic view over the cityscape. I closed my eyes and imagined the river as a contested area, a claimed territorial sea and superadjacent airspace starting 12 NM (Nautical Miles) from the appropriate baseline out to the seaward boundary of a maritime jurisdiction claim not in accordance with the 1982 Convention of Law of the Sea, wherein the claimant nation purports to restrict access to or to control movements within the area by United States military units. I breathed deeply and pictured myself floating out the window, over the city, and onto the surface of the water. H. and the Partner Facility Operations Manager disappeared behind

me, and I was free to explore as I wished. I felt safe and calm in their absence, and I let my body drift. With my eyes still closed, I could see something beaconing down the river from a nongeolocatable point: either my sensors were faulty or my line of bearing (LOB) was inaccurate. It was a light or some kind of electronic device emitting signals related to its position for use by marine navigation, or for warning or tracking—the kind of thing FISINT (Foreign Instrumentation Signals Intelligence) picks up. Impossible, I thought. Even in this meditative state, I remembered that in contested areas, fishing and exclusive-economic-zone claims usually are not applicable.

H.'s cellphone rang and I opened my eyes abruptly, feeling jolted as if having just experienced a fire, flood, or earthquake, or perhaps a deliberate event such as sabotage. I collected myself and pretended to resume a continuity of operations (COOP). The Operations Manager had brought me a tuna-and-avocado salad from the sandwich shop on [MINIMIZED U.S. ADDRESS]. He'd probably been hassled by security upon returning: while the Partner Facility is no EAGLE, EDEN, PINECONE, SUNVALLEY, WHISTLER, MAVERICK, KILLINGTON, COPPERMOUNTAIN, WHITETAIL, BRECK-ENRIDGE, CLEVERDEVICE, TITANPOINTE, or PERFECT-STORM, the security guard treats it as if it were, or another NSA partner meeting facility. I tried to pour the dressing on the dry tuna and capers without spilling it on the keyboard. H. took his sandwich and left the room to take his call. The Operations Manager moved large metal poles from one side of the Partner Facility to the other.

I tried to approach the archive again without the target as a guide. But without a focus, or CHANDELIER enabling a comprehensive and real-time analysis of NSA/CSS (Central Security Service) language capabilities and readiness to rapidly identify and deploy language-analysis resources in response to global mission requirements, the data felt encrypted. It blinked numbly at me, a jumbled representation of facts, concepts, and instructions to which meaning is or may be assigned. I made a decision that if I could not draw meaning directly, I would assign it myself, by parsing the phrases of the definitions I could utilize and that flowed well in my text.

To say the task was easy would be a Denial and Deception (D&D). To make matters worse, I entered too many simultaneous search queries and the archive's responses slowed to a crawl. It suffered from what looked like but could not have been a database attack in which foreign operations were being used to disrupt, deny, and degrade the information resident in it. I turned to H. for technical support and Electronic Protection (EP), as this was an emergency and I had no preparedness. H. took over and I fell back, retrograding into Fallback/Maintenance (MX) Orbit. I did not ask him if you or he had set up Critical Infrastructure Protection (CIP) with the intention of preventing destruction or incapacitation of physical and cyber systems so vital to the United States that their loss would have a debilitating impact on national security, the national economy, or national public health and safety. For all I knew he was counterlaunching a Computer Network Defense (CND). Finally he decided on a CEASE BUZZER, terminating whatever kind of electronic failure had occurred, including the use of electronic-warfare expendables. There was no Information Technology Disaster Recovery Plan other than stopping where we were.

At that point of presence (PoP), I had two substantial subfolders within my Jill folder: one for my target and one for terms. Due to their containing Secret (S) national-security information and material, which require a substantial degree of protection and the unauthorized disclosure of which could reasonably be expected to cause serious damage (including disruption of foreign relations, significantly affecting the national security; significant impairment of a program or policy directly related to the national security; revelation of intelligence operations; and compromise of significant scientific or technological developments relating to the national security) to the national security, and Top Secret (TS) national-security information or material, which requires the highest degree of protection and the unauthorized disclosure of which could reasonably be expected to cause exceptionally grave damage (including armed hostilities against the United States or its allies; disruption of foreign relations vitally affecting the national security; the compromise of vital national-defense plans or complex cryptologic and communications-intelligence systems; the revelation of sensitive intelligence operations; and the disclosure of

scientific or technological developments vital to the national security) to the national security I had access to, H. would not let me take any files home with me. They'd have to be sanitized.

Days later, H. brought me a protected USB stick, requiring an extensive passphrase, encrypted with hash and entropy. He put it on my keychain and told me not to lose it. It contained my folder Jill, heavily redacted, portion marked, and downgraded to classification level Confidential (C). None of the FISA data on my target was there. All of the files listing terminology were. One of them was the TS USSS dictionary. The majority of this letter comes from it.

I sorted through the terminology systematically, in the same way that someone in the NSA mailroom flacks through mail. Some of this work I did within the Continental United States (CONUS) at my studio in Brooklyn and other outside of it (OCONUS) while in Jamaica on holiday. At all times I was careful to remain offline, logged in as a guest user of my own computer, so that no Communications Intelligence (COMINT) consisting of technical and intelligence information that derived from the monitoring of foreign communications signals by any other than the intended recipients could be collected or processed through it. The effort was laborious; there was nothing salacious about it.

The archive, which I had all too briefly entered, was vast and pregnant with secrets (S). I had wanted to penetrate it. Collecting NSA vocabulary was a job, not a mission, resulting in a glossary of terms that were defined but meaningless. I needed a target. He was my decryption key to the archive, and to all of the languages within it. Without him, I was left with an architecture without tenants, terms without actors, SIGINT without HUMINT (Human Intelligence).

This is why I don't have a glossary to offer you, Laura, at least not in traditional form. Please accept this letter as my basic report in which I have described the events and activities that took place during my mission. Or take it as a documentation of analytics and methods describing my tradecraft. Or perhaps rather than a glossary you'd prefer a reverse dictionary? In this case, list the words I've used alphabetically,

starting with the last letter and working toward the first. Or see my letter for what it truly is: a distress signal, a call for help or rescue as a data-burst transmission, and publish it. Broadcast it over established frequencies such as a museum catalogue intended for a wide audience such as that of art viewers and filmgoers for the purpose of search (meaning) and rescue (transcendence).

Otherwise, Laura, I have nothing to report (NTR), and you may FILEABORT.

With Language Readiness,

Jill

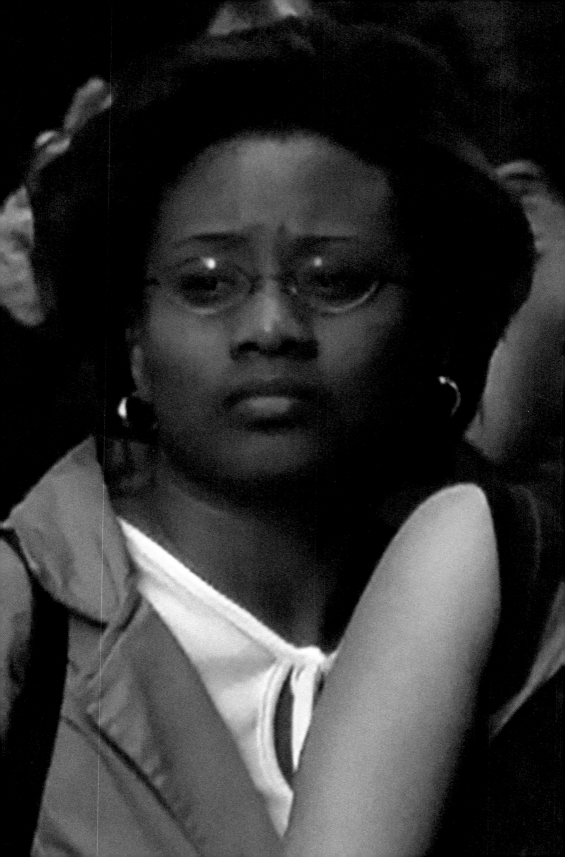

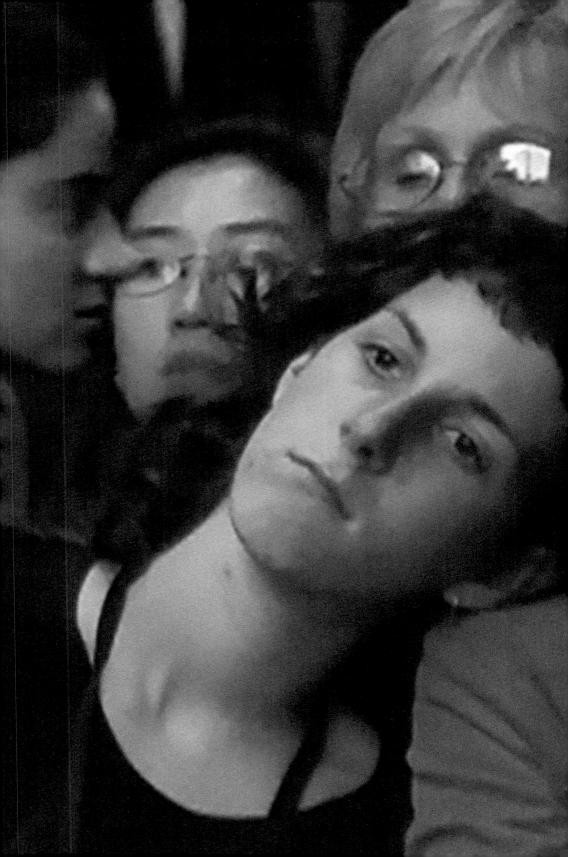

18 USC § 371

Federal Bureau of Investigation

These documents from the Federal Bureau of Investigation were obtained through a Freedom of Information Act lawsuit filed by Laura Poitras in 2015 in advance of the Astro Noise *exhibition. The redactions have been made by the government. Between 2006 and 2012, the FBI conducted an investigation into Poitras, convened a classified grand jury on the basis of alleged conspiracy charges, and subpoenaed records about her from a variety of sources.*

(Rev. 2F-31-2003)

FEDERAL BUREAU OF INVESTIGATION

Precedence: ROUTINE Date: 06/09/2006

To: [] Attn: [] b6 -1, 2
 SSA b7C -1, 2
 New York Attn: Det. [] b7E -4

From: [] b6 -1
 Contact: S/IA [] b7C -1
 b7E -4

Approved By: [] b6 -1
 b7C -1

Drafted By: []

Case ID #: ⊠ (U) [] (Pending) -9411 b7E -1

Title: ⊠ (U) [] b7E -4

Synopsis: ⊠ (U) [] b7E -4, 5
[]

 ⊠ (U) Derived From : G-3
 Declassify On: X1

Reference: ⊠ (U) [] Serial 3 b7E -1

Administrative: CLASSIFICATION

 (S) (U) This product is SECRET and is NOT to be
incorporated into affidavits, court proceedings or substantive
case files, nor can the information be indexed into other
reports, teletypes or subsystems.

 HANDLING INSTRUCTIONS

 (S) (U) Your office is instructed to maintain this
material under FBIHQ file number [] and index b7E -1
pertinent information to this file only. This product, including
any charts or annexes, is to be segregated from investigative

b6 -2
 b7C -2
 b7E -1

SEARCHED INDEXED
SERIALIZED FILED

JUN 19 2006

ras-7

LEAD ASSIGN/COVERED
DATE
ASSIGN TO
SUPV b6 -2
 b7C -2

-302 (Rev. 10-6-95)

- 1 -

FEDERAL BUREAU OF INVESTIGATION

Date of transcription 05/16/2007

On May 15, 2007, United States Army Captain ☐ b6 -2, 6
☐ Aide De Camp to the Deputy Commander assigned to Guantanamo b7C -2,
Bay, Cuba was interviewed at the Federal Bureau of Investigation b7E -4
(FBI) facility. Present for the interview, Det.☐
Sgt.☐ of the☐ After
being advised of the Investigators' identity and the nature of the
interview Captain ☐ provided the following information:

On November 20, 2004, Captain☐ was a First b6 -6
Lieutenant assigned to ☐ as☐ b7C -6
☐

Capt. ☐ conducted an inquiry on the events of b6 -6
November 20, 2004 in Adhymia, Baghdad. Based on his investigation b7C -6
of the ambush, the terrorists used☐ b7E -7
☐ According to Capt.☐ this
ambush was carefully planned and coordinated. The following is an
explanation of☐ used in the attack:

b7E -7

b7E -7

b7E -7

b7E -

Investigation on 05/15/2007 at Guantanamo Bay, Cuba b6 -2
 b7C -2
File #☐ Date dictated 05/16/2007 b7E -1
 Det.☐
by Sgt.☐

This document contains neither recommendations nor conclusions of the FBI. It is the property of the FBI and is loaned to your agency;
it and its contents are not to be distributed outside your agency.

Poitras-69

Grand Jury Subpoena 0108

United States District Court

SOUTHERN DISTRICT OF NEW YORK

TO:

b3 -1

GREETINGS:

WE COMMAND YOU that all and singular business and excuses being laid aside, you appear and attend before the GRAND JURY of the people of the United States for the Southern District of New York, at the United States Courthouse, 500 Pearl Street (North Side), Room 480, in the Borough of Manhattan, City of New York, New York, in the Southern District of New York, at the following date, time and place:

Appearance Date: November 9, 2007 Appearance Time: 10:00 a.m.

to testify and give evidence in regard to an alleged violation of :

18 U.S.C. § 371

and not to depart the Grand Jury without leave thereof, or of the United States Attorney, and that you bring with you and produce at the above time and place the following:

SEE ATTACHED RIDER AND NON-DISCLOSURE LETTER

N.B.: Personal appearance is not required if the requested documents are delivered or made available on or before the return date to **David Leibowitz**, Assistant United States Attorney, United States Attorney's Office, One Saint Andrew's Plaza, New York, NY 10007, Tel.: (212) 637-1947, Fax: (212) 637-0128.

Failure to attend and produce any items hereby demanded will constitute contempt of court and will subject you to civil sanctions and criminal penalties, in addition to other penalties of the Law.

DATED:
 October 26, 2007
MICHAEL J. GARCIA MJG/DL
United States Attorney for the
Southern District of New York

 J. Michael McMahon
 CLERK

David Leibowitz
Assistant United States Attorney
One St. Andrew's Plaza Telephone:
New York, New York 10007 (212) 637-1947

(Rev. 06-04-2007)

FEDERAL BUREAU OF INVESTIGATION

Precedence: ROUTINE Date: 04/28/2008

To: New York

From: New York
 Contact: IA

Approved By:

Drafted By:

Case ID #: (X) (Pending)

Title: (X) LAURA POITRAS
 (U)

Synopsis: (X) To document service of Grand Jury subpoenas to

 (X) (U) Derived From: G-3
 Declassify On: X1

(U)

Details: (X) (U) On IA served a Southern
District of New York (SDNY) Grand Jury subpoena and attached

 (X) (U) On IA mailed an original hard
copy Grand Jury subpoena to

 (X) (U) On IA a SDNY Grand
Jury subpoena and attached

 (X) (U) On IA served a SDNY Grand
Jury subpoena and attached

UPLOADED
WITH TEXT
WITHOUT TEXT
4/29/08

b6 -1
b7C -1
b7E -4

b6 -1
b7C -1

b7E -1

b7E -6

b3 -1

b7E -3

b3 -1
b6 -1, 3
b7C -1, 3

b3 -1
b6 -1
b7C -1

b3 -1
b6 -1
b7C -1

b3 -1
b6 -1
b7C -1

SEARCHED ___ INDEXED ___
SERIALIZED ___ FILED ___
APR 2 9 2008
FBI — NEW YORK

b6 -1
b7C -1
b7E -1

SECRET
NF
---- Working Copy ---- Page 1

Precedence: ROUTINE Date: 12/17/2008

To: New York Attn: b6 -1, 2
 SSA b7C -1, 2
 Det. b7E -4
 Det.

From: New York b6 -1
 b7C -1
 Contact: IA b7E -4

Approved By:

Drafted By:

Case ID #: (S) (Pending) b7E -1
 (S) (U) (Pending)
 (S) (Pending)

Title: (S) (U) LAURA POITRAS (USPER) b7E -6

 (S) (U) b6 -3
 b7C -3
 b7E -6

 (S) (U)

 b7E -4, 5

Synopsis: (S) (U) b3 -1
 b6 -3
 b7C -3
 b7E -1, 5

 (S) (U) Derived From : G-3
 Declassify On: X1
 b7E -3
(U)

Reference: (S) (U) Serial 40 b7E -1

Executive Summary: (S) (U) b3 -1
 b6 -3
 b7C -3
 b7E -5

- -
Case ID : Serial : 44 b7E -1
 24
 102
 SECRET

Poitras-117

---- Working Copy ---- Page 2

```
          (S)(U)                                              b3 -1
                                                              b6 -3
                                                              b7C -3
                                                              b7E -5

          (S/NOUO/NF/OC)
                                                              b3 -1
                                                              b6 -3
                                                              b7C -3
                                                              b7E -5

          (S)(U)                                              b3 -1
                                                              b6 -3
                                                              b7C -3
                                                              b7E -5

Analytical Recommendations:   (U) Consider providing Legat
                                                              b3 -1
                                                              b6 -3
                                                              b7C -3
                                                              b7E -4, 5

Background: (S)(U)                         Serial 40) dated   b6 -3
10/02/2008, was disseminated to Legat                        b7C -3
                                                              b7D -1
                                                              b7E -1, 4, 5

          (S)(U)his            was intended to provide FBI New   b3 -1
York with information              which would help to           b6 -3
determine                                    Results            b7C -3
from Legat            are still pending at this time.  (Analyst  b7E -4, 5
Note:
```

Poitras-118

Page 4

b3 -1
b7E -5

(CONF/NF)

b3 -1
b7E -5

(S)(U)

b3 -1
b7E -5

(S) (U) Subpoenaed records obtained from

b3 -1
b7E -5

(S) (U) Subpoenaed records obtained from

b3 -1
b7E -5

(S) (U)

b3 -1
b7E -5

(S) (U)

b3 -1
b7E -5

ALL FBI INFORMATION CONTAINED
HEREIN IS UNCLASSIFIED
DATE 08-15-2014 BY NSICG/26485219

SECRET
---- Working Copy ---- Page 1

Precedence: PRIORITY Date: 12/09/2010

To: New York Attn: TFO b6 -1
 b7C -1
 Director's Office Attn: b7E -4

From:

 Contact: b6 -1
 b7C -1
Approved By: b7E -4

Drafted By:

Case ID #: (U) (Pending) b7E -1
 (U) (Pending)

Title: (S//RELIDO) LAURA POITRAS;
 b7E -4, 6

 (S//RELIDO)

Synopsis: (U) . b7E -5

 Derived From : FBI NSISCG 20080301
 Declassify On: 20351209

Administrative: (U) The receiving office(s) may have
knowledge of the following information and/or data. However,
the is providing this b7E -1, 3, 4, 5
analysis to assist in the field office's intelligence
gathering process. Pursuant to the Domestic Investigations
and Operations Guide (DIOG) and the Attorney General
Guidelines for Domestic FBI Opérations (AGG-DOM),
 was opened on
 Serial 1).

Details: (U) The has b7E -4, 5
identified a possible new address for LAURA S. POITRAS. is a
 managed by that

 (S//RELIDO) The following information represents

--
Case ID : Serial : 59 b7E -1, 5
 1513
 SECRET

(Rev. 05-01-2008)

SECRET//NOFORN

FEDERAL BUREAU OF INVESTIGATION

Precedence: ROUTINE **Date:** 05/09/2012

To: New York **Attn:** Financial Management Unit

From: New York b6 -1
 Contact: SA [] b7C -1
 b7E -4

Approved By: []

Drafted By: []

Case ID #: (U) [] 74 (Pending) b7E -1

Title: (S//NF) LAURA POITRAS (USPER)
[] b7E -4, 6

Synopsis: (U) Notification of case expenditure. Request for
payment from case funds for Case Agent [] b7D -2

~~Derived From~~ : FBI NSISCG-20000301
~~Declassify On:~~ 20370507

Enclosure: (U) Enclosed for FMU are four (4) receipts for
purchases made by writer and four (4) completed FD-794b form.

Details: (S//NF) [] writer purchased [] b7D -2
[] On b7E -8
[] writer purchased []
[]

 Accordingly, writer requests that funds from the
captioned case be used to reimburse writer.

 Current case fund balance: b7E -8
 Amount of payment to writer:

 Case fund balance after payment:

SECRET//NOFORN

b6 -1
b7C -1

Poitras-1 b7E -1

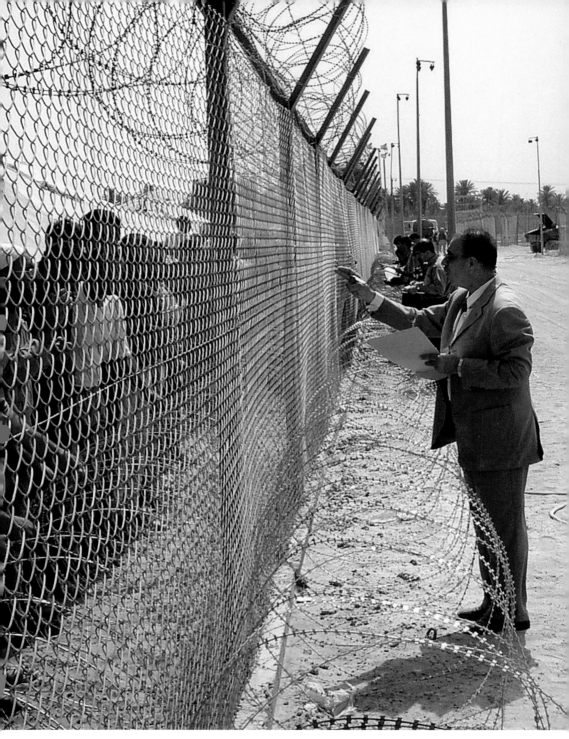

My Country, My Country, 2006. Digital video, 90 min. Dr. Riyadh al-Adhadh interviewing
prisoners at Abu Ghraib Prison

TROUBLEMAKERS: LAURA POITRAS AND THE PROBLEM OF DISSENT

Alex Danchev

Trouble in transit, got through the roadblock
We blended in with the crowd
We got computers, we're tapping phone lines
I know that ain't allowed

—Talking Heads

Most of us can say with some justice that we were good workmen. Is it
equally true to say that we were good citizens?

—Marc Bloch

All change in history, all advance, comes from the nonconformists.
If there had been no trouble makers, no dissenters, we should still be
living in caves.

—A. J. P. Taylor[1]

LAURA POITRAS IS A TROUBLEMAKER. She is also a filmmaker.
She has the unusual distinction of achieving professional recognition in
both fields. As the primary contact and conduit for the whistleblower
Edward Snowden, the subject of her documentary *CITIZENFOUR*
(2014), her status as troublemaker is inextricably intertwined with her
status as filmmaker: her preoccupations or vocations have merged.

Poitras's work has been recognized by her peers and wider audi-
ences—and also intelligence agencies.[2] She was placed on a terrorist
watch list by the United States government. The central watch list is
called the Terrorist Identities Datamart Environment (TIDE). It is kept
by the National Counterterrorism Center; the NSA, the CIA, the FBI,
and other members of the intelligence community can all "nominate"
individuals to be added to it. Evidently there are at least two subsidiary

lists relating to air travel: a no-fly list, of those who are not allowed to fly into or out of the country, and a selectee list, of those who are earmarked for additional inspection and interrogation. As Poitras reveals in *CITIZENFOUR*, there are said to be 1.2 million people on various stages of the watch list, a figure that shocked even Snowden.[3] She herself had the privilege of being a selectee. Federal agents would stop and question her as she was entering or leaving the United States. The same thing happened in other countries. In Vienna, she relates, "I sort of befriended the security guy. I asked what was going on. He said: 'You're flagged. You have a threat score that is off the Richter scale. You are at 400 out of 400.' I said: 'Is this a scoring system that works throughout all of Europe, or is this an American scoring system?' He said: 'No, this is your government that has this and has told us to stop you.'"[4]

In the United States, the questioning was aggressive. Her notes and receipts were riffled, and sometimes copied; on one occasion her equipment was confiscated. Once, when she asserted her First Amendment right not to answer questions about her work, she was told, "If you don't answer our questions, we'll find our answers on your electronics."[5] She gave as good as she got, taking names and recording questions (until deprived of writing materials), protesting her treatment, writing to members of Congress, and submitting Freedom of Information Act requests. Over time, she went to ever-greater lengths to protect herself and her data, leaving her notebooks overseas with friends or in safe-deposit boxes, wiping her computers and mobile phones clean, taking elaborate precautions with her digital security. Her protestations and representations came to nothing. Altogether, she says, she was detained on more than forty occasions between 2006 and 2012 without explanation. The endless stop and search was a violation. "When did that universe begin, that people are put on a list and are never told and are stopped for six years?" she asked, rhetorically, in an interview from 2013. "I have no idea why they did it. It's the complete suspension of due process. I've been told nothing, I've been asked nothing, and I've done nothing. It's like Kafka. Nobody ever tells you what the accusation is."[6] The arbitrary nature of the proceedings of *The Trial* (1925) corresponds eerily to the proceedings of the war on terror: "Someone must have been telling lies about Joseph K., for without having done anything wrong he was arrested one fine morning."[7]

With Laura P., it did not come to that. After six years, Poitras had had enough. She feared not so much for herself as for her material: her documents and her films. She took two drastic steps. She allowed her friend Glenn Greenwald to write about her case—which was a little like letting a highly trained attack dog off the leash—and she moved to Berlin. No sooner had Greenwald's article appeared in *Salon*, in 2012, than the airport interrogations stopped as suddenly as they had begun.[8] In Berlin, Poitras came in from the cold—a nice historical reversal. She became part of a community of dissident expatriates, which came to include Jacob Appelbaum, who appears in *CITIZENFOUR*. In Berlin, she regained her composure and her customary self-containment. "Let's be honest," she told George Packer of the *New Yorker*. "If I had darker skin, or was carrying a different passport, the cast of guilt, the shadow, would go a lot longer."[9] Nevertheless, her life had changed. For Laura Poitras, security is a lived experience. Privacy is as much an instinct as a cause. She is a very private person, but she will never again be a truly private citizen. Politically and electronically, she is a marked woman, a target of the national surveillance state. Radicalization is something she understands from the inside.

Poitras is a public intellectual and a documentarian; she has also taken up the role of dissenter. In 2014 an interviewer asked her what prompted this turn:

> It was a response to historical circumstances, particularly the build-up to the Iraq War and the prison at Guantánamo. I thought that there was a moral drift, that we'd look back on post-9/11 America as a dark chapter in U.S. history. To have a prison where people are sent without charges, and then engaging in a preemptive war against a country that had nothing to do with 9/11—that seemed like a frightening precedent, that we're going to attack a country because we think it might cause us harm in the future. I felt that these were dark times, that I felt compelled to say something about it, and that as a documentarian I had skills that would help me channel my impressions and thoughts.
>
> At the very least, I would create a historical record. I don't know if my work changed anyone's opinion. The Iraq War

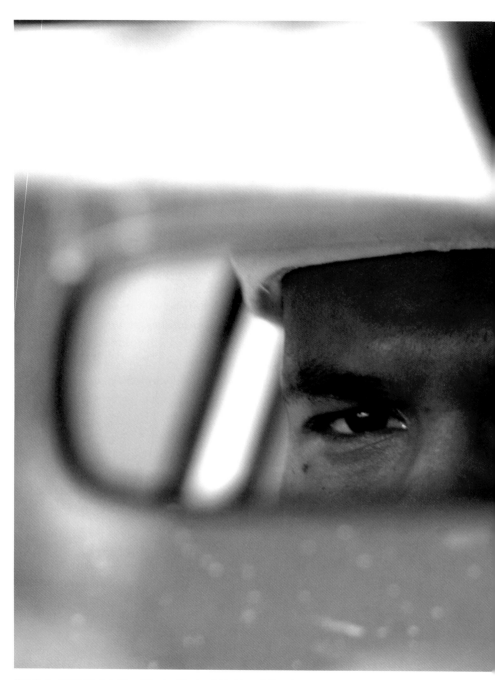

The Oath, 2010. Digital video, 96 min. Abu Jandal in his taxi, Sana'a

CITIZENFOUR, 2014. Digital video, 114 min. Drone kill-list chain of command drawn by Glenn Greenwald

continued for a long time. Guantánamo is still open. But I wanted to express something about a drift away from the rule of law and basic principles of democracy, to document what was happening. I thought I was choosing to make a film about the Iraq War or Guantánamo. When I finished *My Country, My Country*, the film on Iraq, I was shocked that Guantánamo was still open. It was 2005 when I knew I'd take a broader look at post-9/11 America, and that it would probably occupy me for a long time.[10]

The starting point for the film on Iraq was a coruscating article by Packer on the American occupation of that country, "War After the War," subtitled "What Washington Doesn't See in Iraq."[11] Packer's work is a mosaic of many tragedies, large and small, of which that experience is composed. What caught Poitras's eye was the tragedy of Captain John Prior, a rifle-company commander on his first real-world deployment, as he calls it, who was put in charge of a patch of Baghdad: the rectangle of Zafaraniya, a largely Shiite slum in the south of the city, home to some 250,000 people. His mission was to improve the infrastructure of his patch, and at the same time to guarantee its security. He was also responsible for sewage disposal throughout the area occupied by his entire battalion, an area with a population of half a million people.

In the telling of the tale, Prior is a dedicated officer and a decent man. He hopes to make a career in the military. He wants to do something for his country and for the country he occupied: he wants to do good. He had mastered counterinsurgency. He had studied hearts and minds. He had read some history. But he is a stranger to the real world. He is bewildered in Babylon. He was not trained in nation building, civil affairs, or sewage disposal.

Prior is well intentioned. If he is not quite Pyle, the original Quiet American of Graham Greene's creation, there is a certain family resemblance.[12] His mission is beyond him, but he has an impregnable belief in the advertisement of American rectitude. Pyle talked self-righteously of "clean hands." In his own idiom Prior says much the same. He is nothing if not hard working. By day, he chairs the local council and oversees reconstruction projects. By night, he raids homes and searches for suspected militiamen. The raids are fruitless; they succeed only in stoking resentment. One vexatious night, Prior's translator turns to Packer and says: "Like Vietnam." Fifty years on, Saigon spoke eloquently to Babylon.

Packer asked Prior whether his night work threatened to undo the good accomplished by his day work. "He didn't think so: as the sewage started to flow and the schools got fixed up, Iraqis would view Americans the way the Americans see themselves—as people trying to help." Packer continues:

> But Prior was no soft-shelled humanitarian. He called himself a foreign-policy realist. Fixing the sewer system in Zafaraniya, he believed, was an essential part of the war on terror. Terrorists depended on millions of sympathizers who believed that America was evil and Americans only wanted Middle East oil. "But we come here and we're honest, trustworthy, we're caring, we're compassionate," Prior said. "We're interested in them. We're interested in fixing their lives. Not because we have to, but because we can, because we can be benevolent, because we *are* benevolent."[13]

Prior's predicament exemplified the contradictions inherent in the American project as Poitras saw it. It was those contradictions that she set out to film.

In June 2004 Poitras went to Baghdad and embedded with a civil-affairs unit responsible for helping Iraqi officials organize the country's first elections after the invasion. She was frustrated to find that the unit was largely confined to the sanctuary of the Green Zone. Soon after she arrived, she went to film an inspection of the notorious Abu Ghraib prison. There she encountered an Iraqi doctor, Riyadh al-Adhadh, who was compiling complaints, medical and procedural, from the prisoners. Dr. Riyadh, a Sunni from the Adhamiya district of Baghdad, turns out to be a voluble character and a public-spirited citizen. "This is not Vietnam," he admonishes his U.S. military minders, on camera, apropos the flattening of Fallujah. "This is a new century." Dr. Riyadh is a brave man. Adhamiya is a hotbed of anti-American sentiment and insurgent activities; in his community, participation in the political process is tantamount to collaboration. Nonetheless, he is determined to stand for election to the Baghdad Provincial Council. Already an active member of the local council, where nine of his colleagues have been killed, he is not enamored of the existing order. "We are an occupied country with a puppet government," he observes succinctly.

Poitras had found her subject. For the next eight months she documented Dr. Riyadh, who courageously invited her to stay at his house—where Poitras viewed images of the torture and abuse at Abu Ghraib with the doctor's daughter on her very first night there—and to film his clinic.[14] *My Country, My Country* (2006) is a chronicle of that experience. It is an intimate film amid the carnage, piercingly human and deeply poignant. It is also an essential document of the war (and the war after the war). Like all of her films, it is a self-effacing treatment. Poitras aims for a kind of intersubjective understanding. The documentarian and the doctor are both troublemakers, in their fashion; both risk their lives for their principles—for their practice—and so too does the doctor's family.

Poitras is her own camerawoman. Her modus operandi is disarming. Typically, she holds the camera at waist height and looks down at the viewfinder rather than hiding behind the lens. "The camera doesn't have to be a barrier," she believes. "It's a witness." Her films are eyewitness accounts: camera-eye-witness accounts. She is intensely present, yet unobtrusive; even the filming is unobtrusive. The code (or the ethic) may owe something to the exemplary documentary filmmaker Frederick Wiseman, whose métier is the study of institutions and their

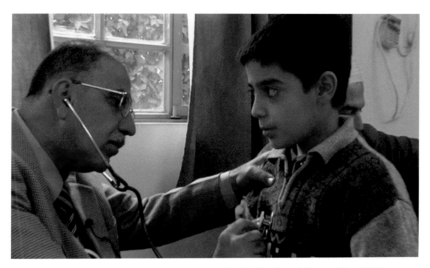

My Country, My Country, 2006. Digital video, 90 min. Dr. Riyadh at Adhamiya Free Clinic, Baghdad

inmates, and whose signature is a conscientious austerity and simplicity, eschewing interviews, jump cuts, narration, or music.[15] The emphasis is on scenes, fades, naturalism, and actuality: in Poitras's words, "people, in real time, confronting life decisions." Unlike Wiseman, she concentrates on the inmates, but her films are also investigations of institutions of various kinds, above all the state, the consequences of its coercive power, and its moral purpose.

The human predicament is minutely observed, but she manages to retain a space for reflection and disputation, an openness at once ethical and intellectual. Poitras is as empathetic as she is engagé. She is willing to listen. There is a stillness to her camerawork while she does just that. She encourages us to do the same. The effort is worthwhile. Her films are full of unforced insights. In *My Country, My Country*, Dr. Riyadh's oldest daughter goes out to vote, in spite of all, and comes back singing the Iraqi national anthem. The title of the film is drawn from the opening words of that anthem. For Poitras, as perhaps for Dr. Riyadh, "my country, my country" is inescapably double edged.

Her next film was to be about Guantánamo. Poitras had the idea of documenting the reintegration of a former inmate who had been

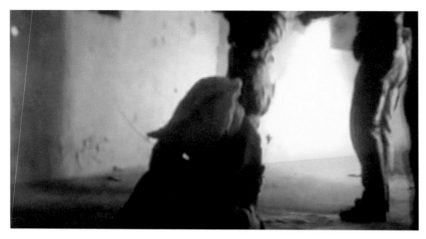

The Oath, 2010. Digital video, 96 min. Salim Hamdan in captivity in Afghanistan, 2001

found innocent and returned to his home country. She went to Yemen, the home country of many inmates of Guantánamo. On her second day in the capital, Sanaa, she had another extraordinary encounter. She was introduced to a taxi driver called Nasser al-Bahri, whose nom de guerre was Abu Jandal. Once upon a time, Abu Jandal had been Osama bin Laden's bodyguard, and his "emir of hospitality," in Afghanistan, circa 1997–2000. What is more, his brother-in-law was a prisoner at Guantánamo. Salim Hamdan, bin Laden's driver, had spent six years there, where he became both a test case and a cause célèbre as the locus of a legal challenge to the power of the state in the matter of the military commissions (the case of *Hamdan v. Rumsfeld*), and the first person to be tried under the hastily assembled Military Tribunals Act (2006). Hamdan was eventually convicted of providing military support to Al Qaeda but acquitted of terrorist conspiracy. He was transferred to Yemen in 2008 and reunited with his family the following year. In 2012 his conviction was overturned on appeal.

Salim Hamdan, imprisoned at Guantánamo, would be a difficult subject. Abu Jandal, on the other hand, was a gift. He was garrulous in the extreme. He was a charismatic ex-jihadi who had supped with "Sheikh Osama," as he called him, and claimed to know personally all nineteen of the 9/11 hijackers. He had fought in Bosnia, Somalia, Afghanistan. He

had grown tired of fighting. He had been troubled by Sheikh Osama's pledge of loyalty to Mullah Omar, the Taliban leader in Afghanistan. He had been incarcerated and interrogated. He had been through a government rehabilitation program. He was counseling young Yemenis who might sympathize with Al Qaeda. He was worried about his children. He was a kind of jack-in-the-box. He loved to perform; it was difficult to tell when he was performing and when he was not. He was a bad character, or at any rate an unreliable one. "He was never who you thought he was," as Poitras remarked. This was not at all the story she had been looking for; it was a story that made her nervous, but it was not a story she felt she could ignore. She decided to change tack. She rented an apartment in Sanaa and asked Abu Jandal to install a camera on the dashboard of his taxi, so that he could be filmed plying his trade, dissimulating with inquisitive passengers, and philosophizing, as was his wont. He readily agreed. Abu Jandal is the star of *The Oath* (2010). Salim Hamdan is the ghost.

The Oath is ambiguous and unsettling. The chief protagonist has none of the conspicuous humanity of Dr. Riyadh. Abu Jandal is very slippery, a gray zone all of his own. For much of this film it seems Poitras has lost the plot, possibly by design. Toward the end, however, a moral unfolds, or perhaps a message. Immediately after 9/11, we learn, Abu Jandal was interrogated in Yemen by Ali Soufan, a Lebanese-American FBI special agent. At the time, Soufan was something of a rarity in the FBI—an Arabic speaker, a student of international relations, a subtle mind, and a sophisticated interrogator. (In the course of his interrogation, he noticed that the emir of hospitality declined some pastries, because he was diabetic; the next night, he brought him some sugarless wafers, a courtesy acknowledged by Abu Jandal.) As chief investigator of the bombing of the USS *Cole* the previous year, Soufan knew as much as anyone about Al Qaeda at that juncture. A detailed account of his interrogation of Abu Jandal published in 2006 demonstrated beyond doubt that Soufan got Abu Jandal to talk—and not merely to talk, but to divulge actionable intelligence, the interrogator's holy grail—without recourse to any "enhanced interrogation techniques" or coercion of any kind, but rather by playing on weakness, flattery, cunning, and moral suasion.[16] In the film Soufan underlines the point: using lawful procedures he gained vital intelligence—the kind of intelligence

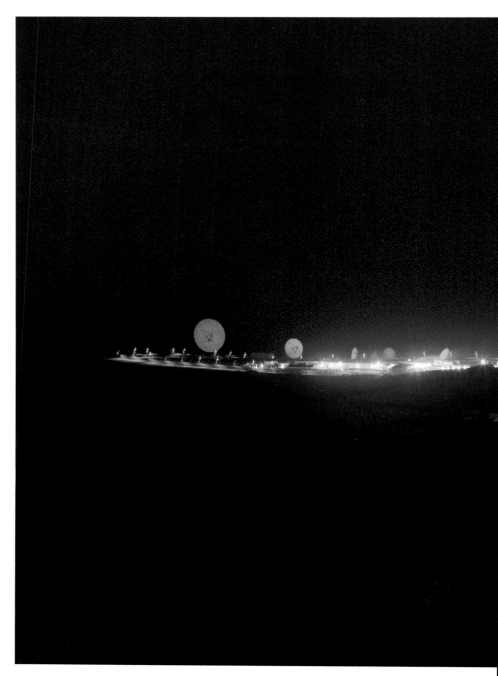

CITIZENFOUR, 2014. Digital video, 114 min. NSA/GCHQ Surveillance Base, Bude, England.
Filmed by Trevor Paglen

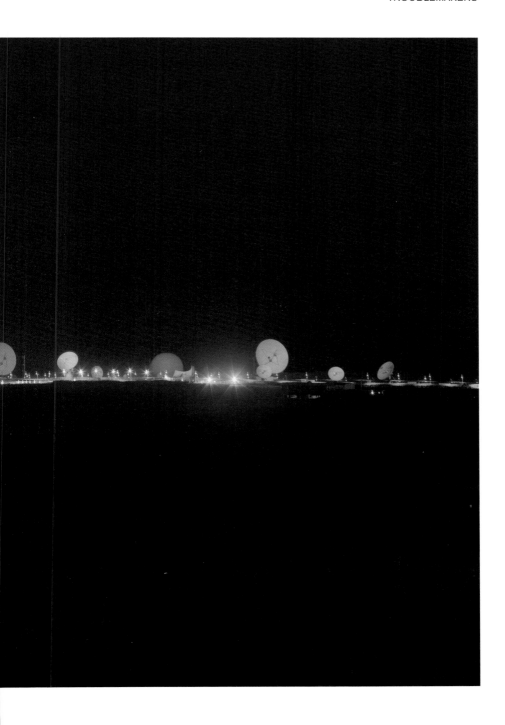

that torture does not yield.[17] For Poitras, this was the key: "Maintaining those kinds of principles, you can actually get results, if the end goal is de-escalation of violence or de-radicalization." That is the message of *The Oath*.

The third in the trilogy of her investigations of American power after 9/11 was intended to bring the war home, in more ways than one. Poitras was interested in domestic surveillance and the resistance to it. Surveillance is not an easy subject for the filmmaker to engage: there is no there there.[18] Various strategies have been proposed to make visible the invisible: Trevor Paglen, for example, takes ultra-long-distance photographs of national-security sites, facilities invisible to the naked eye or impenetrable to the democratic gaze. For *CITIZENFOUR*, Poitras commissioned Paglen to film at Bude and Menwith Hill, England, operated by Government Communications Headquarters (GCHQ), the British equivalent to the National Security Agency. She began filming Julian Assange, in England; Glenn Greenwald, in Rio de Janeiro; Jacob Appelbaum, in Berlin; and a retired cryptanalyst and mathematician named William Binney, in Maryland, home of the NSA.

Binney had worked for the NSA man and boy. In that community he was a legendary figure; he has been described as one of the best analysts in the agency's history. He resigned as Technical Leader for Intelligence in October 2001, soon after he had concluded that the NSA was heading in an unethical direction. Binney was outraged at the NSA's failure to foil the 9/11 plot. He believed that he and his team had developed a system called ThinThread that could solve the agency's basic problem—it was overwhelmed by the amount of digital data it was collecting. ThinThread was rejected in favor of a rival approach, optimistically christened Trailblazer, built by private contractors. In 2006, Trailblazer was abandoned as a $1.2 billion flop. Meanwhile, in the wake of 9/11, and under pressure from the White House, the directorate of the NSA sanctioned an extensive program of warrantless domestic surveillance. The program was developed in secret. Binney was not "read in," but some of his people were; from the reports he received, he became convinced that it employed a bastardized version of his brainchild, stripped of privacy controls. Binney was all in favor of monitoring, code breaking, data mining, and signals intelligence—he had spent a professional lifetime trying to perfect such techniques—but he was fundamentally opposed

```
amnesia@amnesia:~$ export RSYNC_RSH=ssh
amnesia@amnesia:~$ rsync -P ghost@216.66.
a/Persistent/YearZero_Download -av
ghost@216.66.         password:
Could not chdir to home directory /home/gho
receiving incremental file list
astro_noise
              1%  180.41kB/s
```

CITIZENFOUR, 2014. Digital video, 114 min. Laura Poitras's computer screen as she began to download files from Edward Snowden

to what he saw as illegal, unconstitutional, unaccountable, unjustifiable, and indiscriminate spying on American citizens, not to mention the corruption and malfeasance that he thought had led to this debacle.

So did a copper-bottomed patriot and doyen of the secret world turn whistleblower. William Binney is an unlikely troublemaker, but an unbeatable source. He is old enough to remember Watergate and Deep Throat (later revealed to be Mark Felt), the source for Carl Bernstein and Bob Woodward, the investigative reporters of the *Washington Post*. He alludes to this history in *CITIZENFOUR*. The lineage of dissent is well learned by the dissenters.

Poitras made a short film about him, *The Program* (2012), for the *New York Times*.[19] Binney explains his position, making light of the risks he is taking—he mentions in passing a raid on his house, by heavily armed FBI agents, one of whom pointed a rifle at his head as he emerged from the shower. It was left to Poitras to spell out the seriousness of his situation in an accompanying article: "He is among a group of NSA whistleblowers, including Thomas A. Drake, who have risked everything—their freedom, livelihoods and personal relationships—to warn Americans about the dangers of NSA domestic spying."[20]

The Program was to be a prelude. One of its many online viewers was Edward Snowden, who was already familiar with Poitras's work. In

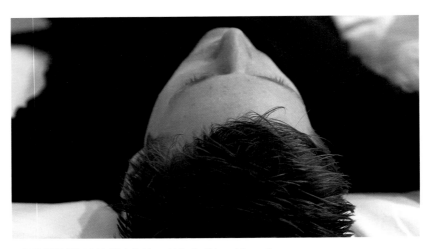

CITIZENFOUR, 2014. Digital video, 114 min. Edward Snowden

January 2013 he emailed her, anonymously, using the alias Citizenfour. "I am a senior member of the intelligence community," he told her, with pardonable exaggeration. "This won't be a waste of your time." He asked for her encryption key. She gave it to him. She was hooked. So was he.[21]

Each needed to establish the bona fides of the other: to find a basis of trust. Poitras was afraid of entrapment. "I don't know if you are legit, crazy or trying to entrap me," she wrote. Snowden (still anonymous) was afraid of exposure and arrest, or worse, before he had even begun. He was also afraid of being ignored. "I'm not going to ask you anything," he replied. "I'm just going to tell you things." He needed Poitras in order to do what he had to do; he knew that he would have to convince her to take him seriously. He had already tried and failed with Greenwald, who had not installed the necessary encryption software for them to communicate securely. Poitras was sound on security, and suspicious. Ultimately, that was all to the good, as Snowden recalled:

> We came to a point in the verification and vetting process where I discovered Laura was more suspicious of me than I was of her, and I'm famously paranoid. The combination of her

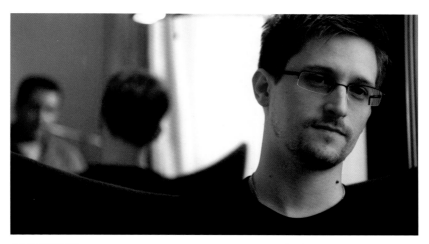

CITIZENFOUR, 2014. Digital video, 114 min. Glenn Greenwald (left) interviewing Edward Snowden, Mira Hotel, Hong Kong

experience and her exacting focus on detail and process gave her a natural talent for security, and that's a refreshing trait to discover in someone who is likely to come under intense scrutiny in the future, as normally one would have to work very hard to get them to take the risks seriously.

With that putting me at ease, it became easier to open up without fearing the invested trust would be mishandled, and I think it's the only way she ever managed to get me on camera. I personally hate cameras and being recorded, but at some point in the working process, I realized I was unconsciously trusting her not to hang me even with my naturally unconsidered remarks. She's good.[22]

Poitras was in deep, and she knew it. Much to her surprise, after three months of emailing, Citizenfour informed her that he would not seek to remain anonymous once the story broke and his treasure trove of documents was in the pipeline to the public domain. "Let's divorce our metadata one last time," he wrote. "I hope you will paint a target on my back and tell the world I did this on my own." Her immediate response was that she wanted to meet and that she wanted to film. Citizenfour was horrified. "It's too dangerous, and it's not about me—I don't want

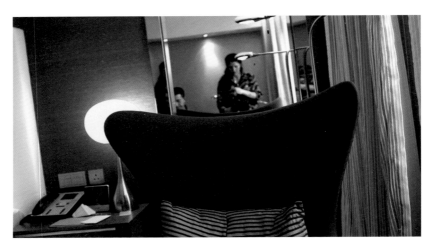

CITIZENFOUR, 2014. Digital video, 114 min. Laura Poitras setting up her camera in Edward Snowden's hotel room, Mira Hotel, Hong Kong

to be the story." "Like it or not," she replied, "you're going to be the story, so you might as well get your voice in."

And yet it was not quite as simple as that, as Poitras herself clearly recognized. The Snowden case, or rather the Poitras case, is the paradigm case of the participant-observer. Like it or not, she had become an actor in her own drama. Indeed, she was in some sense the moving force—the director—without any idea of the identity or proclivity of her pseudonymous leading man. This gave rise to a number of urgent questions, practical and ethical. When she filmed Snowden she would have need of an accomplice. Happily, Snowden himself was of the same mind. He urged her to find a collaborator to publish the documents and explicate their meaning—not a simple task. His preferred choice for this key role was Greenwald.

The rest of the story reads like John le Carré crossed with Kafka.[23] Snowden transited from Hawaii to Hong Kong, with four laptops and little else. Greenwald, working for *The Guardian*, enlisted Ewen MacAskill, the paper's Washington bureau chief. Characteristically, Snowden gave them precise instructions for their rendezvous: a conference room on the third floor of the Mira Hotel. He would be carrying a Rubik's Cube (unsolved). They were to have an exchange about the hotel food, and then to follow him. After a certain stutter—they were

too early, he was too young—they arrived in his room. Without further ado, Poitras proceeded to set up her camera. In a matter of minutes she was ready. "I'm going to begin filming now," she announced quietly, and so it began.

She filmed for some twenty hours, over eight days. This is the core of *CITIZENFOUR*: the encounter with Snowden in hiding; making and breaking the story in the same breathless moment. In short order Greenwald produced a series of incendiary articles, and Poitras produced a short film, *PRISM Whistleblower* (2013).[24] It is this extraordinary setup—people, in real time, confronting life decisions, with a vengeance—that makes the full-length film so compelling: at once thriller and fable; a chamber piece and a political event of tremendous significance; a model of cinéma vérité. *CITIZENFOUR* is riveting. So is Edward Snowden. He sits on the bed, tense but collected. He speaks in sentences, sometimes in paragraphs. He is cogent, principled, realistic, modest. There are flashes of wit, self-knowledge, even self-irony. The modus operandi is as understated as ever.[25]

She was surely right to intuit that he was genuine, in every sense, notwithstanding persistent attempts to demonize, psychologize, or trivialize, fitting him for the standard repertoire of stock characters for which dissenters are always fitted: traitor, narcissist, "useful idiot."[26] Motivations are often tangled, as Dostoevsky observes in *Crime and Punishment*: "Sometimes actions are performed very skillfully, most cleverly, but the aims of the actions and their origin, are confused, and depend on various morbid influences."[27] That may be true of Snowden, as of others, but there is no sign of it.

In truth, troublemakers like Laura Poitras and Edward Snowden have done the state some service. Dissenters are model citizens. As A. J. P. Taylor and J. M. Coetzee remind us, they are traduced at the time, and vindicated by posterity.[28] "After all," another great dissenter has written, "we have gotten used to regarding as *valor* only valor in war (or the kind that's needed for flying in outer space), the kind that jingle-jangles with medals. We have forgotten another concept of valor—*civil valor*. And that's all our society needs, just that, just that, just that! That's all we need and that's exactly what we haven't got."[29]

NOTES

This essay originally appeared in slightly different form in *International Affairs* 91, no. 2 (March 2015), pp. 381–92.

1. Talking Heads, "Life During Wartime," on *Fear of Music* (Sire, 1979); Marc Bloch, *Strange Defeat* (1948), trans. Gerard Hopkins (New York: Norton, 1999), p. 173; A. J. P. Taylor, *The Trouble Makers* (London: Hamilton, 1957), p. 14.
2. For her recent work, Poitras has been awarded a MacArthur Fellowship, a George Polk Award for national-security reporting, and a Pulitzer Prize for public service. She was first nominated for an Academy Award for *My Country, My Country* (2006), the best documentary yet made about the Iraq War, and she won the award for *CITIZENFOUR*.
3. Further information on the watch list has since been divulged by *The Intercept*, drawing on more leaked documents. See Jeremy Scahill and Ryan Devereaux, "Watch Commander: Barack Obama's Secret Terrorist-Tracking System, by the Numbers," *The Intercept*, August 5, 2014, https://theintercept.com/2014/08/05/watch-commander. On the efficacy or otherwise of such procedures, see Mattathias Schwartz, "The Whole Haystack," *New Yorker*, January 26, 2015, http://www.newyorker.com/magazine/2015/01/26/whole-haystack.
4. Peter Maass, "How Laura Poitras Helped Snowden Spill His Secrets," *New York Times Sunday Magazine*, August 13, 2013, http://www.nytimes.com/2013/08/18/magazine/laura-poitras-snowden.html.
5. Laura Poitras, "The Program," *New York Times*, August 23, 2012, http://www.nytimes.com/2012/08/23/opinion/the-national-security-agencys-domestic-spying-program.html.
6. Maass, "Laura Poitras." Maass speculates that her selectee status may relate to unfounded accusations about her prior knowledge of an attack on U.S. soldiers while filming in Baghdad in 2004, or to money she sent to the subject of her film, suspected (groundlessly) of insurgent activities, when his family fled the civil war in 2006.
7. Franz Kafka, *The Trial* (1925), trans. Willa and Edwin Muir, in *The Collected Novels of Franz Kafka* (London: Penguin, 1988), p. 9—the celebrated opening sentence. See Alex Danchev, *On*

Art and War and Terror (Edinburgh: Edinburgh University Press, 2011), Chapter 8.
8. Glenn Greenwald, "U.S. Filmmaker Repeatedly Detained at Border," *Salon*, April 8, 2012, http://www.salon.com/2012/04/08/u_s_filmmaker_repeatedly_detained_at_border/.
9. George Packer, "The Holder of Secrets," *New Yorker*, October 20, 2014, http://www.newyorker.com/magazine/2014/10/20/holder-secrets. Unless otherwise indicated, subsequent quotations from Poitras come from her conversation in this profile.
10. Conor Friedersdorf, "'What the War on Terror Actually Looks Like': Laura Poitras on *Citizenfour*," *The Atlantic* (October 2014), http://www.theatlantic.com/politics/archive/2014/10/what-the-war-on-terror-actually-looks-like-laura-poitras-on-em-citizenfour-em/381749.
11. George Packer, "War After the War," *New Yorker*, November 24, 2003, http://www.newyorker.com/magazine/2003/11/24/war-after-the-war. This article was subsequently woven into Packer's profound study of America in Iraq, *The Assassins' Gate* (London: Faber and Faber, 2006), as its Chapter 7.
12. Graham Greene, *The Quiet American* (1955) (London: Vintage, 2004). Packer weighs the parallel in *Assassins' Gate*, p. 89.
13. Packer, *Assassins' Gate*, Chapter 7.
14. On the Abu Ghraib images and their currency, see Danchev, *On Art and War and Terror*, Chapter 9.
15. David Thomson, "Frederick Wiseman," in *A Biographical Dictionary of Film* (London: Deutsch, 1994), pp. 817–18, is a scintillating and skeptical assessment of the filmmaker. Wiseman's first and most controversial film is *Titicut Follies* (1967), on the Bridgewater State Hospital for the criminally insane in Massachusetts.
16. Lawrence Wright, "The Agent," *New Yorker*, July 10, 2006, http://www.newyorker.com/magazine/2006/07/10/the-agent. The article forms Chapter 20 of his celebrated study of Al Qaeda and the road to 9/11, *The Looming Tower* (London: Penguin, 2007). Poitras makes reference to Wright's account in her interview with Friedersdorf, "'What the War on Terror Actually Looks Like.'"
17. For more on this issue, see Danchev, *On Art and War and Terror*, Chapter 8.
18. Cf. Frank Möller and Rune S. Andersen, "Engaging the Limits of Visibility:

Photography, Security and Surveillance," *Security Dialogue* 44 (2013), pp. 203–21, which focuses on Simon Norfolk and Trevor Paglen.

19. Laura Poitras, *The Program* (2012), video, *New York Times*, August 22, 2012, http://www.nytimes.com/video/2012/08/22/opinion/100000001733041/the-program.html.

20. Poitras, "The Program." The group consists of Binney, Drake, J. Kirk Wiebe and Edward Loomis, "the NSA Four." See also Jane Mayer, "The Secret Sharer," *New Yorker*, May 23, 2011, http://www.newyorker.com/magazine/2011/05/23/the-secret-sharer. Subtitled "Is Thomas Drake an Enemy of the State?" the article provides a penetrating analysis of his case, which sheds light on all of them, Binney included—and on the punitive response of the Obama administration to whistleblowers.

21. The story as it unfolds is told in the well-informed instant history by Luke Harding, *The Snowden Files* (London: Guardian Faber, 2014), and in the first person by Glenn Greenwald in chapters 1 and 2 of his *No Place to Hide: Edward Snowden, the NSA and the Surveillance State* (London: Penguin, 2014). Subsequent quotes from the Snowden-Poitras correspondence are from Harding. Greenwald has his faults, and his detractors, but his book is an invaluable account of the Snowden affair by one of the main actors. Supplemented by his website, glenngreenwald.net, it is also a sourcebook of documents. For judicious critiques of his sometimes simplistic positions on the issues, see David Cole, *"No Place to Hide* by Glenn Greenwald, on the NSA's Sweeping Efforts to 'Know It All',"* Washington Post*, May 12, 2014, https://www.washingtonpost.com/opinions/no-place-to-hide-by-glenn-greenwald-on-the-nsas-sweeping-efforts-to-know-it-all/2014/05/12/dfa45dee-d628-11e3-8a78-8fe50322a72c_story.html; and George Packer, "Intoxicating Conviction," *Prospect* (June 2014), pp. 48–52.

22. "Q & A: Edward Snowden Speaks to Peter Maass," *New York Times*, August 13, 2013, http://www.nytimes.com/2013/08/18/magazine/snowden-maass-transcript.html.

23. Michiko Kakutani, "The Needles in the Monumental N.S.A. Haystack: 'The Snowden Files,' by Luke Harding," *New York Times*, February 4, 2014, http://www.nytimes.com/2014/02/05/books/the-snowden-files-by-luke-harding.html.

24. Laura Poitras, *PRISM Whistleblower* (2013), video, *The Guardian*, June 9, 2013, http://www.theguardian.com/world/video/2013/jun/09/nsa-whistleblower-edward-snowden-interview-video. Greenwald's opening salvo focused on dragnet surveillance calculated to outrage the American public was "NSA Collecting Phone Records of Millions of Verizon Customers Daily," *The Guardian*, June 6, 2013, http://www.theguardian.com/world/2013/jun/06/nsa-phone-records-verizon-court-order. The trio were also concerned to make the point that GCHQ is in some respects even more invasive, as *CITIZENFOUR* underlines. See, e.g., Ewen MacAskill et al., "Mastering the Internet: How GCHQ Set Out to Spy on the World Wide Web," *The Guardian*, June 21, 2013, http://www.theguardian.com/uk/2013/jun/21/gchq-mastering-the-internet.

25. David Bromwich suggests something similar in "The Question of Edward Snowden," *New York Review of Books*, December 4, 2014, http://www.nybooks.com/articles/archives/2014/dec/04/question-edward-snowden.

26. See, e.g., Jeffrey Toobin, "Edward Snowden Is No Hero," *New Yorker*, June 10, 2013, http://www.newyorker.com/news/daily-comment/edward-snowden-is-no-hero; Nigel Inkster, "The Snowden Revelations: Myths and Misapprehensions," *Survival* 56 (2014), pp. 51–60; and Loch K. Johnson, ed., "An INS Special Forum: Implications of the Snowden Leaks," *Intelligence and National Security* 29 (2014), pp. 793–810, in particular the contribution of Rose McDermott (pp. 802–04).

27. Fyodor Dostoevsky, *Crime and Punishment* (1866), trans. Jessie Coulson (Oxford: World's Classics, 1998), p. 217. Snowden read this book in Moscow, his next way station after Hong Kong.

28. Taylor, *Trouble Makers*, p. 16; J. M. Coetzee to Chelsea Manning, December 2, 2014, a letter that appeared in *The Guardian* as part of "Dear Chelsea Manning: Birthday Wishes from Edward Snowden, Terry Gilliam, and More," December 17, 2014, http://www.theguardian.com/us-news/2014/dec/16/-sp-dear-chelsea-manning-birthday-messages-from-edward-snowden-terry-gilliam-and-more#img-6.

29. Alexander Solzhenitsyn, trans. Thomas P. Whitney, *The Gulag Archipelago* (London: Harvill, 1974), parts I–II, pp. 461–62.

Artist's Acknowledgments

I am deeply fortunate to have collaborated with the Whitney Museum of American Art on *Astro Noise*.

In cinema we have the tradition of end credits to acknowledge the unique roles of people who make a film possible. Like films, a museum exhibition is a collective undertaking. As this project presented uncharted waters for me, I am deeply thankful to the many individuals who contributed their expertise, creative vision, and support to the creation of *Astro Noise*.

There are four individuals without whom this work would not exist. From its conception to actualization, Jay Sanders challenged me to push boundaries while making sure I stayed true to my vision; Donna De Salvo offered her unwavering trust and encouraged me to take artistic risks; Brenda Coughlin collaborated on every aspect of *Astro Noise*, contributing unparalleled production expertise and calm under fire; and Henrik Moltke provided the backbone research and reporting on which the exhibition and book are built.

I offer my deep gratitude to Adam D. Weinberg, the director of the Whitney; Scott Rothkopf, the museum's deputy director for programs and chief curator; and the Board of Trustees for their trust and support.

The actualization of the exhibition is the work of Lauren DiLoreto, who managed a million moving parts and made it look effortless; Peter Kirby, whose invaluable wisdom drove the production and turned vision into reality; Ravi Rajan, who brought his shrewd, expert judgment and irreplaceable guidance; Mark Steigelman and Anna Martin, who oversaw the floor plan and construction integral to the show; Reid Farrington, Jay Abu-Hamda, and the rest of the team, whose warm spirits and expertise ensured my A/V needs were met; and Greta Hartenstein, whose curatorial assistance kept us on track.

I am profoundly grateful to Yoni Golijov, for his adept studio management in balancing multiple projects and approaching each with passion and a critical eye; Melody London, for her always beautiful and heartfelt

editing, which brings compassion to the screen; Danny Durtsche, for his crucial role in realizing the art pieces; Iddo Arad and Maura Wogan, for their indispensable legal support; Nicholas Fortugno, for his irresistible brilliance and enthusiastic spirit of collaboration; Josh Begley, for his artistic insight and invigorating support; Djuna Schamus, for her exceptional research; and Charlie Morrow, Jeff Aaron Bryant, Rebecca Drapkin, R. I. P. Hayman, and the whole Charles Morrow Productions team, for bringing their artistry to the sound design.

Bed Down Location in particular presented a challenge. The work exists thanks to a dedicated team. In addition to those whom I have already thanked, I would like to extend my gratitude to Faisal bin Ali Jaber for generously sharing his story and the footage he collected documenting the drone strike that killed two members of his family; Sammi al-Iryani, who devoted himself to the critical task of finding videographers where the drone wars are most active; Jonah Greenstein, who aided in conceptualizing and experimenting with the imagery; cinematographer Stéphane Guisard, who graciously shared his time and hard-earned astrophotography wisdom; and Cori Crider and Reprieve, who provided invaluable assistance. Thank you also to Waleed Ahmed, Matthieu Aikins, Andrew Berends, Iona Craig, Anand Gopal, Abdulrahman Hussein, Sheila Maniar, Paul Mason, Omar Mullick, Jamal Osman, Mohammed al-Qalisi, Muhammed Ali Sheikh, Khaled Taher, and Bassam Tariq. I regret that at the time of this writing I cannot name all the journalists and camera operators who went into the field to bring the drone wars into the exhibition.

The volume you hold in your hands is the result of an artistic collaboration with designer Joseph Logan, who created a book that both embodies the exhibition and stands on its own, and with the book's authors. I'm deeply thankful to each of them—Ai Weiwei, Jacob Appelbaum, Lakhdar Boumediene, Kate Crawford, Alex Danchev, Cory Doctorow, Dave Eggers, Jill Magid, Trevor Paglen, Jay Sanders, Edward Snowden, and Hito Steyerl—for their exquisite writing, and for accepting my invitation to dive deep, stay connected to political realities, have fun, and break the rules.

And yet the texts, however brilliant, could not assemble themselves into a book. For that I owe sincere gratitude to a tremendous publications team: Beth Huseman, for making our ideas a reality and proposing

we print and distribute a free version; Elizabeth Levy, for her consummate oversight and orchestration; Eric Banks and Domenick Ammirati, for their incisive editing; Rachel Hudson, for her design brilliance; Nerissa Dominguez Vales, for shepherding the production; and Jacob Horn, for navigating image clearances, several of which presented unique challenges.

My gratitude also goes to the many people who worked on the public programming indispensible to this exhibition's impact: Megan Heuer, for her leadership and inspired insights; Emily Arensman, for her commitment to the programs' success; Kathryn Potts, Heather Maxson, and Sasha Wortzel, for their work building an incredible Youth Insights program; and Harlo Holmes, for taking on the essential task of designing encryption-education events.

Many friends have shared their support, advice, and knowledge. I'm especially grateful to Kirsten Johnson, Merel Koning, Jeremy Scahill, Glenn Greenwald, Katy Scoggin, Pandora Zolotor, AJ Schnack, Charlotte Cook, Allegra Searle-LeBel, Cara Mertes, Ruby Lerner, Stuart Horodner, Diane Weyermann, Ryan Werner, Jenny Perlin, Ed Halter, David Sobel, Trevor Timm, Bart Beckermann, Sarah Harrison, Ben Wizner, Abdulghani al-Iryani, and Jamie Lee Williams.

The following organizations provided vital assistance along the way: Freedom of the Press Foundation, Field of Vision, First Look Media and *The Intercept*, Creative Capital, Electronic Frontier Foundation, and the American Civil Liberties Union. For their generous support, I thank the Sundance Institute, David Menschel and the Vital Projects Fund, the MacArthur Fellowship, the Guggenheim Fellowship, the USA Rockefeller Fellowship, Anonymous Was A Woman, BRITDOC, the Bertha Foundation, Cinereach, and the Ford Foundation and its president, Darren Walker.

This exhibition emerges from nearly fifteen years of documenting post-9/11 America and the global consequences of the so-called war on terror. None of my work would be possible without the many individuals who took enormous risks to allow me to film their efforts to build a more just world.

—Laura Poitras

Curator's Acknowledgments

To Laura Poitras: It was a little over three years ago in our correspondence that I said, "Let's stay in touch and find a way to collaborate again." I could never have imagined that *Astro Noise* would be the result. The process of working with you on this exhibition and publication has been enlightening and challenging in so many ways, and I am honored that you would put your time, trust, and vision in the Whitney and me.

I was introduced to Laura thanks to the Whitney Biennial 2012. Thank you to my co-curators of that exhibition: Elisabeth Sussman, curator and Sondra Gilman Curator of Photography, and Thomas Beard and Ed Halter, with whom I had the great opportunity to first present Poitras's work at the Whitney. Margie Weinstein, former manager of education initiatives, supported Laura's Surveillance Teach-In as a Biennial public program, and Elisabeth Sherman, Esme Watanabe, and Sophie Cavoulacos steadfastly produced the exhibition.

Being a part of the Whitney Museum at this momentous time is something I will treasure for years to come. To Adam D. Weinberg, the Whitney's Alice Pratt Brown Director, thank you for your endless leadership, enthusiasm, and support through this process and toward everything we all do. Donna De Salvo, former chief curator and current deputy director for international initiatives and senior curator, has provided unfailing encouragement and guidance to me and to Laura as we undertook this endeavor, and Scott Rothkopf, deputy director for programs and Nancy and Steve Crown Family Chief Curator, expertly advised, supported, and propelled this exhibition through to completion. And to the Whitney Museum Board of Trustees, we are so grateful to have your support and deep commitment as we continually champion and challenge the importance and definitions of American art.

Greta Hartenstein, my curatorial assistant, has at every turn through the inevitable labyrinth of such an ambitious project provided wisdom and innovative thinking and offered boundless enthusiasm and support to all aspects of *Astro Noise*. Special thanks as well to Andrew W.

Mellon Foundation Curatorial Fellow Lauren Rosati for her acumen and deft thinking, and to our interns, Lola Harney, Gregor Quack, and Alessandra Gomez.

One of the great pleasures of this project has been working with the remarkable team that has progressively assembled itself in Laura's studio and beyond to manifest the exhibition and book. First and foremost, the brilliant Brenda Coughlin has been our collaborator through all aspects of this project, and we are grateful beyond words for the support and attention she has given to it. Yoni Golijov has not missed a meeting yet and has juggled the many needs and production aspects with uncanny ease. Peter Kirby accepted the unique challenge of facilitating this vision's becoming a technical reality within the Whitney's galleries, and we thank him for his knowledge and ingenuity. So too Ravi Rajan brought his expertise for guiding ideas into aesthetic forms to bear on many aspects of this project, as did Danny Durtsche in his close work with Laura on the specific artistic details that constitute many of the works. A special acknowledgment is due Henrik Moltke, who has studied, analyzed, and translated the most complex material into knowledge that has supported so much important work. The Charles Morrow Productions team (Charlie Morrow, with Jeff Aaron Bryant, Rebecca Drapkin, and R. I. P. Hayman) collaborated to provide innovative audio expertise to design and enhance the impact of the exhibition. And I second Laura's own acknowledgments and offer a major thanks to her additional collaborators and associates whom I did not have the pleasure of meeting but whose work helped realize this ambitious and important exhibition.

From the very first concept meeting it was clear that *Astro Noise: A Survival Guide for Living Under Total Surveillance* would be a book like no other. Beth Huseman, director of publications, never blinked at this prospect and instead fervently saw to it that its ambitions be realized at the highest level in every way. We thank her immensely for her dedication. Jacob Horn, editorial assistant, facilitated its complexities with great care and sensitivity. Designer Joseph Logan worked with Laura and me on the Whitney Biennial 2012 catalogue, and his magical ability to create the most exquisite books amid the frenzy of countless moving parts meant he was to be our trusted collaborator here. And thank you to Rachel Hudson for her work with Joseph and the ideas and care she brought to this book. Project manager Elizabeth Levy gracefully

oversaw all facets of the volume's creation, and her tireless commitment and attention to every detail ensured that it came to fruition. Editors Eric Banks and Domenick Ammirati worked closely with the authors, Laura, and myself to hone our ideas and see to it that the book as a whole maintained the complexity of our intent. Nerissa Dominguez Vales masterfully trafficked the images, production, and printing, and we thank her for all her care. And thank you so much to our writers: Ai Weiwei, Jacob Appelbaum, Lakhdar Boumediene, Kate Crawford, Alex Danchev, Cory Doctorow, Dave Eggers, Jill Magid, Trevor Paglen, Edward Snowden, and Hito Steyerl.

In so many ways, the particularities of Laura's work have asked new things of the Whitney Museum, and we are grateful for the challenges and our ability to meet them. John S. Stanley, chief operating officer, supported us at the highest level. Nicholas S. Holmes, general counsel at the Whitney, deserves a special acknowledgment for guiding us through much new territory and doing so with dedication to the institution and its fundamental goal of supporting artists. He sought the counsel and support of an amazing legal team, including David Schulz, who masterfully led us through the intricacies of presenting these complicated materials, and John Charles Thomas, whose long history with the Whitney and working with artists greatly supports the work we all do.

Thank you to my fantastic colleagues at the Whitney, many of whom worked intimately with Laura and her studio with an open, collaborative spirit. Exhibition coordinator Lauren DiLoreto helmed our flight into deep space, guiding all aspects of the project through pitch darkness, around faint disturbances, and toward our final goal, charted at the distant edge of the known universe.

Thanks to my curatorial colleagues for their support, especially the thoughtful and valued guidance of Emily Russell, director of curatorial affairs, as well as all my curatorial colleagues, who offer continual dialogue and encouragement: Carter Foster, Barbara Haskell, Chrissie Iles, David Kiehl, Christopher Y. Lew, Dana Miller, Jane Panetta, Christiane Paul, Laura Phipps, Carrie Springer, and those curators I have mentioned above.

Christy Putnam, associate director for exhibitions and collections management, has guided her team to design and support this exhibition to its fullest realization. The physical spaces of the exhibition and

their unique details were created with the expertise of Mark Steigelman, exhibition design and construction manager, and Anna Martin, design and construction associate designer. The Whitney's A/V staff played an integral role in the technical aspects of this show and installed and maintained it with extreme care. Thank you to Reid Farrington, Jay Abu-Hamda, Richard Bloes, Peter Berson, and Jeff Bergstrom. So too Peter Guss, director of information technology, and Sang Lee, manager of information technology, offered their expertise to the realization of the work, as did Peter Scott, director of facilities, David Selimoski, engineer, and Larissa Gentile, building project manager.

Thank you to Adrian Hardwicke, director of visitor experience, for his work to envisage how the audience will navigate this uncompromising exhibition and to John Balestrieri, director of security, for his concern for the safety of both the work and the visitors at all times.

To our advancement team, Alexandra Wheeler, deputy director of advancement, Hillary Strong, director of institutional advancement, and Morgan Arenson, manager of foundation and government relations, we deeply appreciate working so closely with you on the support and funding of this exhibition and for your openness to its experimental approach and its real-time manifestation.

And great thanks are due our exemplary Education Department team. Kathryn Potts, associate director, Helena Rubinstein Chair of Education advised from the outset and has thoughtfully considered the sensitivities of an exhibition that asks tough questions to us as both art viewers and Americans, working with her team to guide our visitors through the experience in an engaged and contemplative manner. Megan Heuer, director of public programs and public engagement, and Emily Arensman, manager of public programs, collaborated closely with Laura, her studio, and me and have put forth a formidable and innovative program of public events, taking myriad forms, which we see as integral aspects of the exhibition. A special thanks to the participants in the public programs that will help bring the exhibition content into real-world applications via art, film, encryption, and discussion. For their ongoing support producing our programs in the Whitney's theater and beyond, thank you to Lana Mione, theater manager, and Amanda Davis, performance coordinator. Anne Byrd, director of interpretation and academic programs, facilitated the public's access

and understanding of the exhibition and its artistic intent, and Gene McHugh wrote the articulate, informative texts that accompany viewers through the exhibition. Danielle Linzer, director of access and community programs, worked closely with us as well.

Hilary Greenbaum, director of graphic design, and her glorious team, Virginia Chow, Sung Mun, and Liz Plahn, brought their ingenuity and creativity to the show's typography, signage, and brochure.

Thank you to Jeff Levine, chief marketing and communications officer, and Stephen Soba, director of communications, and their hard-working team, Amanda Angel, Sarah Meller, and Sara Rubenson, among others, for their dedication to the project.

For the advice and generosity of those peers who offered their audiovisual expertise and consultation, we thank Aaron Louis, Director of Audio Visual, The Museum of Modern Art; Anne Breckenridge Barrett, J.D., Director of Collections and Exhibitions, Museum of Contemporary Art Chicago; Daniel Slater, Senior Exhibitions Manager, Victoria and Albert Museum; Benjamin Pearcy, 59 Productions; Lindsay Danckwerth, Director, Special Projects, Galerie Lelong; and Victoria Brooks, Curator, Time Based Visual Art, EMPAC—The Curtis R. Priem Experimental Media and Performing Arts Center, Rensselaer Polytechnic Institute.

A special thanks also to those colleagues and friends who have provided counsel and advice: Julia Angwin, Artists Space (Richard Birkett and Stefan Kalmár), Paul Chan, Tony Conrad, Nicholas Fortugno, Bettina Funcke, Melanie Gilligan, Johannas Goebel (EMPAC), Carol Greene, J. Hoberman, Alex Hubbard, Robert Hullot-Kentor, John Knight, Andy Lampert, Jeff Larson, Annie Ochmanek, Paige Sarlin, SVA Critical Theory and the Arts, Ann Webb (Royal Ontario Museum), Emily Zimmerman, and the one and only Sarah Michelson.

—Jay Sanders
Curator and Curator of Performance
Whitney Museum of American Art

"Anarchist" Image Index

Anarchist is the code name of an operation run by the British Army for the UK's Government Communications Headquarters (GCHQ). From the top of the Troodos Mountains on the island nation of Cyprus, two antennae operating twenty-four hours a day intercept signals from satellites, drones, and radars in the Mediterranean region.

The selection of visualizations in *Astro Noise* comprises snapshots of signals collected through Anarchist. They show various stages in the processing of the collected signals. The images are from GCWiki, an internal British intelligence wiki disclosed to Laura Poitras and other journalists by Edward Snowden.

Pages 2–3: Data feed with Doppler tracks from a satellite, intercepted May 27, 2009

Pages 4–5: Israeli drone video feed, intercepted June 10, 2009

Pages 6–7: Air traffic control signals, intercept date unknown

Pages 8–9: Israeli drone feed, intercepted February 24, 2009

Pages 10–11: Unidentified signal from an Israeli source, intercepted January 23, 2009

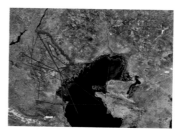

Pages 12–13: Air traffic control data plots near Astrakhan, Russia, intercept date unknown

Pages 14–15: Data feed from a French satellite, intercepted March 30, 2009

Pages 242–43: Unidentified signal from an Israeli source, intercepted April 15, 2009

Pages 244–45: Signal from an unidentified source, intercepted April 5, 2009

Pages 246–47: Data feed from a drone, intercepted July 7, 2009

Pages 248–49: Air traffic control data plots near the Turkish-Syrian border, intercept date unknown

Pages 250–51: Data burst, intercepted October 25, 2009

Pages 252–53: Commercial satellite feed, intercept date unknown

Pages 254–55: Satellite feed with Doppler track, intercepted May 28, 2009

Chris Ketchie
Farrah Khatibi
David Kiehl
Thomas Killie
Kathleen Koehler
Irene Koo
Tom Kraft
Melinda Lang
Eunice Lee
Sang Soo Lee
Monica Leon
Rachel Lesser
Jen Leventhal
Jeffrey Levine
Christopher Lew
Danielle Linzer
Kelley Loftus
Robert Lomblad
Emma Lott
Doug Madill
Trista Mallory
Elyse Mallouk
Jessica Man
Carol Mancusi-Ungaro
Louis Manners
Anna Martin
Heather Maxson
Meredith McDevitt
Patricia McGeean
Caitlin McKee
Michael McQuilkin
Sandra Meadows
Nicole Melanson
Sarah Meller
Bridget Mendoza
Graham Miles
Dana Miller
David Miller
Lana Mione
Christie Mitchell
Christa Molinaro
Matthew Moon
Sara Mora
Michael Moriah
Victor Moscoso
Sung Mun
Eleonora Nagy
Anthony Naimoli
Daniel Nascimento
Ruben Negron
Randy Nelson
Tracey Newsome
Carlos Noboa
Pauline Noyes
Jaison O'Blenis
Brianna O'Brien Lowndes
Suzanna Okie

Kimie O'Neill
Rose O'Neill-Suspitsyna
Nelson Ortiz
Nicky Ozir
Jane Panetta
Sejin Park
Christiane Paul
Mary Paul
Jessica Pepe
Natasha Pereira
Jason Phillips
Laura Phipps
Angelo Pikoulas
Elizabeth Plahn
Mary Potter
Kathryn Potts
Rachel Pridgen
Linda Priest
Stephen Ptacek
Vincent Punch
Christy Putnam
Julie Rega
James Reyes
Gregory Reynolds
Emanuel Riley
Ariel Rivera
Felix Rivera
Jeffrey Robinson
Richard Robinson
Georgianna Rodriguez
Manuel Rodriguez
Gina Rogak
Clara Rojas-Sebesta
Justin Romeo
Adrienne Rooney
Joshua Rosenblatt
Jamie Rosenfeld
Amy Roth
Scott Rothkopf
Sara Rubenson
Emily Russell
Angelina Salerno
Leo Sanchez
Jay Sanders
Galina Sapozhnikova
Lynn Schatz
Meryl Schwartz
Peter Scott
Michelle Sealey
David Selimoski
Jason Senquiz
Leslie Sheridan
Elisabeth Sherman
Dyeemah Simmons
Justin Singleton
Matt Skopek
Adrienne Smith

Joel Snyder
Michele Snyder
Stephen Soba
Barbi Spieler
Carrie Springer
John Stanley
Mark Steigelman
Minerva Stella
Betty Stolpen
Hillary Strong
Paul Suarez
Emily Sufrin
Emilie Sullivan
Denis Suspitsyn
Elisabeth Sussman
Hannah Swihart
Ellen Tepfer
Latasha Thomas
Zoe Tippl
Ana Torres
Stacey Traunfeld
Beth Turk
Lauren Turner
Lucas Underwood
Matthew Vega
Ray Vega
Eric Vermilion
Emily Villano
Billie Rae Vinson
Farris Wahbeh
Adam D. Weinberg
Alexandra Wheeler
Charlotte Wittmann
Andrew Wojtek
Sasha Wortzel
Laura Wright
Sefkia Zekiroski
Kayla Zemsky
Nicolette Zorn

As of October 14, 2015

PHOTOGRAPHY AND REPRODUCTION CREDITS

The following is a partial list of copyright holders, photographers, and sources of visual material. Additional information about images appears on pages 236–37 and page 256. Unless otherwise indicated, all images are courtesy the artist. Every effort has been made to obtain permissions for all copyright-protected images; if there are any errors or omissions, please contact the publisher so that corrections can be made in any subsequent edition.

p. 26: Photograph by Oresti Tsonopoulos
p. 29: Photograph by Greta Hartenstein
p. 38: GCHQ
p. 60: Courtesy Professor Ramzi Kassem, CUNY School of Law, Immigrant and Non-Citizen Rights Clinic, New York, counsel for Moath al-Alwi
p. 80: Photograph by Laura Poitras
p. 107: Courtesy the National Radio Astronomical Observatory Archives, Charlottesville, Virginia/ Associated Universities, Inc./ National Science Foundation
p. 108: Courtesy the Naval Research Laboratory, Washington, D.C.
p. 109: Courtesy the Naval Research Laboratory, Washington, D.C.
p. 110: Courtesy NASA
p. 113: National Security Agency
p. 116: © Trevor Paglen
p. 120: Courtesy NASA
p. 138: Department of the Interior/USGS
p. 141: Digitized by the Internet Archive in 2013
p. 145: National Security Agency
p. 150: Photograph by Daniel Enchev via Flickr
p. 174: Photograph by Hito Steyerl

Slipcase: Excerpt of classified FBI document, 2010, from investigation of Laura Poitras obtained through Freedom of Information Act lawsuit. Redactions have been made by the United States government.

Divider images: Laura Poitras, *O'Say Can You See*, 2001/2011. Digital video, 15 min.

y: 35.7?
x: 7.184

dy: 35.7935678 L=0 Re zH: 0.69048
:-03 dx: 7.184637589E-03 (absc) zL: 0.28571 c

DY: 00:00:02.531644361
DX: 0.023389647
Y Res: 0.03328

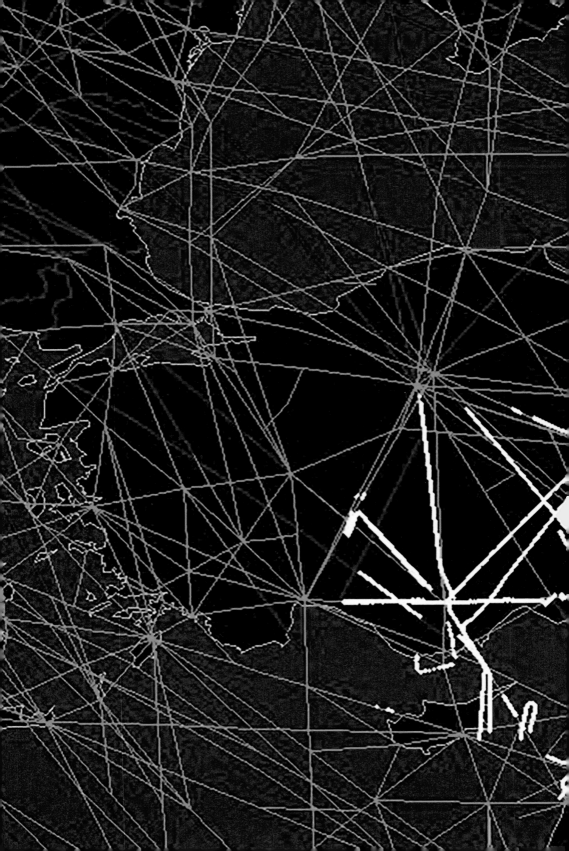

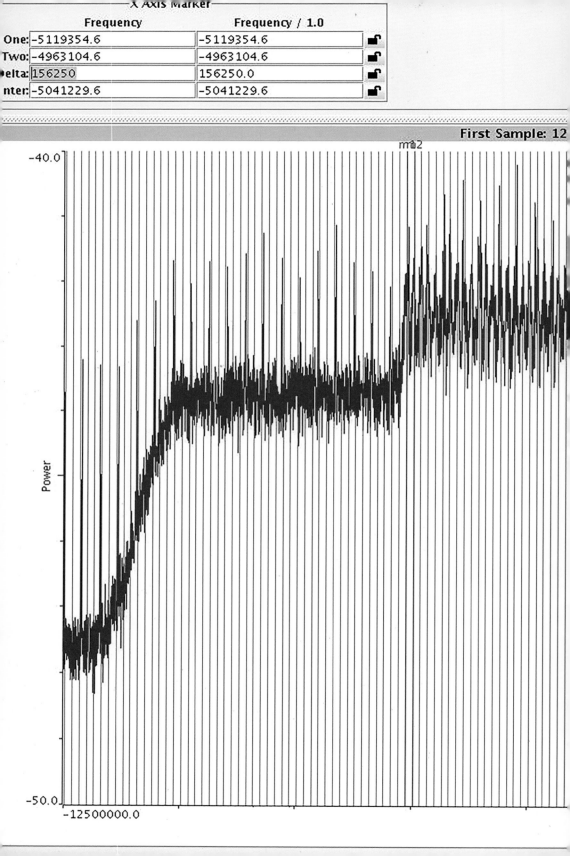

	Frequency	Frequency / 1.0	
One:	-5119354.6	-5119354.6	
Two:	-4963104.6	-4963104.6	
Delta:	156250	156250.0	
nter:	-5041229.6	-5041229.6	

First Sample: 12

-40.0

m2

Power

-50.0

-12500000.0

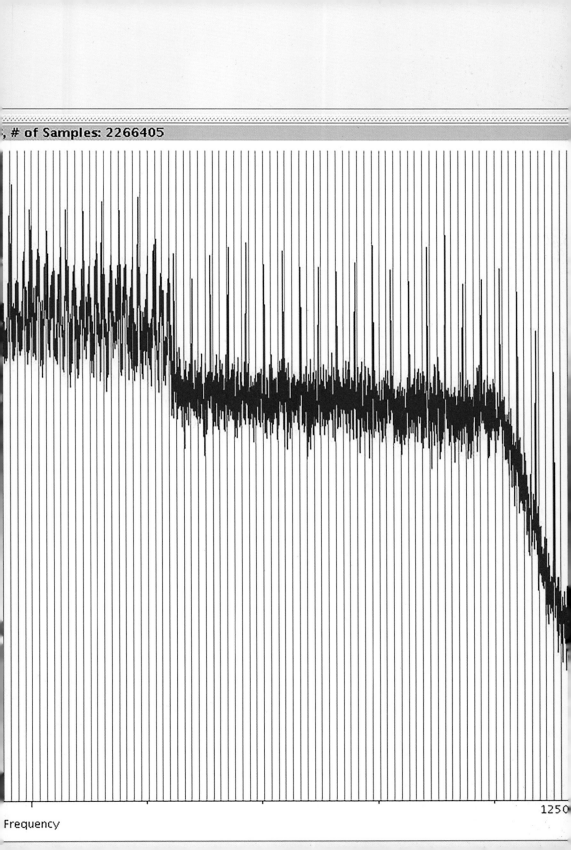

Frequency

1250

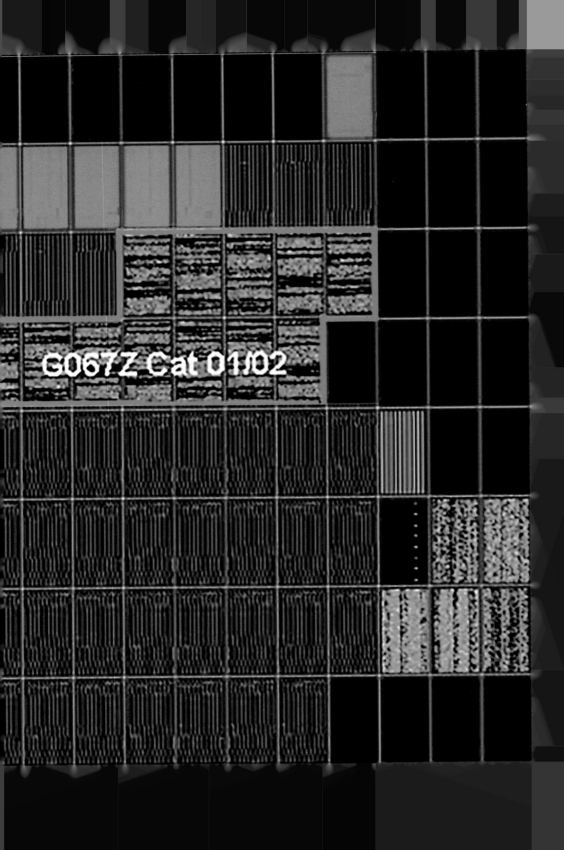

G067Z Cat 01/02